Alligators,
Old Mink &
New Money

Alligators, Old Mink & New Money

ONE WOMAN'S ADVENTURES
IN VINTAGE CLOTHING

Alison Houtte & Melissa Houtte

AVON
TRADE

An Imprint of HarperCollinsPublishers

This title was originally published in hardcover by William Morrow in December 2005.

Various names and a few other facts have been changed for reasons that will become obvious to anyone who has ever owned a business or been involved in an intimate relationship. The names of Hooti customers have been changed unless we had specific permission to use them—or the story was so flattering that we knew they would want to be recognized.

Epigraph reprinted with permission of Simon & Schuster Adult Publishing Group from *What Shall I Wear?* by Claire McCardell and Edith Heal. Copyright © 1956, and renewed © 1984, by Claire McCardell Enterprises, Inc.

HarperCollins books may be purchased for educational, business, or sales promotional use. For information please write: Special Markets Department, HarperCollins Publishers Inc., 10 East 53rd Street, New York, NY 10022.

FIRST EDITION

ISBN-13: 978-0-06-078668-7
ISBN-10: 0-06-078668-X

Interior text designed by Chris Welch

Illustrations by Mary Coleman

The William Morrow hardcover edition contained the following Library of Congress Cataloging-in-Publication Data

Houtte, Alison.
 Alligators, old mink & new money : one woman's adventures in vintage clothing / Alison Houtte & Melissa Houtte.—1st ed.
 p. cm.
1. Vintage clothing—History—20th century. 2. Women's clothing—History—20th century. 3. Clothing trade. 4. Models (Persons)—Psychology.
I. Houtte, Melissa. II. Title.

NK4710.H68 2005
746.9'2'092—dc22
[B] 2005043416

06 07 08 09 10 RRD 10 9 8 7 6 5 4 3 2 1

To

Mom & Dad, Mike, Susan, Jennifer and Caroline

People without a sense of fun, of dash, of whim, may misunderstand Fashion.

—*American designer Claire McCardell (1905–1958)*

Acknowledgments

While it is impossible to thank everyone who has played a role in our professional lives, several people must be credited for their contributions, direct or indirect, to the success of Hooti Couture and the creation of this book.

In no particular order, we want to thank the following, who have generously shared their knowledge and experiences, simply said "You can do it" or been ready with good humor and hard labor: Louise Despointes, Melanie and Mark Geiger, Lily Douglass, Nancy and John, Larry Bergreen, Susan Maruyama, Tony Reagan, Rod Spicer, Ellen Kampinsky, Sheila Wells, Christine Wicker, Robin Wolaner, Anne Kenney, Howard, Chris Houghton, Gigi Warshaw and Russell Joseph Buckingham.

We will always be appreciative of the contributions of friend and illustrator Mary Coleman, whose wit, intelligence and love of vintage are evident throughout the book.

We would not have *Alligators* without the wise guidance of our agent, Gail Ross, and her creative director, Howard Yoon. And we will always be indebted to editor Claire Wachtel of William Morrow for seeing the possibilities, and to editor Jennifer Pooley, for helping us make the most of those possibilities.

Finally, much love to Bob Doyle and Fabian Seijas, men who aren't afraid of boisterous women or old clothes.

—*Alison and Melissa Houtte*

Mothers and Daughters
Passing Down the Thrift Gene

Back in the mid-nineties, while I was visiting my parents in Miami, I was desperate for something to wear to lunch at the newly opened Delano Hotel, the place to be seen on South Beach at that moment. I was meeting an old girlfriend from my modeling days, a woman who now moves with a crowd in Manhattan a few notches above my social circle. I wanted to look good, and I wanted to be cool, literally. It was a ninety-eight-degree day.

Tucked in a drawer in my mother's dresser, which was jammed to overflowing with odd remnants like a monogrammed linen handkerchief and a single baby's shoe, I found an old navy blue slip whose fabric felt like rose petals in my hands. I knew that my mother had tucked away hundreds of such items throughout our house—from her youth, from the childhoods of my four sisters and brother and me—but I didn't know that this had belonged to my grandmother, Mom's mother, until I asked if I could borrow it.

Navy is not my best color, but I was in a bind, and I figured that if

Madonna could wear a slip out in public, so could I. I put it on, and it fit beautifully, hitting just below the knee. It wasn't sheer, so nothing significant was exposed—no nipples, no panties. I cinched the waist with an inexpensive black stretch belt and completed the outfit with sexy, strappy black sandals and a python-patchwork clutch.

As I prepared to leave the house, my father was baffled. "Where's your dress?" he asked.

"This is my dress," I told him, and because I am his youngest daughter, my dad has seen it all and knows when to stop asking questions. He shook his head and laughed.

As I walked onto the Delano's terrace—a seductive sea of overstuffed wicker sofas draped with tanned bodies sporting Dior sunglasses, perfectly pressed Italian linens and rhinestoned Manolos—I was a bit nervous, though I knew I looked good and could hold my own with this crowd. My self-confidence kicked into high gear the minute I spotted my friend and her lightning-quick head-to-toe appraisal of my outfit confirmed my gamble. We exchanged an air kiss, and her first question was, "Where did you get that dress?" She was smiling the smile of a woman who always buys the best—or the most expensive, and equates that with "best"—and who also appreciates a great find. When I told her the source, she immediately responded, "Is there another one in that drawer?"

Lucky for me, my mother had style even when our family didn't have much money. Of course, when I was a little girl growing up in Miami, I didn't know this. My mother was simply an embarrassment to me and my siblings because of:

How she dressed—Roman sandals and loud prints, sometimes going braless.

Where she shopped—Goodwill and church rummage sales.

Her choice of deodorant for herself and her family—baking soda.

And what she expected us to wear—secondhand clothes, usually with "good" labels.

None of our friends had a mother quite like ours—Mom was a strong-willed, hot-tempered feminist, though I never heard that word used in our house. She hated—and still avoids—any kind of housekeeping, yet she would spend time almost every week carefully ironing our organdy and cotton dresses so we would be presentable for church. She was, and still is, a woman whose life can be marked, at least in part, by the clothes she wore—new and used—for minor and major moments in her family's life.

Mom got her sense of what was "good" from her own mother, Marie Neylon, a woman whose hair was always pulled into a bun, stray gray strands held in place by tortoiseshell combs, a woman whose "old country" (Bohemia-Hungary) way of doing things was an embarrassment to her only daughter, Jacqueline. Grandma cooked potato pancakes and beef stew with fluffy dumplings, boiled her bedsheets with bluing in copper pots *after* they came out of the wringer washer and braided her own rugs using upholstery fabric remnants. She was a woman who could sit in the basement for hours on end "picking" feathers, emerging with a halo of fluff on her head after separating the down—the softest, finest feathers—from larger, sharper feathers, so she could make the best down-filled pillows.

None of this sat well with Mom, who will be the first to admit she was a spoiled, unappreciative child when she was grow-

ing up on the south side of Chicago. Mom wanted a *modern* mother, someone who went to the beauty salon, served "American" food and aspired to own wall-to-wall carpeting, rather than sneering at it.

But Grandma Neylon did embrace at least one pastime the two of them could share: She loved to shop, and she patronized only the nicest stores, even though there was very little extra spending money for a family of five living on a policeman's salary. While my grandfather might be wearing a secondhand camel-hair coat—my mother remembers a man more interested in good books than clothes, as long as his uniform passed inspection—his two sons were dressed in Belgian linen suits, and his daughter never wore a hand-me-down.

In the thirties, Grandma Neylon's idea of a pleasant day away from her household duties was to take Mom to Marshall Field, which filled a twelve-story granite building covering a whole city block in downtown Chicago. Once inside this elegant store, Grandma would charge a half pound of fancy mixed nuts, freshly scooped into a box and still warm. Then, pecans and cashews in hand, she and my mother would munch their way from department to department, admiring all the nicest merchandise, lingering in the vast furniture department because that was my grandmother's favorite and shopping for clothes for my mother whenever she needed them. Invariably, at the end of the day, my grandfather would be circling the block in the family car, because they were always late getting back to their prearranged pickup spot.

Her tastes refined by all those hours of browsing, my grandmother scrimped and saved—and, sometimes, lived beyond her

means—so she could buy sterling flatware (one piece at a time), Dresden compotes, Oriental rugs, a nine-foot mahogany dining table and other *good* things, things that would last beyond her lifetime, things she and her husband could leave to their two sons and daughter.

Her eye for quality never wavered, even when she wasn't in Marshall Field or Carson, Pirie, Scott, another of her favorite stores.

My mother remembers visits to the homes of friends and acquaintances where Marie, out of the blue and much to her daughter's dismay, would admire a piece of furniture and put a preemptive bid on the table. "If you ever want to get rid of this . . . ," she would say, without skipping a beat in the conversation.

And she was confident enough about what her daughter would like that she once took it upon herself to buy my mother's dress for her senior prom, surprising Mom with a full-length white crepe gown and a cranberry red full-length velvet coat. "It was beautiful," Mom says, sounding as pleased at eighty as she was at seventeen.

But, almost inevitably, the old-fashioned mother and her more modern daughter eventually did battle. "If my mother said it was black, I said it was white," my mother says regretfully. The same went for all things old and new. As a single woman still living at home but determined to create her own life and her own look, Mom renounced any interest in inheriting the possessions Grandma Neylon had so carefully collected.

"Fine," said my grandmother. "I'll give everything to my grandchildren."

But my grandmother's influence, at least when it came to style, had already stuck, no matter how much my mother might fight it.

A striking, slender woman—almost six feet tall, with thick black hair and the perfect posture that comes from twelve years in a Catholic girls' school—my mother wore clothes well, and by the time she was twenty she had charge accounts at her two favorite stores. Saks Fifth Avenue and Peck & Peck, both New York based, had invaded Chicago, and any allegiances Mom felt toward Marshall Field were dashed by her desire for beautiful suits. It was where she wore the suits, though, that is more memorable to her than the clothes themselves.

From 1944 until 1948, Mom worked as a secretary to the medical director of the Manhattan Project at the University of Chicago, surrounded by some of the smartest scientists in the world, all of them working in high secrecy on an atomic bomb and aware that Germany was doing the same.

In the weeks just before the bomb was dropped on Japan, Mom was the secretary assigned to type a petition letter signed by many of the most famous members of the Chicago operation. It was addressed to President Harry Truman, and it opposed on moral grounds the use of the bomb in Japan. She does not remember what she wore that day.

❧

One more thing about my Grandma Neylon: She was a major snob when it came to labels and stores.

"There is nothing as lowly as Grand Rapids furniture,"

Marie proclaimed more than once in the privacy of her home and to her closest friends, in one breath damning all the work coming out of what was already considered the "furniture capital of America." But her in-laws' wedding present to her and my grandfather had been a mahogany armchair that Marie considered poorly made—and it had come from Grand Rapids.

Her disdain was equally sharp for anyone who shopped for anything at Montgomery Ward. In her book that was not a store for people with taste, people who bought for the long haul—for someone like her, a woman who wore one wool cape for decades, a cape Mom has worn, too, and which she still cherishes. And, on this last point, the gene was cleanly passed from mother to daughter.

As for the Grand Rapids chair: It sits in the foyer of my parents' home, where it has withstood the test of time, and me and my siblings.

❧

Still single in the late forties, my mother moved to Miami with hopes of finding a fresh life and a man she could marry. Ideally, he would be Catholic, but she was flexible. After all, she was twenty-five; most women her age had married years earlier.

My dad, at twenty-nine, was also looking to get married. Yet the match, at least on the surface, was an odd one. George Houtte, who had fled to Miami to escape harsh New England winters, was, and still is, a practical, soft-spoken man whose only religion was hard work. He didn't believe in charge cards or debt of any kind, save a mortgage on your house. You paid cash

or you didn't buy. He was also good with his hands; he would build their first house with a lot of sweat and $4,000.

Nine months after they met, Jackie and George were married simply in a church rectory—and the only wedding gift Mom remembers is an ivory silk and lace peignor set from her parents. Mom agreed to Dad's ideas about money, and Dad agreed to raise their children as Catholics. And that is how they lived, even after I was born ten years later, the last of their *six* kids. Parochial-school tuition was a given by then, and credit of any kind was still taboo—even when the floor panels in the car were so rusted out that we could stick our feet through them. No, if we couldn't afford something new, we would make do with what we had—and anyway, you drove cars till they dropped. The Houttes had definitely not bought into the "keeping up with the Joneses" way of thinking, no matter how much that might pain their children.

But this didn't mean that my mother had forsaken all interest in nice things. Never. A few of Mom's beautiful clothes from her previous life as a single woman still hung in her closet, buried among weary maternity tops and worn stretch pants and a few church dresses. She couldn't part with them, even if it took only the first few babies before she lost the battle with her waistline, and those fitted and unforgiving wool suits stayed on their hangers for good.

And when there was money to spend—when Dad's work as a bricklayer, roofer, carpenter and builder was thriving because the South Florida economy was on a boom swing—Mom shopped just like her mother, if not more so. The seeds of "good" and "junk" had been sown and had flourished, influencing Mom's decisions on everything from cereal to swing sets. At the grocery store, she refused to buy house brands and she seldom bought

prepared foods—heaven forbid that a cake mix find its way into *her* kitchen. To our dismay and her credit, Kool-Aid and Coca-Cola seemed as evil to her as an electric washing machine—"an invention of the devil"—had seemed to her mother. When Mom and Dad bought a sofa and matching chairs, it was the best, Heywood-Wakefield rattan, and while the kids down the street might get new bikes from Sears for Christmas—fresh out of the box, with shiny plastic tassels on the handle grips—not us. Mom would make it known just how inferior she regarded the quality of those bikes to be—and speculate, probably accurately, on just how much charge-card debt those bikes had required—as if this would make us feel any happier about getting a nice *used* Schwinn with a few dings in the paint. She loved Schwinns and our bikes did last a *long* time, and, to be fair, the new shiny bikes down the street didn't stay new and shiny very long.

Mom didn't ignore our desires entirely—there were *new* Betsy Wetsy dolls, RCA record players and Erector sets that found their way under the Christmas tree, too—but she was most proud of her "buys," as if finding a sharply reduced Madame Alexander ballerina would guarantee her a spot in the Smart Shopper Hall of Fame. One year my sister Susan received a giant stuffed black poodle, not because she had asked for it but because it was an expensive German-made Steiff, discovered heavily marked down on Christmas Eve. Mom was smart about such things, as the assorted eBay postings for vintage Steiff toys confirm today, even if there are more sellers than buyers.

Such gifts were memorable in a way, but our neighborhood self-esteem often took a temporary beating when it came time to compare gifts with other kids. We were *different*.

When my mother did pay full price, and put her own taste on hold, it was usually because she was buying a gift for her mother-in-law, something special that was *never* marked down, like a Whiting & Davis purse, a gold charm or a Hummel figurine. These moments were difficult for Mom, but she knew she didn't have a choice. Grandma Houtte was "hard to buy for," and it was always quite obvious when Mom bought wrong.

But Mom was shopping for her own mother, and herself, the day she bought a simple black B.H. Wragge sheath she can still describe as if she wore it yesterday—"it had a British-tan belt that rested on the hips; your father loved it."

Mom paid full price, $60, without hesitation, but with no joy, because she needed something to wear to her mother's funeral.

After my grandfather had died years earlier, before I was born, Grandma Neylon had moved to Miami to be closer to her daughter. Grandma lived maybe twenty minutes from us, in a small, lovely home that included a closetful of toys for our frequent visits. She had asked my father to build the house for her, and, amazingly, had entrusted Mom and Dad with creating a design incorporating ideas from magazine photographs she sent to them. Now she was dead, after a car accident had killed her instantly, and Mom had nothing in her closet that was appropriate to say good-bye.

Grandma was sixty-three, Mom was thirty-nine, and the funeral service remains rich in my mother's mind for many things, including these words, from a friend: "Marie always had style."

❧

I was only three when Grandma Neylon died, so most of what I know of her comes from my siblings and my parents, and from the pieces of her life that she left behind, like her four-poster mahogany bed. Fortunately, by the time she died, her relationship with my mother had begun to mellow. Mom had even come to appreciate much of what my grandmother had brought with her to Miami, so I grew up surrounded by a number of her heirlooms.

I am thankful for my grandmother's passion for good things, because I have mementos of her life that tell me who she was— even something so simple as that navy blue Barbizon slip ("Size 20 Miss," the label says, "U.S. patent number 2,480,882") that I wore to the Delano and will wear again. I know, from my mother, that Grandma Neylon was a strong, independent woman. And that's how I see myself, too, whether I'm dressed in a slip for a fancy lunch or just sitting in a bathrobe at home, paying my own bills.

Whenever I see a B. H. Wragge label, which is rare, I think of my own mother, and that will be the case for the rest of my life. The black Wragge, which Mom topped with a French blue mohair sweater for the funeral, became a Sunday-mass dress for the rest of its life, until she wore it out. And two other Wragges also took Mom through many years of Sundays: a simple pale blue sleeveless linen sheath and a short-sleeved, tweedy-weave, dusty pink wool suit with a wide rolled collar.

Mom kept both of those outfits, worn but still pretty, and to touch them now is to instantly connect to my mother's sense of style and to be given a concrete sense of an era I am too young to remember. I know that the suit and dress will be worn again by

me or one of my sisters or nieces, not because we are stuck in the past or trying to re-create it but because they are still wonderful pieces of clothing, worthy of another generation of memories.

❦

Six kids don't leave a stuck-at-home mother much time for shopping. But once a year through the late fifties and sixties, as finances permitted, my mother would spend a day by herself at Lincoln Road Mall in south Miami Beach. In that era the typical shoppers were newly arrived former New Yorkers, or "snowbirds"—winter residents who arrived faithfully every fall from the Midwest or Northeast, at just the right time to avoid the first snow and the last hurricane. Nobody called the neighborhood South Beach then, and you would have been hard-pressed to find a café cubano.

Mom's favorite destination was the summer sale at DePinna, which had its flagship store on Fifth Avenue in New York. Mom considered it the nicest store in all of Miami, and she also knew that it was way beyond her budget—until prices had been slashed. In one family snapshot, my sister Caroline and I wear matching denim aprons with bright flower appliqués. We know that these outfits came from DePinna's only because, to this day, Mom never forgets the details of a really good bargain *and* I can't forget one of the few outfits I see in old photos that I know was *new*.

More often than not, though, I found myself in used clothes from the time I was a toddler. As the youngest girl, I occupied the bottom rung on the hand-me-down ladder—unlike my lone brother, whose only big issue was how to survive life with five sisters. I was truly the end of the line for everything from Stride Rite sandals to natural straw hats festooned with gros-

grain ribbons and clusters of tiny spring flowers. Mom *loved* to put us in straw hats for church, but even though they were stored carefully between wearings—and a new hat was added to the mix on occasion, if Mom found a good markdown—most were five to ten years old, and even the best of them were a bit bedraggled by the time they reached my head.

Likewise, our cotton, taffeta and organdy Sunday dresses, which were washed and starched again and again, eventually showed their age. But in our house *nothing* was ever thrown away; things were just pushed to the back of a closet or the bottom of a drawer, as though the memories of childhood were locked into every thread and ribbon, and my mother couldn't bear to part with even one. In reality, many of the Sunday memories were less than idyllic, tainted many times by my mother's exhausted rants as we rocketed down the highway toward church, late once again because getting herself and six kids dressed presentably, with all shoes accounted for, was no easy task, no matter how much help my father might offer before sending us on our way. While he began the peaceful work of making from-scratch pancakes for his brood, we predictably faced the cold stare of the priest as we tiptoed toward an open pew, no matter how cute we might have looked in our hats.

This was—and still is—our house and my whole upbringing: My sister Susan can still walk into the "children's closet" and find a matching blouse and maxiskirt, probably dating to 1971, in a bright yellow cotton covered with little red flowers with black stems. "I wore it for the mock United Nations in high school," she recalls almost instantly. "I was Swaziland." My sister Jennifer can still recall her shame and dismay after learning from my

mother that Jen's favorite yellow dress with green ribbon trim, which she wore almost every week through the ninth grade, was actually pajamas. Mom had known but didn't think that was important because the "dress" was so cute. Notable labels and major markdowns were, and still are, a good thing. So are garage sales and castoffs from friends. And while we're at it, "Stand straight," "Mind your manners," "Children should be seen, not heard" and "No, we can't afford that." My parents did not get a charge card until 1980, when I was twenty—and only because they finally realized that traveling without one would make them crazy. Still, even in their eighties, they frown on debt—and their philosophy has served them well.

Of course, the idea of an allowance was a concept that my parents never embraced, or even acknowledged, so my sister Caroline and I had to be creative once we were old enough to appreciate the power of a few dollars.

My first selling job was on the corner outside our house. I was ten. While some kids start their business careers with lemonade stands, Caroline and I started with avocados, guavas, calabasas and mangoes. That's what you sell when you live in rural South Florida, surrounded by thousands of acres of tomato and squash fields and all kinds of groves.

Our merchandise came from already picked crops, had recently dropped from nearby avocado trees or had been approved for picking from my parents' fruit trees. On a good afternoon, after school until dusk, we made $5 and then spent it all immediately at the local country market. We had yet to learn the concept of saving, despite my parents' best efforts.

Because of what we sold, we had a diverse customer base—

largely Cubans, Mexicans, Puerto Ricans and African-Americans—even if we had no idea what a "diverse customer base" meant. We just wanted money to spend on candy, Cokes, cinnamon buns and ice cream.

Eventually we outgrew the fruit stand, but only when our neighbor offered us better money to pull weeds—$3 an hour—plus the added incentive of a warm slice of pound cake and fresh-squeezed lemonade. For more than a year, we ate *a lot* of cake.

My best friend, my only friend besides my sister Caroline, was the girl next door, which, in the country means down the road. Candy did not have to pull weeds, sodas were always available at her house, she always had new clothes, and when she had too many, her mother had a garage sale. So, of course, some of Candy's clothes eventually became my clothes—and that was fine with me. I didn't care about the source; I just wanted to look like the other kids.

Unfortunately, there was an awkward aspect to my friendship with Candy: She was my friend only when we were together in the neighborhood, never at school. She was a cool girl and I wasn't, and when she was with her cool friends, I didn't exist. It still embarrasses me to admit that I let her get away with this be-havior, but I did. And it made me an easy mark the first time I wore my "new" purple corduroy Peanut (think Juicy Couture, circa 1973) hip huggers that my mother had bought from Candy's mother at a yard sale. These bell-bottomed pants that snapped up the front, finishing just below the belly button, were a *lot* more conservative than today's hip-hugging look, but they were my first, and I wore them to school the very next day, feel-ing sure of my total coolness.

Then Candy walked by with her Bratty Pack, cheerleader friends who probably didn't even know my name. She glanced at me and then turned to the other girls: "Look at Ali. Her mom can't afford new pants, so she's got to buy mine." I was humiliated and angry. But not easily intimidated, thank goodness. I wore the pants again and again, feeling only slightly less cool than I had before the insult. And—for reasons I still can't explain—I kept up my part-time "friendship" with Candy. Which begs the question, Does anyone really know what goes on in the mind of a thirteen-year-old girl?

Even though our family now lived in a nice house that my father had built at night and on weekends, after working a full-time construction job, it didn't take long for the neighborhood to know about the Houtte family's willingness to wear other people's clothes. We were the biggest family in the area, our house didn't have air-conditioning and, of course, there was Mom at *every* garage sale and constantly prowling Goodwill and the Salvation Army, with kids in tow. So even though we had a real swimming pool—not the plastic-and-aluminum above-ground kind—some folks regarded us as "needy." At the very least, we were sending a mixed message.

One afternoon the teenage daughter of a well-to-do family that owned a grocery store where several of my sisters had worked came knocking at our front door. She had a large box filled with clothes that her mother had told her to bring to us, to see if we would like them. Some of my sisters might have been embarrassed, but not me—and not Mom.

"How nice of you to think of us," Mom said. "We'd love to have these." And she meant it.

Mom also lived what she preached to her daughters when it came to hand-me-downs and castoffs. Months later, at a fancy wedding given for another daughter from the grocery-store family, Mom looked gorgeous in a secondhand black crepe sheath and bolero jacket edged in midnight blue satin. For once she can't remember where she found it or how much she paid.

When I started playing tennis in high school, the Goodwill became my favorite store. While I had once hidden in the thrift shop's racks when out with my mother—to avoid being seen by anyone I knew—I now hunted with a vengeance, digging for Head and Fred Perry tennis outfits for myself and for anything else that might appeal to my sisters.

The Goodwill habit was supported by the money I now earned from my first *real* selling job, at a small-town shop that was short on style, long on polyester and optimistically named Discovery in Fashion. I think the manager hired me because I was energetic, and my tall, skinny body made most clothes look good, even though my own wardrobe was mostly thrift-store finds. And I didn't know what I didn't know about selling, so I jumped into the job with both feet. I was full of ideas and suggestions that I was glad to share with any customer who walked through the door. I wanted people to feel happy about shopping in this store, so I tried to be encouraging without a hard sell. But not insignificantly, commissions were a part of my paycheck, giving me a real incentive to succeed.

My very first day, I sold three hundred dollars' worth of clothes—and that was a lot back in 1977.

∽❧∾

The more I sold, the more I loved the process of selling, and I was beginning to think that I should learn how to sell myself, because people—strangers, acquaintances, early boyfriends—kept telling me I should be a model. But I had no idea how you did something like that. And anyway, I had to go to college. That was what my parents expected me to do, especially because neither one of them had.

Community college was the first stop for all my siblings, and that's where I started, too. But I know that no one else in the family had ever registered for a class in self-improvement. I figured that if I was going to do anything about this modeling idea, I'd better figure out how to look good. I was almost six feet tall, lean, gawky, flat-chested and clueless about hair and makeup. And my mother's idea of a "beauty" regimen was lipstick, periodic electrolysis and plenty of Bain de Soleil sunblock—so I needed more substantial guidance.

My self-improvement teacher, a striking, well-dressed brunette in her late thirties who could have easily been a model—though she never discussed her credentials—pulled me aside one day after class and asked if I might be interested in participating in a fashion show. At the time I dressed carefully, wearing my best Goodwill finds every day to classes. But no one on campus except my sister Caroline knew they were secondhand, and *no one* in my circle used the word "vintage," for any reason. I wouldn't hear that word until the early eighties.

When I jumped at my teacher's offer, she gave me the address of a fancy shop where I would be fitted in clothes for the show.

And when I told her I had never done anything like this before, she steered me toward modeling classes.

I was so nervous at the fitting, as the shop owner put me in designers I had never heard of, with prices beyond my imagination, that I couldn't stop sweating. Thierry Mugler, Versace, Claude Montana—at $1,500 apiece. As soon as I slipped them on and saw myself in the mirror, I knew I made these clothes look good. But I couldn't wait to get them off, because I was certain I was going to ruin them.

This was November, and the show was in February, so I was in a hurry. I immediately dipped into my savings and signed up with one of those schools that promise fame and fortune to *anyone* who walks through their doors. Did my parents think this was a huge waste of money and time? Maybe, but they were kind enough not to say so.

Twice a week, for two hours at a shot, I put on three-inch heels and the work would begin for me and six other girls. To the beat of Donna Summer and Gloria Gaynor, and following in the footsteps of our sexy and energetic teacher, we learned to walk the walk, stepping seductively and turning with attitude. When we weren't on her runway, she had us in front of a makeup mirror, learning the fine art of the smoky eye and the pouty lip. And *Vogue* and *Harper's Bazaar* were the class reading assignments. It was a blast.

A few months later, my increasingly curious parents were in the audience at the Miami Beach Convention Center when I took my first professional steps down a catwalk, terrified that they would see me trip and fall before the evening was over. But when they caught their first glimpse of me in a fishtail evening gown, they had no

idea that I had already been approached by a Frenchwoman who had cast a hard eye over about a dozen of us in the dressing room as if we were cows at an auction. I didn't know that this stranger was a former model herself, that once her face had been peppered with pearls for a cover of *Vogue* magazine.

Louise Despointes, dressed head to toe in vintage—Levi's jeans and a Western snap-button shirt—with lots of large sterling-and-turquoise jewelry and strong red lipstick, asked me and another girl if she could take Polaroids. But, she added, "the look in Paris is more natural. Could you remove some of your lipstick?"

Without giving one thought to all the work the makeup artist had just completed, I grabbed a tissue and swiped it across my lips. The other model, equally anxious to please, did the same thing. Louise clicked off a few shots, then asked for our phone numbers. She was headed to New York, Louise told us, but she would call once she got back to Paris and had a chance to show our photos to her colleagues. The whole exchange lasted perhaps ten minutes.

The makeup guy shook his head at my rudeness about the lipstick, and I realized belatedly what bad professional manners I had just shown. I apologized, he fixed his work, and then I made my runway debut. Afterward, full of an eighteen-year-old's naiveté, I announced my plans as soon as I saw my parents: "I'm going to Paris."

Louise was true to her word, calling about a week later. Her offer, as the owner of a modeling agency called City, was simple: She would send a one-way ticket to Paris, I would have room-mates and live in a safe neighborhood. My rent and plane ticket would be deducted from what I earned with my first jobs. She

would also advance me cash for expenses, if necessary. And I would be picked up at the airport by one of her employees. There were absolutely no promises about how much I might earn, no hype about the likelihood of fame.

Nobody in my family could quite believe what was happening. I had never been on a plane, I didn't speak a lick of French and now I was moving to Paris. One of my mother's bridge partners flatly predicted that I was going to be trapped in some sort of white-slave trade. Neither of my parents thought that was likely, but they had every reason to be nervous.

Me? I was too immature for self-doubt. I was going to be a model, and that was that. I carried a thousand dollars in cash and traveler's checks, the bulk of my savings from the past few years, with a little bit left in my account in Miami, just in case. My two suitcases were packed with everything I thought of as hip, cool or essential in 1979: all the old Calvin Klein denim I could find at Goodwill, new Frye cowboy boots and plenty of Fruit of the Loom cotton underwear.

The day of my departure, Mom and Dad took me to the airport, and we were met there by my boyfriend of the previous few months—a born-again Christian who worked at Goldman Sachs. At the boarding gate, he gave me a Bible just before we parted, as if a daily reading would protect me from a new world certain to be brimming with evil and temptations. But I suspected I would never get past page one, and, for better or worse, I never did.

I had found my ticket out of Homestead, Florida. And I was about to learn the business of clothes through the eyes of the French. I was headed for a religious experience of sorts, just not the sort my boyfriend had in mind.

Finding Yourself
(in Clothes and Life)

For decades the Tropicaire Flea Market had spread itself across the potholed asphalt of an old drive-in movie theater in Miami every Saturday and Sunday, and by the time I was fifteen, I was a regular with Mom and my sister Caroline, either selling or buying and—always—boy watching. For me it was easier to flirt with guys at the flea market because I knew we had something in common— an appreciation for old stuff. Most of the boys I knew at South Dade High School saw me as just another tall, skinny girl with no curves. But at the Tropicaire I was a smart shopper with an eye for great old Levi's.

Mom always wore a huge straw hat, usually vintage. She was way ahead of her time when it came to being wary of the sun's effect on the skin, but none of her daughters would listen. And forget about my father and brother, Mike, who both spent even more time in the sun than any of us girls. While Mom begged us to protect at least our faces, my brother and father went hatless, and my sisters and I slathered ourselves with

Johnson's Baby Oil every time we went to the beach. After all, how could you live in Miami and not have a great tan?

But given a choice between the beach and the Tropicaire, I took the flea market every time. I had become Label Girl, every bit as obsessed with "good" brands as my mother could have hoped. So when I spotted a single-breasted, gray flannel suit with cuffed pants, I was drawn as much by the maker as by the look. Never mind that the fabric was way too heavy for our tropical climate, even on the coldest day in January. I knew the name Brooks Brothers from all the magazines I scanned whenever I went to the grocery store. Even then I always studied both the men's and women's clothes in any feature or advertisement.

This suit was handsome and classic. I had no idea what decade it came from, but it had a four-button fly, not a zipper. And I wasn't sure where I could wear it, but I knew I had to have it, especially after I tried on the jacket and it fit as if it had been cut to order. I couldn't try on the pants, but I was willing to risk it. I asked the price, and the owner said she wanted a dollar. "For the suit or each piece?" I was still learning how to negotiate, but I knew enough to assume nothing when I was quoted a price. Each piece, she said, and I paid the two dollars happily.

Eventually, as always, Mom, Caroline and I regrouped—the straw hat always made Mom easy to find. When we compared our best buys, Mom didn't disappoint me by questioning why I would buy a heavy wool suit. She just oohed and aahed about "Brooks Brothers!" When I got home, I tried on the pants, and they fit me as well as the jacket did. Now the only question was, Where was I going to wear this outfit in sultry South Florida?

Louise Despointes's investment in my future was a good one, though the payback was a bit slow in coming.

I was a tough sell—a somewhat awkward, oversize duckling in the biggest fashion pond on earth. Louise had set me up in a grim apartment on the outskirts of Paris, where another of her American models, a girl named Donna, lived with her high-maintenance cat. It was nothing like my fantasy of Paris life—somehow I had it in my head that I would have a view of the Eiffel Tower—but the rent was cheap and I learned to find my way around the Métro, that being the only affordable way to get to the modeling agency. My new roommate was older, more experienced, more confident, and she was happy to answer my questions, but her help went only so far. She couldn't be there to see what I was doing right and what I was doing wrong as I made my first forays into professional modeling.

It wasn't unusual for Louise's newest recruits to get work within a day or two of their arrival—her eye was *that* good. But this didn't happen with me. Not in two days, not in a week. It became obvious, at least to Louise, that I needed a bit more polishing, and within a few days she went to work.

First she took me shopping for a more appropriate outfit for my "go-sees"—the daily cattle calls of the fashion industry, no matter what country you work in. Whenever a creative director or photographer or designer needs a certain look, modeling agencies are called with the "specs"—male, female, short, tall, blond, brunette, short hair, long hair, perky, sporty. Then dozens of women or men find their way to a designated address, where each of them is studied for maybe a minute or two before the next pretty person is summoned. If a body or face is "right" for the shoot, the agency is called and the model is booked.

Based on my first few go-sees, it was obvious that clients felt

I was too tall for most jobs. So immediately the Frye boots were ditched in the closet. But I needed something to wear on my size-tens, so that's how our shopping day started. We were looking for the lowest heels in Paris, at the lowest price, and it took stops at eight shops to find them.

By French standards I was an amazon—a European size forty-one was difficult to find in any but the most expensive stores. And those did not suit my budget. So we hunted high and low before Louise finally settled on schoolgirl-style loafers. Not exactly what I had in mind, but she was calling the shots.

Next she put me in a pair of inexpensive red-and-white-striped cotton slacks—too short on my long legs, but Louise said that was okay—and a fitted, cropped cotton pullover in a red-and-white check. Is this the look? I wondered. Could I really find work as a model in Paris looking like an overgrown middle-school student? My roommate certainly didn't dress this way. But I was not about to be difficult. Louise clearly knew what she wanted, and I believed in her, too. I had no reason not to.

With my "wardrobe" settled, Louise tackled my straight brown hair, ordering up the first of five cuts I would have in the next two months as she cast about for just the right look that would make me a hot commodity. Photos were taken, then it was off to a new hairdresser. More photos were taken as we refined my "look," and then my hair was cut again, by yet another stylist. It was a strange experience, though not a bad one, maybe because most of the time I had little or no idea what people were saying about me—so my confidence was never shaken.

❧

In the midst of my tour of Paris hair salons, I got my first job. It had taken three weeks for someone to decide he or she liked me enough to hire me.

The studio of designer André Courrèges had put out a call for a tall girl, and I was sent over. To me Courrèges was just another difficult French name and, more than likely, another dead end. I had never studied fashion; I had no sense of French couture beyond the most famous: Chanel, Dior and Cardin. In fact, the word "couture" was not yet a part of my vocabulary.

So even after Courrèges's staff hired me to be one of his "fit" models, it was several weeks before I discovered I was being pinned into paper and cloth patterns designed by a legend of the French fashion industry. I had no idea I was sharing space with the man many credit as the father of the miniskirt.

Being a fit model is not glamorous work, though it is an amazing opportunity to see how designs take shape, to glimpse the struggles of an artist long before his ideas hit the hanger. Day to day, however, it can also be incredibly boring. The studio usually kept a couple of models ready and waiting every day that design work was in the fitting stage. We each were given a white cotton robe and a particular style of bra. Then we would pick through a basket of worn pantyhose, looking for the cleanest pair to wear that day. Finally we sat in a small, curtained cubicle, waiting for the call. Sometimes I waited five minutes, sometimes half an hour.

Once they were ready, though, I had to move fast. I can still hear Courrèges's assistant, Sandra, speaking nervously in her

broken English. "We need you right now," she would urge, hurrying me into a room filled with mirrors and positioning me precisely, as though I were a mannequin, on a spot marked on the floor. I had to stand perfectly still, never say a word and do exactly as I was told. "Alison, shoulders back, stomach in," Sandra would command as she waited tensely for Courrèges.

When André Courrèges finally did appear on my first day of work, before I actually knew who he was, all I wanted to do was stare at his feet. He was wearing what struck me as perfectly ridiculous shoes, especially for a man. I would come to learn that his white "moon boots" were a staple of his personal style, and he wore them every day that I worked at his studio.

In my fit job, once something had been pinned onto me by Courrèges or one of his assistants, Courrèges would step back and just stare. If he wanted me to do something, he signaled with a gesture, never words. And if I failed to understand, his assistant would quickly instruct me what to do next—walk a straight line, raise my arms, whatever was needed to show how the piece might work. Always there were at least three people in the room, including Courrèges and his wife, Coqueline. I was an insignificant member of this team, someone of so little importance that if Courrèges ever knew my name, he never spoke it during the time I worked with him. But I was strangely content with this bit part. I didn't need anything more—not then, at least.

I remember only one big problem from my early days at Courrèges: my feet. Every fit model was given a pair of white patent-leather go-go boots to be worn at all fittings, and on my first day Sandra was frantic as we struggled to find a pair in their closet that would fit me. Finally I had no choice but to make do.

"Put the boots on, put the boots on!" Sandra yelled, watching the door and growing more tense as I wrestled to pull the damn things over my heels. "He's coming, he's coming!" she wailed. At last I stood up, using all my weight to stomp my way into these boots and knowing that my feet would pay me back for this torture someday.

Every time I returned to the Courrèges salon after that first day, I hoped against hope that new, bigger boots might somehow have materialized to end the agony. Amazingly, a few weeks later, they did. I was given a pair that had been made *just for me*.

"Mr. Courrèges likes you. . . . Mrs. Courrèges likes you," Sandra told me early on, though the language barrier kept me from learning anything more. I think they liked my energy and my obvious joy at having a job, any job. Another possibility was my hair, which by then was all sharp angles, just like many of Courrèges's designs. All that cutting was finally producing results.

But being a fit model, even for a top designer, wasn't exactly what Louise Despointes had had in mind for her commissions when she forked over the price of my plane ticket. She wanted me in magazines, in ad campaigns, in high-profile work where I would be seen. So the agency kept me running around Paris to assorted go-sees, still with minimal results.

∽◎∾

When I wasn't working, it seemed I was always eating, usually by myself. And since my French was barely "taxi" quality, just enough to get from avenue Montaigne to boulevard Saint-Germain, ordering a meal in a restaurant was intimidating. It was much easier to go with the tried-and-true cuisine of

tourists: croissants and croque-monsieurs. When in doubt, point at something in a *boulangerie*. So easy, so tasty.

What happens to models who become too pudgy for Paris? They're shipped to Hamburg, Germany, and it took me only five months to get there. One week I could say that I worked with André Courrèges, and the next I was sharing a funky *pension* with several other "healthy girls" and a cat-loving housemother who didn't speak a word of English. Breakfast was one dense roll, butter, jelly and the blackest coffee I'd ever seen. And very soon it was cold as hell, and I would have traded all my miniskirts for one sturdy snowsuit. Winter was horrible in Hamburg, even with a surplus layer of body fat. But I was working, because German designers weren't nearly as particular about the weight of their models.

I had met a guy, too, and he loved to cook and drink good German wine. This new development softened my feelings about Hamburg, and a few short weeks into an intense relationship, I could even see a future here, though I had just turned nineteen. Impulsive about men? Very. A good judge of character? Not always.

Romance or not, I had no intention of missing a Christmas celebration with my family back in Miami. The new boyfriend wasn't wild about this plan, but it wasn't negotiable. Christmas was the most memorable time of the year at my parents' house—from my mother's potent homemade eggnog to the rit-

ual of trimming a huge tree on Christmas Eve—and I needed to see my sisters and my brother and Mom and Dad. I also badly needed to be warm again, at least for a week or two. In short, I needed a Florida fix.

Fortunately, my family already knew why I was in Hamburg, not Paris, so I didn't have to do much explaining once I got home. But my first encounter with a bikini made me a walking billboard for my gluttonous ways. And my situation would only be aggravated when I received a Dear Alison letter from Mr. Hamburg just as the holidays came to an end. My broken heart gave me a whole new excuse to pick up a fork and tuck in to Dad's buttermilk pancakes and Mom's macaroni and cheese. It would be more than six months before I would find the self-discipline I needed to get back to Europe.

Fourteen pounds. That was the issue. It doesn't sound like a lot to many people, but for me it was the difference between a zipper that would go up easily and a zipper that was near the breaking point—or just wouldn't budge. If I couldn't squeeze into a designer's sample, I wasn't going to get the job. And even if I could fit into the clothes, no amount of camera magic would hide plump cheeks. My predicament boiled down to a simple equation of good habits and bad habits. Was I capable of controlling my appetite, in a smart and healthy way, or should I start looking for a less body-centered line of work?

Before long it hit me: I did not want to be one of those people who spends her life obsessing about one noteworthy moment in the past, someone who lingers on "what might have

been." Already I was tired of talking about my time in Paris, knowing that it was much less than it might have been. I was not content to be sleeping in my old bedroom, with nothing more than a few photographs to show for the most adventurous months of my life. I needed to give the business another shot, I had to prove to myself that I could be a success.

My regimen was simple and far from glamorous: daily runs in the neighborhood and regular lawn-mower duty for my parents' two and a half acres, for the workout part of the day. And for food I chose a fast-food diet, long before Jared discovered Subway. With a girlfriend I made almost daily visits to a Wendy's salad bar. Not Paris cusine, not even the take-out kind, but that was okay. Within three months I was down to 129 and picking up a few dollars with small fashion shows in Miami. I had a strategy for getting back to France, and that meant my next stop was *Germany.* I wanted to make a lot of money fast, so I would be able to survive a slow start in Paris, and I knew I could do that with catalog work in Hamburg.

I called Dorothy Parker, the German agent I had worked with before, and begged for a second chance. Dorothy ran a strict, almost boot-camp-like agency, and she didn't have time for flakes or party girls. "I've lost weight," I said. "And I've cut my hair." Again. "Can I please come back?"

I was buying the plane ticket this time, and I had some new clothes, a bit more maturity, and a better body. I thought I looked fabulous, and I knew I could make a go of this career. But Dorothy still had to open the doors. She said she would, but there was no encouragement in her voice. She had heard my kind of story before.

The day I walked into her office, straight from the Hamburg airport with luggage trailing behind me, my adrenaline offset any jet lag. I reintroduced myself, and Dorothy shook her head in disbelief, confirming my most optimistic thoughts of the past few months. "Alison, sit down right there. I want to make some calls."

She sent me that same day on seven go-sees, and I was booked for six of the jobs. Instantly I was working six to seven days a week. In two months my pockets were full of deutsche marks, and when I had time, I was shopping like a woman possessed. I could afford to dress well, and I knew that the better I looked, the more I was going to work.

One night, while I was eating in a hot new restaurant, dressed in a mustard yellow miniskirt and a matching T-shirt, a familiar face approached, tentatively. "Alison? Is that you?" I smiled a smile that confirmed it was me. "My God, look at you. You got it together. . . . What happened?"

Louise Despointes was back in my life.

As always, she took immediate control. "I'll get you a ticket. I need you in Paris tomorrow," Louise said, just assuming I would go willingly and happily.

"I'm sorry," I said, "but I'm booked for the next four weeks. I'll see you as soon as I can." I wasn't willing to walk away from such good money, and I knew that the Paris market was a lot tougher. Louise might say she could sell me, but could she really? I had more self-confidence than I'd had when I left Paris, but still, I was just nineteen, and the fashion game was intimidating.

Louise kicked into hard sell. "No, I'll make you a star. Cancel everything. Forget the Germans."

But I wasn't going to do it, I *couldn't* do it. Dorothy Parker and her clients had embraced me when I needed a fresh start—I owed them decent behavior in return.

"I'll be back in four weeks," I insisted. Was I really saying no to the hottest modeling agent in Europe? Was this really me? I was proud of my answer, but a little stressed by the encounter, too.

The next day Louise called Dorothy Parker. She wanted to put an option on me to work in Paris, immediately—as in that week. Louise *was* influential, but Dorothy held her ground. Clients already had commitments for me from her agency. Louise would have to wait her turn.

Six weeks later I was finally back in Paris, in Louise's office. She might be angry with me, but Louise was never stupid.

I had returned with a new, expensive German wardrobe, but in Louise's French eyes this stuff was second rate. "No, no, Ali," she said. "This is not fashion here." I knew better than to argue, so off we went on another shopping trip. There was no mistaking how my status had changed this time around. Good-bye, cheap schoolgirl loafers. No thanks, ill-fitting cotton pants. Louise headed straight to the Les Halles district, where hip boutiques—pricey but not old-French pretentious—were filled with the work of young designers whose clothes and shoes would soon fill my closet: Fiorucci, Robert Clergerie, Stephane Kélian, Agnès B. And then there was a store named Scooter, which was famous for its accessories. I loved this store so much

that later when I got a cat of my own, she wouldn't get some affected Parisian name. She *had* to be Scooter.

Still, the prices I saw that day overwhelmed me. "Shouldn't we try some cheaper stores?" I asked. "I can't afford this." But Louise was adamant. She put me in sexy but classic leather skirts and simple snap-front fitted jackets—always with an eye toward emphasizing my shoulders and legs. Louise no longer had doubts about my future. "Alison, when I am finished with you, you will be able to afford anything you want."

In the end I spent maybe $700 that day, not a stunning amount, but more than I had ever spent before. I bought a black leather skirt, fully lined, simple, short but not too short, and I wore it throughout the prime years of my career. Like a pair of Levi's, it worked with everything. And I fell in love with Agnès B.'s minimalist lines and good cottons, shopping there again and again for years to come.

Louise's role in my return engagement was not limited to clothes. As "artistic director," coach and therapist, she weighed in on everything from my choice of lipstick color to the way I introduced myself to potential clients.

Each night the phone would ring if I had a major go-see the following day, and Louise would tell me exactly what to wear—and she would do this for years, both in Paris and, later, in New York. She studied all of my photographs and spotted the slightest awkward details—the way I held my hands or the fact that I seemed to have a stiff *lower* lip. Her comments always seemed helpful, not personal or petty, and I never took them as anything but solid, constructive advice. I felt fortunate to be working

with a master of this very strange business. I wanted to succeed, and Louise wanted that, too, for me and for her.

～❧～

I was busy, working long hours almost every day, but I desperately craved a flea-market fix. A friend had told me about a place called Clignancourt, out on the edge of the city, where there was a dealer who specialized in vintage Hermès Kelly bags. I had first noticed these purses because so many Frenchwomen seemed to be carrying them, especially at the big fashion shows. But I had no idea how expensive they were (usually thousands of dollars, depending on the bag's size, color, condition and whether it was leather, alligator, crocodile or some other skin). I didn't even know how these purses got their name—that the actress Grace Kelly had once carried this style of bag and made it famous. I just wanted one.

So I jumped on the Métro, ignorant about one other thing: I was headed for one of the oldest, largest, most famous markets in the world.

The first thing I noticed was that the sellers were all dressed up—sport coats, dresses, suits—and several were sipping red wine and savoring cheese and bread, as if on a picnic in Luxembourg Gardens. I wasn't in Florida, at the Tropicaire Drive-In, anymore.

Once I stopped gawking, I put my meager French to work and quickly figured out that there would be no five-dollar finds today. Or ten-dollar finds, for that matter.

When I finally located the man with the Kelly bags, it was as if I had stepped into a miniature leather-goods museum. Carefully

displayed were maybe a dozen different purses, all accompanied by the cotton storage bags that come with every Hermès purse. Between my limited French and his limited English, I determined that his pieces started at $500, much more than I expected to spend—or was willing to spend. So I kept moving, though hardly making a dent in the miles of booths and for the first time in my life, I left a market without making one purchase. Silly, silly me. Any Hermès bag I might have bought that day would be worth at least four times what I might have spent. I can't say the same for any of the *new* clothes or accessories I purchased at that time of my life.

But one vintage purchase, made on a later visit to Clignancourt, did serve me very well, though it's still hard to believe that I found old shoes that not only fit perfectly but also worked so well with much of my wardrobe. The shoes were Victorian lace-ups, topping off just at the anklebone. The leather was a creamy camel color, the heels small and the toes pointed. They carried me throughout my modeling career in Paris and New York. I usually wore them at least once a week, and I lost count of how many times I had them reheeled. I've never found another pair of vintage shoes that loved my feet so much. And the best part was that I paid only ten dollars, buying from one of the market's fringe vendors rather than one of the pricier official sellers.

❦

Almost everything about my life changed this time around in Paris. But when I traveled to Marbella, Spain, for my first location photo shoot, the client was my old boss, André Courrèges.

Now I was wearing his designs for *everyone* to see, and I can still picture one dress quite vividly, because it reminded me, oddly, of those pink foam-rubber hair curlers that my mother used back when I was little. The dress, all black, had three distinct rows of fat, tubular, 3-D curls, circling horizontally between the hem and the hip. From there your eyes moved up to a giant V cutout from the neck down to below nipple level. The V reconnected at the neck in a bow, and the sleeves were a simple, short bell shape. For the photo shoot, the stylist added a leather headband with a rhinestone clasp.

It was the "curls" that made me want to giggle, but I hadn't forgotten Sandra's instructions, back when I was just a fit model: "You can't giggle. You can't laugh." I kept a straight face.

I never bought any Courrèges. Even when my modeling career was in full flight, his pieces were out of my price range. But whenever I come across white go-go boots or spot a piece with his label, which is rare, I have wonderful flashbacks to my first months in Paris and to the quirky experiences in my first real modeling job.

❧

The Courrèges shoot in Spain is memorable for two other reasons: I was staying in a hotel for the first time in my life, a statement that now sounds so weird to me. And it's where I first met Maylen Pierce, who became one of my closest friends in spite of some really stupid advice. I was still very conscious of not wanting to gain weight again, yet I found myself eating one of the hotel's giant cinnamon buns every morning. Maylen, another model on the shoot, and a woman with one of the most

amazing bodies in Paris, told me that if I drank enough tequila at night, I'd vomit and weight wouldn't be a problem. So I tried her tip the next night. Okay, I didn't say I was always behaving intelligently, did I? That was the first and last time I attempted purging of any sort. I was sick as a dog soon afterward—but I never threw up.

~⚬~

In April 1983, more than two years after I returned to Paris, my face appeared on the cover of *Marie Claire,* then one of the hottest fashion magazines in Europe. I am wearing short hair, a collarless white blouse with sheer sleeves, a small gold earring in the shape of a lion, a white metal watch and a white chain-link bracelet. The only other accessories are my freckles and a hint of lip gloss. The message: clean, simple, sporty, natural.

Within weeks of that cover, I was booked by American *Vogue* and was on a plane from Paris to New York, my first trip ever to Manhattan. In the city, and then days later at the Beverly Hills Hotel, *Vogue* put me in clothes by a young American design star whose name I was hearing for the first time: Stephen Sprouse. After touching and wearing the work of some of the best French designers, I was about to begin another crash course, this time with people whose names I could at least pronounce.

While I was in New York, the *Vogue* editors wanted to shoot me for a cover—and that was tough to turn down, but I had no choice. I had a previous commitment back in Paris, with another major label—Comme des Garçons. Designer Rei Kawakubo had booked me for her next show as soon as she'd seen how I wore her clothes in the *Marie Claire* feature story.

This would be the biggest show I had ever done.

The day of the show, I was designated as lead model, the first to walk onto the runway. I was stunned, and as I stood in position waiting for the show to start, wrapped in a black dress that had required the attention of two Japanese dressers to get it on me, I became more and more nervous. Finally I turned to the model behind me, talking just to fill the void. Her name was Anna, she was a tall Swedish blonde with short hair, and she worked for Louise at City, too. "I don't know why I'm opening this show," I said. Without skipping a beat, she responded with a sneer, "I don't know why you're opening this show either."

Never again would I say such a stupid thing; this was one of my competitors, not a "friend." She wanted what I had at that moment, and my comment was naive, though not disingenuous. I *was* perplexed by this sudden "stardom," but I had just been reminded this was business, not a bunch of girlfriends dishing over a good lunch.

I wore my gray flannel suit on that first plane trip to New York, after it had seen me through two good years in Paris. Usually I wore it with a vintage men's alligator belt that had cost me one dollar, and, depending on the occasion or assignment, I wore it with everything from a simple black boot to really high heels.

Every time I wore it I felt elegant and smart, and when I moved to New York in 1984, it came with me.

❧

Throughout my twenties and thirties, I was often paid ridiculous sums to dress up in Calvin Klein and Donna Karan, to sell Diet Dr Pepper, Häagen-Dazs ice cream and Absolut vodka— my face appeared on everything from New York City bus-stop placards to television commercials to magazine covers and billboards.

When I wasn't working, I partied at clubs like Area and Palladium and shopped at Barneys, Bergdorf's and the Twenty-sixth Street flea market, where I became obsessed with old alligator bags. I didn't see myself as a collector, yet I couldn't stop buying them. Did I need seven alligator purses? No. But for a little while that was my addiction. I didn't always behave very smartly in those days, especially when it came to money and men. I was making more than I could have ever imagined, and I was saving a decent amount, but every day I was surrounded by beautiful things, and I felt a need to be seen in those beautiful things. And some of the men I dated were with me simply because of how I looked in those beautiful things. In hindsight that was the worst part of the whole business.

My life wasn't the real world, but I didn't spend much time thinking about that.

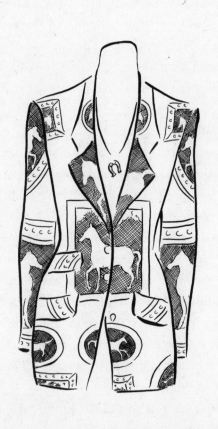

Out on My Own
Hard Lessons, Hard Decisions

I n the back of my closet, ignored for at least a decade, is a silk jacket I bought one afternoon in Paris, after lunch with Louise. It was the late eighties, work was going well and I was back in France shooting a print campaign for Pierre Cardin. Louise wanted to make a quick stop for presents at the Hermès boutique on the rue de Faubourg Saint-Honoré, and I tagged along. I had always loved this store, and I still have a few scarves that I bought there, but I had never owned anything more substantial because the prices were out of my league.

This particular day, however, a tailored, three-button silk jacket caught my eye. Against a Bing-cherry-red backdrop, the jacket was covered with portraits of Greek gods, always in the company of horses, and each of the images had its own ornate gold picture frame, making the jacket a sort of moving museum show in keeping with Hermès's equine-centered roots. I pulled Louise over to see the jacket, and she insisted I

try it on. I was happy to comply, though I had no intention of buying it, not at $2,000.

Louise had other ideas, and she began the hard sell, as if she were working on commission. And she was, in fact. When her models made money, Louise made money. "This will be good for your career. Clients will notice you. You want this. . . ."

"Louise," I said, "you've got to be kidding," shaking my head in disbelief. "It costs $2,000. That's a lot of money."

"That's nothing," she said, her expression as straight as the hair on her head. "Grab it. You can afford it."

At that point in time, money was not a major concern for Louise. She was coming off a very good year in New York, where she had opened a new agency with thirty-five models, including me. And technically she was right. I could afford it, if that simply means having money in the bank to cover the bill when it arrives in the mail. And I was having a good year, too; a day of catalog work would pay for this jacket. But that didn't mean I wanted to drop $2,000 every week just to keep my closet full of goodies. I couldn't afford to be that dumb about money.

I took another hard look in the mirror. Then, filled with Paris-infused giddiness and a temporary case of shopping insanity, I gulped for air, whipped out my charge card and walked out of the store with a beautiful orange Hermès shopping bag in one hand.

Back home in New York, I wore the jacket to dozens of go-sees, often with vintage Levi's 501s. I have no doubt that I was booked for many jobs, at least in part, because of what I was wearing. My jacket said success, at least in the world where I spent most of my time. But even the most expensive things grow tired and outdated, and the gods and horses eventually were put out to pasture.

I will wear the Hermès again, when the time and mood are right—

and eventually I may sell it. Until then, every time I spot it in my closet, I am reminded of Louise, a woman whose instincts both changed my life and helped shape my sense of style. I also have come to realize that I've spent much more, in smaller increments, on countless pieces of clothing that are long gone and forgotten. Applying fashion math, I have no regrets about my Hermès fling.

When I was thirty-four—and still single, much to my surprise and relief—I needed a new source of income. Or, more to the point, I needed a new career. For the most part, I was living off savings—even though I had had my extravagant Hermès-style moments, I had actually put away a lot of what I made—and I had a small income from an apartment I'd bought in Miami Beach.

While I continued to get the occasional phone call from my agency, the reality was that my career was fading faster than a cheap black sweater. As I occasionally weighed my options, I did not consider, even for a minute, going back to college. Me, sitting in a classroom for three and a half years? Try three and a half hours, max. I didn't have the self-discipline, and, sorry to say, I couldn't think of one subject I was passionate about that came with college credits. Am I embarrassed to admit that? No. It's who I was. I wanted—I needed—a real-life, on-the-job education.

My options weren't obvious, but, to be honest, I didn't spend much time worrying. I was still in "I'm a model, life is grand" mode, even though the allure of the profession was hardly as strong as it had once been. I was tired of feeling old when I found myself surrounded by a bunch of twenty-year-olds. I was tired of a business where daily rejection is a given. Still, it was

hard not to think that another big paycheck might be just around the corner. I was spoiled.

Then, out of the blue, a longtime friend put an idea on the table that changed my life.

I had known Lynn from my earliest days in Paris, the first time around. We had two things in common: our agent, Louise, and Florida, though we had grown up in different parts of the state. Lynn's modeling success had come more quickly than mine, and she moved to New York before I did, but we were close in Paris, and when I finally got to Manhattan, we quickly decided to share an apartment in Greenwich Village. We partied together, we met each other's families, we analyzed the men in each other's lives—we were inseparable. If there was one difference between us, it was how we viewed clothes: When Lynn wasn't working, her style was jeans and pullovers, and her interest in vintage went no further than men's red-and-black-plaid wool jackets. I leaned toward "I'm a model" glam—fringed leather jackets, leopard-print leggings, snakeskin pants—mixing old and new and always finishing off the look with accessories galore.

When our two-year apartment lease was up, our financial advisers said it was time to buy places of our own—we needed to be smart about all the money we were making. I still can't believe I had a "financial adviser" when I was twenty-five.

I bought a condo in the West Village; Lynn found a garden apartment in Chelsea. We were close enough to see each other easily and often. But all that changed immediately when Lynn met the man who would become her husband while moving

into her new place. He was a neighbor, and within a week he was up to his elbows in dirt, helping her in her garden. Within a month I could tell that this was someone for the long haul.

We still saw each other a lot, working and playing together, and when Lynn and Jack bought a country house on the Delaware River, I spent many weekends with them. Our relationship was different, but still strong.

Lynn was modeling less and less, and by the time she got married—I wore vintage gold slippers with my bridesmaid dress—she had opened a weekends-only antique store in an old gas station in upstate Pennsylvania. "Shabby chic" was in its early life as an interior-design trend, Lynn had an eye for the vintage furniture that filled that niche, and her merchandise displays were so creative that even the most nondescript wooden chair looked appealing.

While Lynn was building her new life, dividing her time between a house in Brooklyn and the Pennsylvania property, I was working and playing hard in Manhattan, often keeping late hours thanks to a string of fast-lane boyfriends involved in restaurants and nightclubs. My life was often fun, occasionally miserable, frequently exhausting. Both of my closest girlfriends had found husbands, but all I could seem to find in the relationship department was turbulence. Sometimes I was envious of their seemingly settled lives.

~⊘~

Lynn's business proposal was simple: She wanted to open another shop in her Brooklyn neighborhood, Park Slope, and she wanted a partner. Was I interested? Almost instantly I was

caught up in the romantic notion that drives so many people into starting their own businesses: "My shop" sounds so good when you say it—even when you have a partner and it's her shop, too. Plus, we'd been such good roommates, how could we fail at business? Yes, I was interested.

I had no idea where Park Slope was—I'd been to Brooklyn exactly once, for a party. This time I was going in daylight, on the subway. Lynn had given me directions to Ozzie's coffeehouse on Seventh Avenue, where we would meet.

I took the Q train to the Seventh Avenue stop, coming up out of a dark and dirty station on Flatbush Avenue. I'd heard of this street, but I couldn't remember what I'd heard, and I wasn't paying much attention now. I had my directions, and I was focused on finding my way to Park Slope. As I turned the corner, I saw Seventh Avenue, lined with trees, brownstones and churches. It was warm, friendly, so unlike a lot of Manhattan. I was hooked, and I hadn't even reached my destination.

Lynn had found a small space, maybe 350 square feet, much smaller than the living room of an apartment we'd once shared. It was right off Seventh. Since she already had a business, I was happy to defer to her judgment. Then she outlined what she had in mind: She would sell furniture while I handled clothing and every kind of accessory from hats to hankies. I'd pay 25 percent of the rent for 25 percent of the space, we'd split utilities the same way, but we'd go fifty-fifty on whatever sales help we needed, even though Lynn had a much better chance at a healthy income because of the space allocation. Agreeing to that last point was one of my earliest business mistakes, but I was so excited about this opportunity that I was thinking more with my heart than my head.

Fine, I said. I was ready to go. After all, I had spent the last four-teen years selling myself to potential clients. Now I'd sell something a little more affordable and much more in demand: old stuff.

We decided to call our shop Weeds, and two months later we opened our doors. Lynn had been happy to take me along on her shopping trips, introducing me to a new world of rural auctions. I made a profit from my very first month, and I loved my new life, still modeling occasionally while hunting down enough merchandise to keep my part of the shop full. It was early spring when we opened, so I had loaded up on what I'd want to wear that time of year, what I'd be looking for if I were at a flea market or garage sale. That was the easiest part.

I wasn't nearly as confident about pricing, and I wanted to make a good first impression with customers, so in the beginning almost everything flew out of the shop because it was such a bargain. This was good and bad. The good: Rapidly changing stock meant customers could stop by once a week, knowing that new merchandise was waiting for them. The bad: Could I find enough stuff to keep my hangers full?

I was naive to think that a business relationship wouldn't affect my personal relationship with Lynn, but that's what I thought, and for three years we made it work, though not always easily. Usually we found our way through minor disagreements, and though communications became strained, I assumed we could continue to be partners. We had always divided our time in the shop, so it wasn't as if we saw each other every day. Weren't we simply experiencing the same challenges that any marriage might go through?

Eventually, though, I had to face a hard reality: I felt physically

and financially constrained by our space agreement. It took me six months to gather the confidence to voice my concerns, and I wasn't ready to split with Lynn; I just wanted to renegotiate our deal to a straight fifty-fifty partnership. I needed half the space if I were going to survive in this business.

Finally we had the conversation, and it was a short one.

"You'll always be twenty-five percent at Weeds," Lynn said, leaving no doubt in her tone or manner. I was shocked at how quickly the door had been slammed shut. I had assumed there might be some options, some flexibility, but I was wrong. Now I knew what I had to do.

❧

Within two months I had a new business name and a new space: Hooti Couture, 179 Berkeley Place. But I was moving just a block away from Weeds, and that was awkward. The location was much closer to my old business than I had wanted it to be, but Park Slope was where my customers lived and it was where I now lived. I couldn't leave. However, Park Slope was showing the first signs of a boom time, and a small space was hard to come by. I needed to act before rental prices went any higher, and the reality was that Lynn and I were going to have distinctly different shops, wherever I landed in the neighborhood. I also knew that vintage shoppers would visit us both, because you never know what any "secondhand" store is going to have on any given day.

The final days at Weeds were awkward, but Lynn came to Hooti for the opening champagne party and I remained hopeful that the relationship could be salvaged. I was wrong. Weeds closed about a year later, after Lynn's first baby was born. I have seen her just a few times since, mostly by accident.

For a long time, I didn't cry about what we had lost. When I did it was at a point when I was feeling overwhelmed by the demands of opening Hooti and doing almost nothing to take care of myself. I was feeling alone and it was a sad, sad time. This would pass, though, and I would find new strength from my new life.

❦

In the rush to get my new business off the ground, I couldn't afford to dillydally on the name. But I wanted to get it right, especially because I planned to have this store for a long, long time. Fortunately, my grandmother Houtte's singular interpretation of our family name proved to be my inspiration.

My father's parents were both born in France, coming to New England as children in the early 1900s, so they both spoke French. Beyond this, my grandparents' differences were glaring.

My Grandfather Houtte was old-country, just like my mother's mother, if not more so. His English had a thick accent, he started every day of his retirement in Miami in a fresh white T-shirt and khakis and he lived to work in his garden, building compost piles that were works of art and rock walls that would stand for decades. Much to my grandmother's dismay, he was also a scavenger—a recycler, really, just like I had become. I remember dozens of issues of *National Geographic*, stacked care-

fully in his garage, magazines in perfect condition that he had salvaged at a nearby dump.

My grandmother, on the other hand, wanted nothing to do with the old country or old things. I don't remember even a hint of an accent, and the only time she spoke French was when she argued with my grandfather. In fact, Clemence Houtte wasn't even comfortable with her last name.

"Hootie." That's how the family name should be pronounced, she insisted, and 'round and 'round she would go with my father—my grandfather having long since given up the battle. Dad would always point out that there was absolutely no foundation in the French language for that pronunciation. It was "hoot," he said, and had always been "hoot." But until her death, she always introduced herself as "Clemmie Hootie." I still wince at the sound those two words make, hooked together the way they were.

Yet when it came to finding a name that would suit my new business without being dull or cloying, I couldn't resist what seemed so obvious. I needed something easy to pronounce (who could have trouble with Hooti?), something that said fashion/style (couture), but something that didn't sound too self-important (the "Hooti" knocks some of the wind out of "couture"). I didn't want to be drawing a clientele that bought only the finest pieces of "collectible" vintage. That's not me and that's not what the store is about. On the other hand, I didn't want Hooti ever to be mistaken for something just a notch above Goodwill. Hooti Couture was the only name I seriously considered, and it has proved to be a wonderful choice. Just hearing it makes people smile.

⤳⤲

I sometimes wonder, when I have a very old, American-made wool suit or blanket in my hands, whether the fabric might have been touched by Grandma or Grandpa Houtte long ago. It's possible, though unlikely, because tens of thousands of immigrants worked in the mills in Lawrence, Massachusetts. By the time Victor Noel Houtte and Clemence Severine Poulain were fourteen years old—before they had ever met, before they had a chance to complete the eighth grade—they were working with thousands of other French, Germans, Italians, Poles, Syrians, Scots and Lithuanians for the American Woolen Company, which had massive mills in eight states and would control 20 percent of the textile production in the United States by the 1920s.

But by 1912, while handsome magazine advertisements for American Woolen were encouraging men to "know your style, pick your cloth," mill conditions had become so bad that more than a third of the mill workers died in their teens or twenties. My grandparents had either just started at the mills or were about to start the year of the famous Lawrence Strike of 1912, when workers finally revolted, although they spoke so many languages that they couldn't always communicate very effectively with one another.

My grandparents spent nearly forty years in the mills after that strike—and my father and his brother both worked there briefly as well. I have no doubt that some of the oldest men's and women's suits that have passed through Hooti started as bolts of wool created by hardworking people like them. But my

grandparents were luckier than some: When the mills finally closed, in the early fifties, Grandma and Grandpa Houtte headed for South Florida to be closer to their son, leaving harsh weather and harsh memories behind.

<center>~❧~</center>

When I first started selling old stuff, I wasn't totally comfortable describing my work, so I would dress it up for certain modeling-industry friends and acquaintances—kind of like my grandmother tried to dress up her name. "I sell *antique* clothes," I would say, though I didn't know the first thing about Victorian ball gowns, fine lace or pre-1980 couture, and seldom sold anything that was truly "antique." How phony does this sound? Pretty phony.

But I soon found myself growing attached to my merchandise in ways I never could have imagined. Not so attached that I couldn't sell it, but attached in such a way that I wanted these things to find a good home, and a personal pronoun—"she," usually—found its way into my selling vocabulary, as in "Isn't she lovely?" to describe a pin or purse.

These days I wouldn't dare use the word "antique." It suggests rich, boring and overpriced. And that's not where I want to be. I am a Brooklyn shop owner, dealing in vintage or second-hand clothing, even when I'm introducing myself at fancy parties in the Hamptons. If I have just found a fresh batch of fifty-year-old circle skirts at a rat-infested pig farm, I am happy to share the story of this good fortune, with no apologies.

Still, when people learn what kind of business I have, a few tend to flinch. "Oooh, clothes from dead people," they say. Or

they simply associate the idea of buying old clothes with being down-and-out, able to afford nothing more than sweat-stained or moth-eaten castoffs. Occasionally I am asked, when I explain what I do, "Why would anyone want to wear someone else's clothes?"

Usually I change the subject. I don't talk about actress Jennifer Garner in vintage Valentino at the Oscars or the teenagers and twenty-somethings in small towns and big cities who scour the Salvation Army, Goodwill and their parents' closets for pedal pushers and pastel tuxedos. I avoid any reference to the buckets of money moving on eBay for everything "vintage," from an eighties-era Red Lobster Lobsterfest T-shirt (final bid: $15.50) to a bow-shaped, pearl-trimmed, gold-tone hair clip with the marking of highly regarded jewelry maker Miriam Haskell, probably from the forties (final bid: $88). As for exploring the desire for "personal style"? Forget it. Nothing is going to convince some folks of the appeal of vintage clothes.

In fact, much of what I sell does come from the closets of people who have died, and the coolest clothing and accessories sometimes do have imperfections—small holes or stains, ripped seams or tarnished metal or a missing stone or but-

ton. And yes, old stuff may smell. So what. A little Woolite or dry cleaning easily fixes that.

But what makes vintage so hot as a fashion trend is also its biggest hurdle, especially for time-pressed shoppers and anyone who hates to shop. Hunting for the perfect fur-collar coat, mod dress or rhinestone brooch takes time and energy, even when the owners of your favorite shops know your likes and dislikes and their stores are packed to the eaves with goodies.

Sizing is often a mystery, all cashmere sweaters and cowboy shirts aren't created equal, and if that Pendleton plaid wool skirt is tight at the hips, it's not like a customer can ask me to bring her another, one size larger. As for the perfect beaded evening bag to match a sequined sheath—maybe I have something or maybe I just sold it.

The good news is that when something fits, or completes a look in just the right way, customers feel like they've hit the jackpot. The odds were against them, but they got lucky. Which is why I am always amazed—and pleased—when a customer comes to Hooti because she *must* find something for an event *that night*, as if Hooti is Barneys or Bergdorf's.

But that's why most of my customers love vintage. For them, dressing is an adventure, not a chore.

◦◦◦

*J*ust before Hooti opened its doors I dug through my favorite snapshots of my family, looking for just the right "signature" image for my white shopping bags. Something that said vintage without being clichéd or too cute or too upper-crust.

The first one I used was my parents' wedding-day photo,

from January 1950. It shows a young man and woman standing, looking happy. Mom has long, dark hair and is wearing a simple fitted day suit with heels, with a three-orchid corsage on her wrist.

The next photo that decorated the bags is also set sometime around 1950, but it's just of Mom, in casual pants and a tailored shirt, perched on a wooden fence, looking carefree. I am confident Mom had yet to have her first baby.

Most recently I have shifted to the early seventies, and there's Mom again, wearing Mr. Dino and posing proudly with her new car, a canary yellow Mercury Cougar with bucket seats and four on the floor. In this photo her beautiful hair has turned totally gray and is now worn short, in tight curls that suggest an Afro.

These images have proved more popular with customers than I ever could have imagined. They seem to set just the right tone for the shop while allowing people the chance, I think, to recall a moment earlier in their lives or the lives of their family. The photos celebrate happy moments, big and small, and when people buy something at Hooti—people who see a future for something from the past—I want that to be a happy moment, too.

But Does It Fit?

Finding the Perfect Home on Flatbush Avenue

O ne day last fall, a casually dressed woman, no more than twenty-six or twenty-seven and whose face was new to me, spent a good forty-five minutes in the shop closely scrutinizing an assortment of hats. Every one that she carefully touched and tried on was distinctive for the fact that it was little more than a piece of soft nylon netting in the loose shape of a cereal bowl, though every hat had a different accent on the crown—a faux jewel, a puff of fur, a tiny nosegay—and the colors varied from cognac to blush pink to cream. Every hat was as light as a feather and as feminine as a lacy handkerchief embroidered with tiny violets.

I had bought about two dozen of this style just a few days before, imagining they had once been worn by women who spent their days lunching "at the club" in the 1950s, fitting lightly over perfectly coiffed heads, no matter how big the bouffant. This time around I had been confident my older church-lady customers would be the ones to wear them—until I saw the very same look on the cover of W, and a friend

who works at Bergdorf's told me the store was selling hats just like these for $115. Mine were priced at $18 to $20.

Finally the young woman made her choice: a cream-on-cream confection of netting topped with a cluster of teaspoon-size feathers. Her choice was pure pretty, and as I was writing up the ticket, she asked if I could wrap the hat in some hot pink tissue that was stacked on my counter. "It's for my mother," she said. "She likes to wear these to church." I asked if it was her mom's birthday, but she said no, it was just a gift.

The next morning the hat-buying woman called the shop and reintroduced herself. "My mother flipped over the hat," she explained. "Can you hold another one till I get there?" I knew which one she wanted—a teal version topped with a petite bouquet of papery spring flowers. When the thoughtful daughter arrived, she once again asked if I would wrap the hat in pink tissue. Of course, I said.

The following day, a Saturday, the doors of Hooti had been open only a few minutes when a woman in her fifties came into the shop with what appeared to be her teenage son and her husband. She scanned the shop for maybe a minute, then walked straight toward the remaining netted hats as soon as she spotted them. I knew this must be the mother. I introduced myself, and she expressed her delight with her daughter's purchases. She then proceeded to try on almost every hat before settling on her favorites. I sold twelve to her that morning, and she asked that they all be wrapped in pink tissue. As I prepared her package, her husband stood proudly at her side.

"My wife knows just what she wants," he said, smiling.

I made a big mistake in the summer of 2002, and my business could have died because of it. How big a mistake? Well, a lot

bigger than the time I paid $575 for zebra-print Prada flats that were way too small. I had bought a size nine when I know that nothing less than a ten will do. That's how much I loved those shoes.

No, this mistake was potentially much more costly, because after five years I took Hooti's Park Slope lease for granted.

Louie had been my landlord at 179 Berkeley Place since the beginning. He owned the Chinese restaurant next door, so I saw him frequently, and we seemed to be a good match. Our disagreements were small and easily resolved, I always paid my rent on time and he was willing to let my vintage-dressed mannequin stand right next to his corner restaurant window. Every day out she went, luring potential customers walking along Seventh Avenue, styled for whatever "personality" I wanted her to assume at that moment: Mannequin as naughty fifties housewife, mannequin as sexy party girl, mannequin as nasty witch— she could do it all.

Unfortunately, she also caught the eye of city inspectors, who regularly wrote me $50 tickets whenever she got closer to the curb than the law allowed. That's a lot of money, so I tried to be careful, but this mannequin had a way of moving. Was she trying to escape the store? Or was she simply trying to distance herself from yet one more plate of sweet-and-sour pork? No matter, business was good. I could afford her wanderings— though eventually her occasional tumbles off the sidewalk into the gutter took their toll. Her shoulders began to collapse, and finally her career was over.

Everything wasn't perfect with Louie and me, but is it ever, with a landlord or a boss or a partner? Maybe that's why vin-

tage clothing is such a great fit for me and my customers. We don't expect perfection—at least most of us don't—and we don't need perfection, especially if the price is right and we like the look and feel of whatever we are buying. In fact, we relish the realness of lives already lived with a shoe or a purse, the "character" that comes with many pieces I sell. How many times do you see a pair of new boots or jeans that look as interesting as the old stuff—when the leather has stories to tell and the denim has faded because of real life, not an artificial treatment?

On Berkeley Place, I knew the price was right, and the fit was okay, so I ignored Louie's smelly garbage bins and the cook who was always spitting out the back door, right next to my outdoor displays of kitchen linens or denim or trench coats. And as for Louie himself, he was a good, decent man.

I knew that my lease was about to expire, but I *assumed* I could stay as long as I wanted, and I had other things on my mind. I had just made an offer on a one-bedroom co-op, and Hooti's busiest season of the year was right around the corner, so I was shopping like mad. There wasn't much time to obsess about something that I hadn't thought was an issue. And then it was too late. Louie's lawyer stopped by the store with a message one day in late July: "Louie would like the space back." On September 1.

What? "Louie would like his space back?" Pause. "In five weeks?" I asked. Only the slightest pause. "Yes," he said.

It seemed that Louie wanted to expand his restaurant, making my shop into a take-out window. Wontons to go, which meant

Hooti had to go. My loss would be my neigh-bors' gain, at least in the convenience department, I fig-ured. But, in fact, Louie never made the take-out win-dow a reality, and soon some-one else was there, selling new, expensive cashmere and other fancy-boutique essentials. That shop succeeded and moved to Sev-enth, and now Louie's daughter uses the space for a bridal-veil boutique.

I was pissed, at Louie and at myself. This was my *home* (I rented an apartment right next door to my shop, so it really was home, for better and worse), and now I had to leave it. How was I going to keep all my customers, the single women and men who stopped by on their way to work or their way home, some-times just to chat? The young mothers with dogs and kids and limited time and energy to browse? The couples strolling on a sunny afternoon, grazing from shop to shop, buying gifts for each other? And what about the relationships I had with other small-business owners down the street and around the corner? Was all of this about to blow out the door as easily as a bunch of netting hats?

Minute by minute my predicament unfolded in uglier detail: I was supposed to close on the new co-op—my other home—

in a month. Would that fall through if my business closed, even temporarily? And if it didn't, how could I possibly handle two moves at once? And what if I had no store in September? My "fall line" could end up sitting in boxes while my customers took their business elsewhere. I was in big trouble, and I had no one to blame but myself.

When it comes to business, though, tears and temper tantrums aren't part of my arsenal—and they never have been. Crying is not good business for any woman; it's manipulative and isn't worthy of us. And tantrums are a big waste of energy.

<center>~∾~</center>

What's the difference between a good home and a great home? When do we know if something fits acceptably or fits perfectly, whether it's a dress, a hat, an apartment or even a relationship?

As I watch customers work their way to a decision, sometimes quickly, sometimes slowly, sometimes painfully, I am reminded what an imprecise and curious process it is, one colored by such obvious factors as price or "need," and other, quirkier variables like mood and weather.

At Hooti the decisions I make every day define my success or failure. Almost daily, merchandise finds a new home in the store, and some of it is a perfect fit—moving quickly, bringing a nice profit, making the new owner happy, I hope. Other things linger awhile but still find the right partner. Yet there are always items that are pushed aside again and again before being donated to a more appropriate home or sometimes just being discarded. I can make those decisions in the same way that I can say no—politely,

I hope—when someone wants to buy something for less than it is worth to me.

I didn't know I really needed a new, better home for Hooti until I was forced to think about it, to step back, to realize the fit was just okay, not great, that I could do so much better.

Good energy is one of my strong points—it worked for me when I was a model, and it works for me as a businesswoman. I'm also good at decision making: I seldom waffle on the big stuff. I decided that closing Hooti was not an option under any circumstance. Every year I was making more money, and everything "vintage" was hot and getting hotter. And, quickly, I saw the upside of my lost lease: Here was an opportunity to grow, to move beyond my safe little world on a side street in Park Slope, Brooklyn.

It was as if I had been dressing in Armani and now I was ready for something bolder, more outrageous, say, a Betsey Johnson leopard-print sweetheart dress with Candie's heels.

I've known women who waited to have a man in their life before they bought a house or a condo—or just a good piece of jewelry. I've never been able to relate. Investing in property or buying myself an expensive vintage watch, when I can afford it, fills me with confidence. I watched my parents succeed over the years by taking risks with property and business, and there's almost nothing that scares me when it comes to signing a lease or a mortgage or buying a houseful of old clothes. Long-term commitment to a guy? Well, that's a different story.

I also know, from past experience, that my instincts about real estate are just as good as my instincts about an old fur stole or a sixties polyester shirt. Once I decided where to look for my new home, I was sure I could make a quick deal on the right space.

One fact was certain: Park Slope proper was likely to end up in my rearview mirror. Starbucks was rumored to be paying $14,000 a month for a space just six blocks from my store. Sure it's large, but rents had gone ballistic on even the smallest spaces, and I needed something with storage.

The three hundred square feet I was about to lose cost $1,850 a month, and that was without a basement. Every day my adjacent apartment had served as both home and storage area. I was sick of climbing over hanging racks to get through my front door every morning and night. But one question did nag at me: Why had I put up with that for so long?

Second, I knew I wanted to stay in Brooklyn. I had lived in Manhattan, I had worked in Manhattan. But that was another life, a model's glitzy life with late nights at clubs, bars, parties. I could still do that stuff when I wanted to, but I didn't need the city to be a success. Brooklyn was my home now, and Hooti would stay in Brooklyn, too.

But where in Brooklyn? If I could stay close to my old customers, that would be best. And familiar territory made sense, too. If I knew nothing about the location, could I make a smart decision about it by just looking in a few windows and driving down a couple of neighboring streets? Maybe, but it was much riskier.

In my mind one street was the obvious first choice, a gamble,

but not a big one: gritty, grimy, screaming Flatbush Avenue, which I had come to know well after so many trips to Manhattan by way of the Q train. Just five blocks from my current location, Flatbush was in my face every time I walked to the train's Seventh Avenue station. But I knew no shop owners who might share their retailing experiences, the sidewalks were as dirty as they are wide and many storefronts were empty. The flip side, though, was extremely appealing. The bordering neighborhood, Prospect Heights, was on the cusp of a boom, with many still-affordable brownstones, unlike those in Park Slope. And empty storefronts surely meant competitive rates and the likelihood of fresh business blood on the way. And the customer pool? Would this ethnically diverse community respond to Hooti and help me expand my customer base, or would I be ignored, seen only as the white girl who peddles other people's castoffs? No, I was confident that would not be the response.

I didn't bother to consult any friends, because most of them would have called me crazy even to consider Flatbush. And anyway, I seldom consult friends, male or female, about business. When in doubt, I talk to my accountant or my parents, whose commonsense opinions are usually hard to dispute.

The morning after I heard from Louie's lawyer, I parked in front of two empty storefronts within spitting distance of the Q train station, on the Park Slope side of Flatbush. Ideally, I wanted something around five hundred square feet, plus a basement; physically, I was taking just a modest step up from Berkeley Place. My new home didn't have to be supersize to be more successful.

The first space I called about met my needs, but the price was steep (in my book): $3,000 per month, plus three months' security. Twelve thousand dollars before I even unlocked the door! My palms started to sweat a little bit.

The numbers were similar for the space next door, and I could feel the second-guessing begin to dance around the edges of my brain. Even on this unattractive street, where few business owners seemed to wash their windows, where English might be the third language, where no one would use the word "charming," a little shop might cost more than I wanted to pay. Could I afford $3,000 a month for the perfect space? Yes. But was it the right move? I didn't know.

The stretch of Flatbush that I was interested in is the physical dividing line between "the Slope" and Prospect Heights, which also makes it a racial and economic divide for some folks. I knew that at least a few of my old Hooti customers, who are predominantly white, might not even want to *cross* Flatbush. And, those issues aside, could six lanes of traffic be a business killer? After all, cars typically go by so fast that drivers would barely notice my windows unless they were stopped at the light.

I was chewing on this when I saw another for-rent sign, an old-fashioned, homemade number, not a slick posting by a pricey leasing company. A good thing, definitely.

The space, 321 Flatbush, was the current home of the Brooklyn Tabernacle Church offices. It was a rather sad space from the outside, plain like its immediate neighbors—a tired dry cleaner and a faded one-hour photo-processing shop.

These businesses looked as if they had been there *forever*. That's what I saw first.

Then I turned around, and I fell in love. Looking past the belching trucks, ignoring the squealing brakes, I could see Seventh Avenue stretching straight in front of me for miles, lush with trees, brownstones and church steeples leading the way into the heart of my old neighborhood. As many times as I had driven and walked the streets of the Slope and Prospect Heights, I was seeing Seventh from a fresh angle, as if its asphalt were rooted in Flatbush Avenue and drew its strength from this rich and historic boulevard. This was a crossroads that felt right. If this spot were to be my new home, I knew that my customers could find it—and find me.

One more thing about 321 Flatbush: It was on the sunny side of the street—sunny, that is, in late afternoon. Hooti's windows would have the best light when customers were most likely to see them. And in the winter, pedestrians would be warmed should they stop to look in those windows. Certainly, I hoped, there would be enough sun to guarantee that my two outdoor trees, fixtures at the old Hooti, would continue to thrive, too.

<center>～☙～</center>

When I think about a "perfect" fit, blue jeans and boots often come to mind.

Back in high school, both my sister Caroline and I were already tall, and growing taller by the day, and our beloved jeans were getting embarrassingly short. But we just couldn't bring

ourselves to part with them, so we improvised, drawing heavily on a sixties look, even though it was now the late seventies. Sorting through Mom's stash of odds and ends, we found ribbons and scraps of brocade and other ornate fabrics and attached those to the hems, giving us the length we needed.

We felt so smart, and we wore those jeans to death.

Much later, when another one of my sisters spotted a pair of old, lace-up, ankle-high boots at a rural Colorado antique store, she was curious. Despite more than ten years in Texas, she had never seen shoes quite like this. She pulled them on, tightened the laces, stood up, took a few steps and bought them. They fit, sort of, and they cost only $37.

"What are you going to do with those ugly things?" asked her shopping companion, a woman who never buys old, except for diamonds. "Wear them," my sister said. And that's what she did—once. Then the lust was gone, vanishing just as fast as the passion that prefaces a long-awaited first kiss that fizzles rather than sizzles. The boots didn't fit right—or feel right either. In her book, boots should make you feel sexy—or at the very least confident and powerful. These just made her feel tired, heavy-footed, as weary as the coarse leather and weathered, sloped heels she had tried to renew with saddle soap.

So she shipped them to my shop, where they sat with other boots by the front door, waiting to catch the eye of someone new, someone who would love wearing them—someone with a spare $125. It took only a few days for the boots to find the more perfect pair of feet, a new closet, a new home.

~∞~

So how much was a move to Flatbush going to cost me? I dialed the number on the sign, and Chris King answered. I identified myself and my store, and his response was instantaneous: "My wife loves your shop!"

His wife loves my shop. *His wife loves my shop.* Hallelujah.

Chris wanted $2,000 a month for five hundred square feet plus a basement. That's all I needed to know—I was done looking. But I didn't tell him that. No, I *had* to negotiate, because I'm good at it and I think my father taught me well. In fact, one of my sisters, who will remain nameless (you can do this when you have four sisters), once started crying while sitting next to my father as he helped her buy a new car. He is not in any way an abusive man, but his bargaining approach was so foreign to her—and embarrassing—that she came undone. And then my dad came undone. He hates to see his daughters cry, so the salesman lucked out.

Ten minutes later Chris showed me fourteen-foot tin-clad ceilings, two decent display windows, one long wall of old red brick, and a *huge* basement with nasty stairs. "Is the rent negotiable?" I blurted. I'd seen what I needed to see.

"Make me an offer," he said.

"You don't want to hear my offer," I smiled, as confident as I was happy.

I was about to throw out another figure, but he had other appointments to get to. We agreed to meet first thing in the morning, and he made it clear that other folks had expressed interest in the space, too. "Make me first on your list," I said as sweetly as I knew how.

The next morning I looked good. My hair was freshly washed, I was wearing makeup and my outfit, a tailored fifties dress and heels, reflected a professional woman with just a hint of glamour. Same as with the go-sees from my modeling days, I wanted the client to pick *me,* not anyone else.

Chris and I got right to business: I offered $1,500.

"Excuse me," Chris said. "Let's try another number." I offered $1,550.

"How bad do you want this space?" he asked. His brother watched, grinning and laughing.

"Seventeen hundred?" I asked. His brother laughed again.

In another minute we settled on $1,850, exactly what I was now paying on Berkeley Place. Sure, I was agreeing to pay an extra business-improvement tax ($164 twice a year), and Chris insisted on $1 million in liability insurance, but that was small potatoes. He wanted only two months' deposit, I could have the space for five years, with a 3 percent annual increase, plus the option to renew for another three years at the same rate. I was ecstatic. If some of my customers refused to cross Flatbush, it would be their loss, not mine. I was moving.

Nothing is ever easy about a move—even if you're going just five blocks. But Flatbush was a different world, a different tempo from what I knew on Berkeley Place. I asked my friend Mary Coleman to help at Hooti so I could spend time on and around my new street just getting to know my new neighbors and the feel of the new space. And I needed to pick up the

pace on my clothes shopping. The new Hooti must be filled with all new old stuff. Everything must feel fresh, not just the paint.

Last, I needed to talk to Henry Williams. If Henry was about to have a bad spell, I was going to have one, too.

Here's what I know about Henry: One day early on at Weeds, in 1994, a lanky, scruffy, youngish man, maybe thirty, stood outside the shop, waiting quietly.

"Is there something you wanted?" I asked.

"Is there anything you need done?" Henry asked. He wanted to earn some money.

"I'm sorry, but I don't think so." I went back in, but he didn't leave.

Finally I noticed that our flower box was full of weeds, and they were not quite as appealing as our store's name. I went outside and asked the man his name. Henry Williams, he said. I introduced myself, then asked if he could help us with the flower boxes. Ten minutes later all the weeds were gone, I gave Henry Williams a couple of dollars and he left.

The next day he was back, and Henry and I have worked together ever since. Henry is the one who often helps open and close the shop, the one who runs errands and sweeps the sidewalk, the one who once listened to me sob for twenty minutes in the store, before the doors opened, about a miserable breakup with a guy. "It's going to be all right, Alison," he told me, as sane and sober a response as I could have hoped for from any of my girlfriends, my parents or one of my sisters.

I know Henry is homeless, though I have met a few of his

friends who occasionally provide a place for him to sleep or take a shower. I know he can be moody, irritable and unreliable and sometimes can be so threatening that I once had to lock the shop door and call the police. I know that last detail makes me sound crazy, but it's not that simple. Henry has become a friend, an awkward and troubled friend, but a friend. And when he is doing okay, he is a help to me and the shop—and I know I'm helping him in some way, too. But I can't tell him how to live his life. And I'm not ready, yet, to abandon him.

So the question is, could I count on Henry in the coming weeks?

In order to build something that's going to last, you can't be afraid to tear down some things. I bought myself a sledge-hammer. Partitions had to go, and Henry was willing to do the hammering. I would haul the debris to my newly delivered Dumpster, because I needed a workout. We worked as efficiently as we ever have.

Along the way, I told my dad about my reconstruction plans. I appreciate his opinions, even if I don't always follow them. The space will be all white, I announced, even the red brick wall.

"You really don't want to paint the brick," he said. "You'll regret it."

Nope, I said, I want all white.

Then Chris, the landlord, weighed in: If I painted the brick, every last speck of paint would have to be removed when I moved out, restoring it to its original condition. Okay, the red brick would stay red.

The floors would be a rich fire-engine red, not the same red as the walls, but I didn't care. For me red says power (kind of what boots do for my sister). And from a purely practical standpoint, dirt wouldn't show as it would with a pastel. I am not a pastel person anyway. I want over-the-top.

As the painter began work, the adrenaline was pumping. Whenever I saw a customer, at the old shop or on the street, I talked about the new location as if Hooti were headed for its Broadway debut. I yakked on and on about the bigger space, all the new merchandise, about the energy of Flatbush. At this point I didn't see any negatives associated with the move, and I didn't want my customers to see any negatives.

I was exhausted. Almost on automatic pilot, I moved the contents of my one-bedroom apartment to my new co-op two weeks before Hooti was set to reopen. One big chore was out of the way. At least I knew where I would sleep every night, no matter what happened on Flatbush Avenue between now and opening day.

⌖

One problem had yet to be resolved: I had to get my two large trees, each potted in a wooden barrel, from Berkeley Place to

Flatbush. I did not want to open Hooti without them—they would be the first potted plants on the block, a splash of green in a sea of gray. I explained my problem to Henry, and he said he could handle this.

A few days later, he tells me the trees are on the way, but he doesn't explain how. Then he is gone. So . . . is he gone as in *gone*? I never know for sure until he resurfaces.

As the hours go by, I keep looking down Seventh, and, finally, in the distance I can see one of the trees, moving along the *street,* not the sidewalk. Soon I hear Henry singing and whistling as he pushes a homemade dolly he built with scrap wood and junk wheels. It is awkward and hard work, but once delivery of tree number one is completed, he goes right back for the second. Henry is pleased at this accomplishment, and so am I.

It is still a couple of days until our opening. Mary Coleman and I are organizing and pricing clothes and working and re-working the organization of the racks while Henry sulks; he doesn't like whatever I've asked him to do. The Hooti Couture sign, with dapper shoppers and a French poodle, has been moved from Berkeley Place, and my two windows are decorated with my first visual hello to pedestrians and motorists.

On the "floor" of one window sits a stuffed rooster, in the other a stuffed pheasant. Both are festooned with rhinestone earrings and necklaces and look ecstatic as they stand in beds of real, fresh straw. Filling each space are new/old mannequins, both in fifties sweetheart party dresses—strapless, fitted waist, full skirt—one in icy blue, the other in lipstick red. There is a

little lamp in each window, too, so Hooti will be bright at night. This is the tone I want to set: electric, a little bit silly, hip but not too cool.

Just after dusk two elderly "church ladies"—elaborate hats and Bibles are their trademarks—stop to study the windows, their expressions at first puzzled by the birds and their baubles. And then they start to giggle.

The Label Game
What's in a Name—and What Is It Worth?

*I*t was a crazy Saturday, like a lot of Saturdays at Hooti. And after ten years in retail, I know that New Yorkers do not want to wait in line, no matter where they are shopping. I don't blame them—I hate lines, too.

The customer who had my attention at this particular moment had been rooting through a newly purchased tray of costume jewelry as if it were a field salted with diamonds. She had already settled on two pieces and was haggling like I haggle over a very long and delicious gold-tone necklace studded with assorted colored stones.

"I can do fifteen," I said. A darn good price—surely that would satisfy her. But no. She hesitated, and something made me hesitate, too, even though three customers were now waiting to pay me. I reached for my magnifying glass.

"How about ten dollars?" she said.

I needed to write up some tickets and get people on their way, and I'm sure this smart shopper sensed my anxiety. "Okay," I said just a

second before the tiny lettering on the back of the necklace came into fo-
cus. The piece was signed, and with a name I know.

"Oh, my God, this is Judith Leiber!" My words come out almost as
a gasp, and a few heads turned. I wanted to grab the necklace out of her
hand and stuff it in my pocket. But I couldn't—this was my mistake
and I had to live with it.

"Judith who?" the customer asked, and heads turned again. Several
shoppers obviously knew about Leiber and her ornate evening purses
that sell for thousands of dollars at her Madison Avenue boutique and
stores like Neiman Marcus. Judith Leiber, whose work has been carried
by presidents' wives and whose name can now be found on everything
from eyeglasses to shoes. Judith Leiber, who never lasts long at Hooti,
when I'm lucky enough to find anything with her name on it.

This necklace was a cool piece, and the customer was thrilled at her
good fortune—and I could only remind myself that I had paid almost
nothing for this tray of jewelry. In the end her good fortune was my good
fortune, too, because all the customers in the store at that moment were
reminded that Hooti is a regular "must" on the shopping circuit, since
you never know what you will find. That's a label I love.

I'm amazed at how many people don't have any idea what I'm
talking about when I use the word "vintage"—"What do you
mean, 'vintage'?" I'm asked almost every day by a new face in
the shop, usually someone who has wandered in out of curios-
ity and immediately asks, "What kind of shop is this?" Depend-
ing on the initial response, I will either go into more detail or
keep it short, especially if the person is wincing at the prospect
of anything used.

Then there are the people I've met who think the "vintage"

label is an all-or-nothing way of dressing, that people who shop at my store wear *only* vintage or "retro" clothing. I can't pull that off, and I don't want to. And I would feel terrible if people avoided my shop because they thought dressing in vintage would make them look like a character from *Grease, I Love Lucy* or *Saturday Night Fever.* That's okay—if it's Halloween.

For me "vintage" means using older pieces to help create a fresh, one-of-a-kind style, with almost no rules as to how that's achieved. It means looking at what designers are putting on their runways and fashion editors are putting on their magazine pages, then finding the real thing, merchandise from the twenties to early eighties that has inspired the latest hot looks, as well as pieces that compliment them. It means introducing my customers to designers—dead and alive—whose signatures they may never have seen before, such as Judith Leiber or Enid Collins, a Texas designer whose happy hand-painted and jewel-studded purses from the fifties and sixties are a funky and sometimes pricey collectible. Finally, vintage style, for me, is as much about wardrobe accents as it is about "investment" pieces like a Chanel suit or Burberry trench.

One of my customers, a thirty-something man who favors new navy blue blazers with French-cuff shirts, shops Hooti only for silk pocket squares and cuff links. Another, Gabrielle, buys only forties box bags—rectangle-shaped, short-handled purses no bigger than a mini-six-pack—in materials from leather to Lucite. Then there's the woman who I know will buy any pair of forties-era shoes, size six, that I have at Hooti when she stops by—and that's her only nod to vintage. Which is fine with me. Whether it's a pair of open-toe pumps, a fifties beaded cashmere

sweater or a label-less silky camisole, I want customers to know they can put those finds with something new from the Gap, Neiman Marcus or Target, and they won't look exactly like everyone else who shopped those stores this season.

I like to think of dressing with vintage as the ultimate "mix and match" between the twentieth and twenty-first centuries of fashion, inspired by a hodgepodge of "labels" that draw as much from pop culture as from a specific decade or designer. In vintage, certain celebrities' names say as much to me and my customers as does any current designer's name: Dean Martin—sharkskin suits; James Dean—tight jeans; Marilyn Monroe—supersexy sixties halter dresses. At Hooti such name-dropping is often the common language when we talk style, no matter what the customer's age, and if a discussion incorporates the designer "names" of the moment—whether it's Ralph, Kate, Marc or Giorgio—all the better. Time and again their designs show that they thrive on past eras, too.

The bottom line at Hooti, though, goes beyond any one name or one look—old or new. Vintage, as defined in my store, is about surprise and fun and affordability, meeting customers' everyday style needs—from churchgoing wardrobes to Wall Street attire—with pieces of the past.

❧

Much of Hooti's merchandise comes from auctions—where I often buy clothes in bulk, by the pound or by the box. I frequently have no idea exactly what I've bought until I sort through my purchases, deciding what should go on the racks right away, what will be saved for a few weeks or another season

and what is marginal and will be sent straight to Goodwill. I have to work fast and be decisive, because I may be handling four hundred pieces or more in any given week.

In the early days of Hooti, as I was sorting through yet another shopping haul, I came across a strange dress, kind of like a puzzle that tied around the body. I had never seen anything quite like this before, and it was not obvious how it should be worn. The fabric felt wonderful in my hands, a cottony/linen texture, in a tan, almost pale khaki color. The label said "Claire McCardell," and I'd never heard of her. I don't keep fashion reference books at my fingertips—I'm just not the "research" type; I'd rather be looking at the real deal rather than a photograph, even when I have no idea what I'm looking at. So I slapped the dress on a hanger as best I could and priced it at $25. It sold almost immediately, and I didn't give it much thought until a couple of months later, when I had another dress with the same label, also very reasonably priced, and the lucky buyer filled me in on who this was.

As it turned out, the dresses were highly collectible pieces of modern American fashion history, created by a woman who was among the first to put zippers in clothes and is credited with the concept of "mix and match" separates—long before teenagers and women started finding affordable shorts, pants, culottes, skirts and tailored shirts with labels like Bobbie Brooks and Ship 'n Shore in every major department store.

McCardell died in the late fifties, two years before I was born, but her designs are still so highly regarded today that at one recent sale on eBay, a never-cut paper pattern for a classic McCardell backless sundress, size sixteen, bust thirty-four, waist

twenty-six—not a size sixteen by today's standards!—brought multiple bids, finally selling for $36.55.

I didn't learn about McCardell from Lorna Koski, but I could have. Lorna has worked as an editor at *W* and *Women's Wear Daily* for many years, and she was one of my early customers in Park Slope and one of many who followed me down Seventh and across Flatbush. Lorna is a walking vintage encyclopedia as well as a good friend. She not only knows her designers but is outrageous enough with her personal style to show up at a party wearing a black tulle Chanel hat the size of a bicycle wheel. She's no vintage snob, though: Her tastes range from the most collectible couture labels to animal-themed costume jewelry. Lorna can talk easily—and I listen carefully—about everyone from Claire McCardell to Elsa Schiaparelli, the couture designer who may be most famous for her use of the color pink. But one of Lorna's lessons, offered one afternoon in the shop about seven years ago, proved much more beneficial to me than she might have hoped.

I had found an amazing piece, a sixties-era kelly green belted leather trench coat trimmed in fur, probably silver fox. My learning curve for both furs and designers was still a big one, so this coat was a mystery to me.

"Isn't this stunning?" I said to Lorna, who was making one of her frequent visits but had yet to spot it.

As she casually scrutinized it, briefly studying the label, she asked me for a price.

"One hundred fifty," I said. With that information Lorna's spiel began.

"You know who this is, don't you?"

"No," I said. I just knew it looked darn good on my rack. I

wasn't at all label-focused at this point in my vintage life. My philosophy then and now: "The more I sell, the sooner I'm back on the road, on the hunt for the next great finds." Research was not a part of my daily routine.

The coat's label said Bonnie Cashin, a name I had never heard of or seen before.

"This was one of Ingrid Bergman's favorite designers," Lorna said. And instantly, with the mention of just one name, Lorna and I were talking the same language of style. Lorna went on: Cashin was another serious fixture in fashion Americana— she was so big that her work is in the Metropolitan Museum of Art. And she had done everything from the first Coach leather purses to wardrobes for 20th Century Fox, including the movie *A Tree Grows in Brooklyn*. In other words, Cashin was a name I *needed* to know to be good at this business. I might be learning on the run, but I wondered, momentarily, if I was running fast enough.

"In Manhattan this would be six hundred or six hundred fifty dollars," was Lorna's final guidance on this piece. But she didn't say anything about buying the coat, and then she was on her way.

An hour later a tall African-American woman whom I didn't know tried on the coat, and it was a perfect fit and look for her, the green complimenting her dark skin. I was ready with *my* spiel. "This is a collector's piece," I said, repeating almost verbatim the little bit of Cashin history I had just learned. And my new price was $300. The woman took once glance at herself in the full-length mirror, and that was it. She whipped out her charge card, and the coat was gone. I was shocked and pleased.

The next morning Lorna was waiting when I arrived to open the shop. I was surprised to see her. "I want the Bonnie Cashin," she said, the cash in her hand. I felt horrible. "Lorna, why didn't you tell me you wanted it?" I said. "Why didn't you ask me to hold it? I sold it an hour after you left."

I knew she was disappointed, but her first question was "How much did you sell it for?" I told her, and she seemed pleased that her information had helped me but displeased that she'd missed out. "That woman got a steal," she said.

Fortunately, even a beautiful piece of Bonnie Cashin couldn't come between us. And eventually I was able to make amends, and this time I knew exactly what I was selling.

The coat was a Claire McCardell that I had bought, along with dozens of other pieces, from a Park Slope woman who was clearing out her late mother's home. Her closet had been filled with all the best labels, from Bergdorf's to Christian Dior; the only negative was the fact that the owner had been a smoker. Sometimes you can fix that problem with a simple hand washing or spraying the piece with Febreze and hanging it outside on a sunny, breezy day—but that's not a good idea if the item is a bright color that will fade easily. Dry cleaning works sometimes, and sometimes nothing works.

As for the McCardell, it was stunning, a black wool with a nubbly texture, collarless and flared and hitting right at the knee—and dry cleaning fixed the smoke problem. The coat had no buttons, zippers or hooks; it was simple and chic, what I would call a day-into-evening kind of coat. I saw it as a piece of art and tagged it at $350.

It had been on the rack one week, a few women had tried it on but no one had commented on the label, and I suspect that most Hooti customers don't know that name. Then Lorna saw it, immediately tried it on, and that's who owns it now.

❦

I once owned a pantsuit that had a great label—Dries Van Noten, the Belgian-born designer whose clothes are both simple and feminine. But the suit was tainted—a gift from a boyfriend who couldn't seem to stop labeling *me*.

Harry had many good qualities, including a wonderful sense of humor. He had surfaced after a bit of a dating drought, so I can't say I was I scrutinizing him as sharply as I might look at a rhinestone necklace these days, checking to see if all the stones are in place and the clasp is secure. He had good taste in food and clothes, he had a fast car and a country house, and he was a close friend of a longtime girlfriend. A promising profile, at least superficially, right? But the issues that surfaced during our two-year relationship were big ones.

When we were in the country, he refused to stop for garage sales, and when we were in California—both of us on business and staying at the Chateau Marmont—he wouldn't introduce me to his parents because he was Lebanese and they would never accept me. He was embarrassed to admit this and didn't want to talk about it, *ever*. And, to be honest, I really didn't see myself marrying this guy, so at the moment I became aware of the dead-endness of this relationship, I really didn't care. I wanted to have fun, not deal with reality.

But the matter of how he introduced me to friends and clients at parties and business dinners was harder to ignore: "This is Alison, my girlfriend the model." It was always the same, even well after I became "Alison the secondhand-clothes dealer" or "Alison who sells vintage clothes." To him I was only "Alison the model," and, true, I was still modeling occasionally, because I needed to pay my bills. Obviously my new career just wasn't as sexy in his Wall Street world—and it didn't send the same message about *him*. It became clear that I was nothing more than arm candy— and eventually I grew tired of having less than love in my life. But not tired enough to do anything about it.

Did I bolt for a place of my own? No, even though I knew I should—especially after Harry started commenting about my eating habits.

"You better watch your weight, you're still a model," he reminded me periodically. And this from a guy with a bit of a gut—a point I made to him more than once. But my diet *was* leaning more toward Pennsylvania auction food—pierogi, french fries and doughnuts, which my friend Nancy always had waiting for me at her store and still does. I invariably go for the most decadent ones—chocolate covered and cream filled—but Nancy doesn't take any chances. An assortment, from a little bakery down the street, waits for me beside every pile of vintage goodies she wants to sell. Nancy knows me well.

Harry didn't go on these buying trips, so he had no idea *what* I was eating; he just saw the end result. I had no intention of putting on a quick twenty pounds, but I wasn't in full-time-model mode either. My vintage income didn't depend on the

size of my hips and waist, even if the success of my relationship might.

Just before we broke up—I'd like to say I was the one who called it quits, but I can't—Harry thought I needed to be dressing a bit more sharply for his dinners in the city, and he wanted to buy me a Dries Van Noten cement gray linen pantsuit. "This is too fancy for my new lifestyle—it won't work in the store," I told him after trying it on at Barneys. I've never done well with men who insist on defining my look—one ex-beau always wanted me in long hair and farm dresses when I was in a short-hair, blue-jean phase—and I would much rather name the store and the brand, if someone insists on shopping for me. I'm not good with fashion surprises of any sort—and I know very few women who are.

Harry didn't want to hear my negative response to the suit. He was not a big fan of my growing vintage wardrobe, and till the end he still saw me as a model—and as someone he could control.

Despite my reservations, he bought the suit a few days later—it cost a thousand dollars—and I wore it a few times, to please him. Then, finally, Harry figured out I had a new love, my shop, and he moved out. I was sad for a little while, but there was relief, too, be-

cause I knew that this was inevitable, and now I could move on. The new me still loved fast cars, a hip restaurant and a Barneys shopping bag, but not at the expense of my personal identity. I was making a fresh start, and I would stop at any garage sale I wanted to.

For me, letting go of this relationship meant letting go of the suit, too. It was my past, not my future, and it needed to be with someone for whom there were no emotional ties. It wasn't vintage, obviously, but that didn't keep me from putting it up for sale at the shop. It might send a mixed message about the focus of the business, but I suspected that most of my customers were focused on great finds and good prices, not a particular decade of vintage design. I was right. The customers who stopped to admire the suit and didn't recognize Van Noten's name were a bit taken aback by the $250 price tag until I explained who he was and mentioned the original price. Those who did recognize the label were curious about how it had come to be on my racks. So I told them the story of Harry, that he wanted me to be somebody I wasn't, and that it didn't match my new vintage lifestyle. I don't believe that bad karma moves with clothing from one owner to the next—if I did, I couldn't be in the vintage business—and I do think customers like hearing a slice of real life, especially when it comes to relationships. They nod, they wince, they commiserate—sometimes they share their own horror stories.

It took only a few days for the right buyer to come along, someone who would always look at the suit with good feelings about what a steal it had been—someone who had chosen this suit for herself.

❧

Lots of my customers don't care whether something has a "good" label—or any label. What's important is the look and the fit—and I love that about them. But over several years of selling, I came to realize that customers who were not serious, experienced vintage buyers would not even try on a piece of clothing at Hooti if a tag said it was a fourteen or a sixteen, especially if the shopper was an eight or a ten. Even when I assured them that American sizes from the forties, fifties and sixties are not equal to today's sizes—that the size-sixteen suit would be more like a ten today—the customer would move on to something else. Very few people want to hear that today's size eight was once a size fourteen.

The severity of this "problem" finally hit home by way of a seventies flamingo pink jumpsuit with a built-in belt. This piece had two things working against it. First, there was the label: Lane Bryant, which was once known more for supersizing and affordability than style. I know Lane Bryant well, and fondly; I was a Lane Bryant model for several years, in catalogs, where everything was polyester and way too big for my body. Some models refused to do Lane Bryant—and for many years my mother refused to be seen in the store. But not me. Work was work, and I couldn't afford to be a snob.

Even though these were clothes for big women—the Lane Bryant art director once told me my butt and legs flattered their designs; I'm still not sure how to take that—Lane Bryant didn't want to show big women at the time, so everything I wore was pinned to perfection for the camera. What you saw was about

half of what you would got, especially if you were buying this outfit in a size eighteen or twenty. But no stores or labels that I knew of were yet using plus-size models, no matter whom they were targeting as their customer.

The second problem with the pink jumpsuit was the tag right under the Lane Bryant label: It was double digits—a size eighteen. Even though the jumpsuit seemed to pull customers into the store—I hung it at the front door, and you could spot it from a block away—the minute people got close enough to see the size, they didn't give her a second look.

It took me two weeks to figure out the size was the problem, and then I didn't hesitate. I cut out the tag—an easy snip, snip, but not in front of any customers—and within a few days, she was gone. The buyer was a size eight.

From then on I knew what I had to do, even if it was considered heresy in some vintage circles. I started removing size tags in most of my American women's clothing that was not couture or highly collectible. I would leave the designer or store label, even for the least coveted brands, but the size tags had to go on everything that was more than twenty years old.

Am I being deceptive, just like the art directors and marketers used to be, when it came to big clothes and big women? I don't think so. I'm just removing an obstacle from the vintage shopping experience, and when I have my doubts about this practice, all I have to do is think about my stubborn mother. For decades she said she had never bought anything that was less than a size sixteen—her point being that she was always a large woman—and she refused to believe what I knew about how sizes had changed.

Yet when one my sisters, who is a true size ten, recently tried

on my mother's pink wool B. H. Wragge suit from the fifties, it fit perfectly. Mom was surprised, but the proof was standing right in front of her, so there wasn't much wiggle room, even for her.

<center>⌁</center>

Unlike many vintage-shop owners, I never attempt to estimate "current" sizes on my Hooti Couture tags, because that's a no-win situation, too. My estimate of a size ten could keep someone who's a twelve from trying on a piece that's perfect for her, so not only would I have invested a ton of time on sizing, but my information might prevent a sale. No, with vintage clothing the best way to know if something works—the *only* way to know if something works—is to try it on.

But most Hooti merchandise is tagged, though the information is totally fictitious and created solely to entertain by a woman who loves to keep our customers laughing in the aisles.

I first met Mary Coleman in my earliest days of selling, and she soon became one of my regular customers. Mary was in the store one afternoon when I found myself in a pinch, without a backup and needing to be out of the shop for several hours the next day. I knew that Mary didn't have a full-time job at the moment, so I asked her if she might be interested in helping out.

She was, and customers responded immediately to this witty, savvy and creative woman.

A few weeks later, I asked Mary if she would work on the tags. Often my descriptions had been nothing more than "*Fab Fifties*" or "*Sexy Sixties*"—uninspired at best. She immediately

started giving pieces whimsical histories with absurd, entertaining and occasionally sentimental one-liners that often incorporated the names of actors and other celebrities while talking to the likely potential buyer—but never in a heavy-handed or obvious way. And almost always the lines ended—and still do—with Mary's signature dot-dot-dot, as if the end of the story were still waiting to be written.

"Oprah's first paycheck . . ." teased a flowing seventies culotte dress in Caribbean colors. *"Julie Nixon comes to realize Daddy will resign . . ."* winked the tag on a late-sixties icy blue polyester high-necked dress. And one of Mary's favorites, and mine, too: *"Martha Stewart's first Realtor . . ."* read the tag on one of several identical seventies-era plaid wool skirts that I bought as never-worn back stock from a store that had closed. *"Martha Stewart's fourth Realtor . . ."* said the next skirt. And *"Martha Stewart's sixth Realtor . . ."* said the skirt after that. Until all those sold, I knew I could count on at least a few giggles every day from the skirt section of the shop.

Sex has proved popular, too, especially with guys. *"Robert Redford IS Jay Gatsby. . . . Buy it and get laid . . ."* Mary was in tag-writing heaven when I expanded the men's section of Hooti, and this tag accompanied one of several gorgeous forties military-issue khaki wool jackets I had found in Pennsylvania. Every one of those jackets had a tag celebrating one of Redford's movies, even if the era wasn't an exact match or the movie had nothing to do with the military. It was just impossible not to imagine him looking gorgeous and ready to fly off to certain death. And those jackets flew, too—right out of the store.

As pop culture's icons come and go, Mary has been there, pulling the freshest names into the mix, and over time only a very few customers have assumed, at least for a moment, that the tags had a grain of truth in them. When that happens, we are quick to correct any misunderstandings. *"J.Lo cruises Flat-bush . . ."* does not mean Jennifer Lopez once owned the caramel-color seventies maxicoat with the huge white-tipped faux-fur collar—or has ever even been to Flatbush Avenue. But we invite customers to share our conviction that this coat would look great on her—anywhere—or on someone who wants to look like her.

After our move to Flatbush, I realized we should capitalize on all the local color of Park Slope and Prospect Heights, so now that finds its way into Mary's tags, too, and customers are thrilled. *"I saw a Soprano at Blue Ribbon Sushi . . ."* said the tag on a sixties peacock blue sleeveless cocktail dress. A new batch of Mary Coleman tags debuts at the start of each Hooti "season"—and we do recycle the best lines, because using them just once seems like a waste, and Hooti *is* in the recycling business, after all. But new tags or old, I have no doubt that customers shop longer and spend more because of them.

❧

What kinds of price tags should I expect? That was the first thing that crossed my mind when I spotted an advertisement in the *New York Post* for a "supermodel garage sale"—a fund-raiser for some endangered-species organization. Did I really want to pay the $25 entry fee to look at expensive hand-me-

downs in Manhattan? But my curiosity won out, and my new retail neighbor on Flatbush, Suewayne Brown, who had recently opened a high-end boutique called redberi, wanted to go, too.

Suewayne and I dressed up—we knew there would be competition, because the ad had promised there would be "supermodels" at the sale—and took an $18 cab ride into the city in order to get there when the doors opened. Already this had the potential to be a pricey afternoon.

Once there, we ran to the entrance of the large loft-type building where the sale had started a few minutes earlier. Who knew what deals we might be missing out on? But first there was the doorman to contend with, and he directed us to the eighth floor. A garage sale with a *doorman*? All this scene needed was a red velvet rope. We attempted a cool demeanor as we paid the cover charge, but once I spotted the one-dollar boxes, all my coolness flew out the window. I started grabbing merchandise like a wild woman—Suewayne looked at me and said, "My God, you are fast"—and I just kept sorting through the discards. Then I headed for the five-dollar racks of clothing, and then to the ten-dollar racks. Suewayne wanted me to check out a soap opera star, the media was everywhere and models were trying to mingle, but I

knew I didn't have time to take in the scene. Even a second wasted on celebrity gazing—or posing—might mean a bargain lost.

In forty-five minutes I had built a pile of merchandise—at least four dozen belts, fifteen pairs of shoes, jackets, skirts, jeans, tops, dresses, jewelry and one hat. Every item had been labeled with the name of the supermodel who'd once owned it—my finds included Kirsty Hume, Amber Valletta and Shalom Harlow—and the merchandise had all the best designer labels, from Europe and the United States. When we finally left, I was carrying ten shopping bags and Suewayne was carrying eight, more than enough for us to catch the eye of the photographer from *W*.

"Where are you girls from?" he asked.

"Brooklyn," we said proudly. We posed, with big smiles, then grabbed another cab home, both satisfied that this had been a day of smart shopping. We were weary and stuffed, having had our fill of the designer sandwiches, red wine and incredible chocolates that had been included in the cover price. If every garage sale were this decadent, I'd be wearing muumuus to Hooti.

◦‿◦

One other thing about sizes and tags: Like me, many of my customers have big feet, and only a few can wear the vintage size-five or size-six shoes that I most frequently come across. Fortunately, most supermodels have big feet, too, so the next day Hooti's shoe racks were full of nines and tens—used, though not vintage—but when it comes to shoes in particular, I never

draw that line at Hooti. Good merchandise, in the right sizes, is always the higher priority than age.

Within a week I had sold all fifteen pairs of shoes and boots, each with a supermodel's name taped across the sole.

Star Parris, like most of Hooti's customers, does not have a super-model body. In fact, she is a pear-shaped woman with a tiny waist and what she describes as an "apple" bottom. She stole that description from a line of jeans called Apple Bottoms by Nelly, which recognizes that not everyone has a tiny butt and which Oprah listed as one of her "favorite things" in 2004.

Star was the first woman in line the day Hooti opened on Flatbush, and she can be a bit pushy. She had even tried to charm her way into the store in the days just before we opened. She became one of Hooti's top-ten customers in the first six months, and her interests leaned hard toward glam—outfits you might see in fifties movies with black-tie wardrobes at dinner-time. I was a bit baffled, because every time Star came into the shop, she was wearing sweats and sneakers. And she just kept buying.

Then one day she started showing up dressed in head-to-toe vintage, and all her past purchases were brought to life, one out-fit after another. You would have thought I had hired her as a model to walk Flatbush for the day, selling Hooti as if she were wearing a sandwich board.

Star is a size four on top and an eight at the hips, and one day she spotted a full-length, backless, off-white halter dress with

large hand-painted butterflies in tropical shades of blue, gold, turquoise and purple—with a shawl to match. It was a dress that would make you want to move to Maui.

Both pieces were signed on the fabric, like a canvas, with the name Shaheen. I had known Alfred Shaheen's work from my early days on Berkeley Place, and whenever I got one of his dresses—often the tag would read "Shaheen's of Honolulu" or "Alfred Shaheen Master Printer"—I hung it on the wall as if it were a painting. They didn't stay there for long, though, and I still can't keep Shaheens on the racks—especially the sexy, Polynesian-flavored halter dresses—even though most customers don't know the name.

Star tried on the butterflies—assuming the dress was about her size, because the tag said twelve and I would never fool with any of the tags on a Shaheen—and it fit perfectly. After parading around the shop, showing off her find to everyone, she bought it and wears it often. And with or without her Shaheen, Star remains a regular at Hooti, and I can't get enough of her vintage energy.

❧

Flatbush Avenue is as colorful as any design by Alfred Shaheen, but the street can be a much tougher sell. Since moving there, I have been fascinated by how my address is initially perceived by some Manhattanites, especially those who have never been to the street or my neighborhood and whose expectations for Hooti are frequently more negative than positive, simply because of my location.

I am more than happy to shoot down any stereotypes about the street, of course, and I would no more put a single label on Flatbush than I would on my store. I see both as constantly evolving, full of energy and predictable only in their unpredictability.

But I can't avoid the fact that my business is largely about labels. They can provide instant "knowledge": Chanel means elegance and quality, as defined by the French; Woolrich translates as all-American, its clothes as ageless and rugged as the almost two-hundred-year-old company; London Fog says classic and dependable, which is what a raincoat should be. Yet many of the best products that pass through Hooti have no label or mark of any kind. Oftentimes, those are the most memorable, and often the people who buy them are my most confident shoppers, content with their own judgments and not needing a name embossed in leather or stitched into a tiny piece of satin to tell them if something is "good" or "bad." But every time I think of one label-less alligator purse that came and went quickly at Hooti, I can think of only one thing: my defensiveness about Flatbush.

One Friday evening—often a lively time at Hooti—an attractive woman in her forties whom I had never seen before walked into the store. I hate being pounced on when I enter a shop, and at Hooti I try to walk that fine line between seeming welcoming and overbearing. So I let her take in the shop for a minute or two before saying anything.

This woman had a sharp eye, and almost immediately she spotted my most expensive purses. These are usually kept on a shelf behind my cash drawer, so they won't easily walk out the

door. I had just added a few alligator bags to the display, including a striking and unusual off-white one in near-perfect condition—no dryness, no flakiness, original alligator-skin handle, original hardware, maybe with a couple of little scratches on the metal, and a clean, unblemished lining.

"What are you asking on the white gator?" the woman inquired, her tone tinged with just a bit of acid. I don't run into that very often, but when I do, I try to ignore it.

"Two hundred fifty dollars," I replied, handing her the purse. "I don't get many gators, and I *never* get a white gator." Sometimes I feel compelled to explain the higher-priced merchandise, sounding almost apologetic, even when I know something is a bargain. I wish I could stop doing this.

"Two hundred fifty dollars," she repeated, as if talking to herself. Then she said it again. "Two hundred fifty dollars." Pause. "My husband's going to kill me." I smiled, because I hear this a lot, and I have come to realize that it is usually the mantra of someone whose credit-card debt has gone off the charts, not of an oppressed woman in a bad marriage.

And despite her tone, I was in a negotiating mood.

"Okay," I said. "Two hundred dollars."

"He's still going to kill me," she said again, her voice a mix of frustration and self-pity. Now I was curious, but less sympathetic. What was this woman really saying? Does she buy everything she sees? Does she already have twenty alligator purses just because that means status to her? Is she $30,000 in debt for clothing or shoes that have never even been worn? Is her life defined simply by shopping? Or is this simply a negotiating tool? I didn't know, and I don't ask, of course.

"I'm gonna take it, but I'll get it tomorrow," she said finally. She hadn't asked if I would hold it; she wasn't offering money; she wasn't even trying to be pleasant. And I couldn't help but sense that she thought she was doing me a favor just being interested in this purse. So my hackles were up.

"I'm sorry," I said, "but I can't do tomorrow. Gators move quickly, and I can't hold it."

She instantly got angry. "Oh, two hundred dollars! This is crazy. I can't believe you're asking two hundred dollars for an alligator purse on *Flatbush Avenue*."

On Flatbush Avenue? *On Flatbush Avenue.* Now I was angry. She had insulted my neighborhood and, by extension, every person who has ever found his or her way to my store. Her label was one I didn't want or need in Hooti.

She turned to leave. "I'll be back for *my* purse. You aren't going to sell it. It'll be here tomorrow." I nodded but said nothing.

Such encounters are very rare, thank goodness, but I can do a good job of stewing about them, working over the details as carefully as I might examine the wool of an old coat, looking for evidence of moths or hard wear. Not this time, though, at least not right then.

No sooner had Gator Woman walked out the door than in walked one of my favorite customers, a woman who always seems confident about her decisions. Rita, whose family owns a restaurant in Park Slope and who appreciates beautiful vintage as well as a good deal, immediately spotted *the purse* and asked to look at it.

I couldn't believe what was happening. I had not said one

word about my previous encounter—talking negatively about customers to other customers is just like mentioning that last bad date to this weekend's dinner companion; it's *never* a good idea. Now I felt as if I had stepped into the middle of a bizarre dream. What were the chances of two customers picking out the exact same piece of merchandise, within minutes of each other, from among hundreds of things that might have said "look at me"?

Rita wanted to know the price, and again I said $200. Did I want her to buy it? You bet. But I was not going any lower than $200 just to prove a point.

Rita didn't hesitate; she would take it, along with several other goodies she spotted in her next twenty minutes in the store. As she was paying her bill, she shared her excitement about the gator. "Alison," she said, "I was just at Dolce & Gabbana, and they have the same purse in cream gator, and you don't want to know what they're asking. . . . And this one is much nicer." I smiled and thanked her for the information. I had just made a very nice profit on this bag, so I really didn't care if I could have sold it for hundreds more. Just as important to me was the fact that this purse was leaving with a customer who valued my store, not with someone who sneered at it.

The next morning I made a point of looking my vintage best. I know that when I look good, I make the store look good. Superficial? Sure, but sometimes that's all people see.

Almost as soon as the doors opened, Gator Woman arrived, husband in tow. She didn't say hello; all I heard was, "Where's my bag?" She said it loudly, as soon as she scanned the shelves

where the white alligator had been. "You didn't sell it. Now, where is it?" her voice full of entitlement and certainty, as if I were playing with her and had tucked the bag under the counter, just to be cruel.

Trying to avoid any hint of smugness—and that was difficult—I explained that the purse had been bought by the very next customer the night before.

To this news Gator Woman announced to everyone in the shop, "I am having a really bad day right now."

Then, to me, her arms folded across her chest, her eyes staring laserlike at my eyes, she commanded, "You need to get *that* woman on the phone right now. That is *my* bag. I will give her one hundred dollars more for that bag. I want that bag."

"I'm sorry," I said. "I can't do that." I explained that the buyer collected vintage purses and probably wouldn't sell it, even for a thousand dollars. I didn't tell her about the time Rita had been wearing a Hooti coat in Barneys when a stranger walked up and offered her a thousand dollars in cash. Rita had told that would-be buyer that the coat was not for sale. I knew the message would be the same this time. And, Rita aside, I couldn't think of even one circumstance that would make me do what this woman was asking: That's just bad retail etiquette.

Now the woman was irate and announced again, "I'm having a bad day right now." She seemed to look at her husband for some confirmation of this point, but he wasn't listening, because his very next comment was directed at me, and I still can't believe anybody would say something so insensitive and inappro-

priate: "I wish I had a camera. You look good enough to be in a movie." For the first time, I felt bad for this woman, as unpleasant as she was. What was this relationship all about? What was behind this scene about this purse, really?

"Now I'm *really* having a bad day," his wife announced again, and now she was pacing in front of the counter, still complaining loudly. But she wasn't ready to stop shopping just yet. "What else do you have for me?" she said.

"Can I show you some designer dresses?" I asked. Wrong suggestion.

"I don't want a designer dress," she snapped. "I want that handbag."

Nothing else I could say was going to improve this encounter—so I started moving toward the door. "I'd be happy to take your name and number if I get any more gators," I volunteered.

"I'm not giving *you* my phone number," she shot back.

"Well," I replied, happy to lose her business once and for all, "then I guess you're not going to get an alligator handbag."

I know that Flatbush Avenue will never have the cachet of a Madison Avenue or a Rodeo Drive, because Brooklyn is too much of a cultural mishmash for that, thank goodness. And to some people Flatbush will always be just a grimy, noisy street that is the fastest route to someplace else, because they never stop to look closer, because this is not *their* neighborhood. For those who know better, Flatbush is a place where P. Diddy's mother

sells soul food just down the street from a hip restaurant with addictive fried zucchini; where locals may have family in Haiti, Jamaica, Thailand or Hong Kong; where English is spoken, and so are French, Spanish, Creole and Japanese. It's where Hooti customers like Gelsomina, a designer at Ann Taylor who knows who Judith Leiber is and owns one of her purses, is comfortable rubbing shoulders with a security guard from Rikers Island treating herself to a full-length mink coat.

"Can you find me a matching hat?" my Rikers customer asks, before bringing back her friends, who also want fur coats now that they've seen hers.

It's about watching someone new to the shop, say, a young man, maybe not even twenty, whose hair is braided close to his head around a small Mohawk, whose influences seem to be a mix of seventies and Aztec, wearing black-rimmed glasses, a short, fitted striped sweater and a midcalf wool skirt layered over baggy pants. Think Barton Fink meets Jean Paul Gaultier. Later, after he is gone, when I ask another customer if she noticed his amazing hairstyle, she tells me he's an art student at Long Island University, just down the street. She's a student there, too. "He's got it going on," she says admiringly. And a week later he's back, this time leaving with a pre-toupee Burt Reynolds–style buckskin leather jacket and a simple seventies black-and-white check A-line wool skirt, with the tags still on it, that fits him perfectly when slung low on his hips.

It's about girlfriends catching up on their lives while they move from rack to rack, and who cares if anyone else hears the details about a vanishing boyfriend or a high-maintenance boss?

It's about a single mother with a weary face who needs to

keep her daughter's first prom dress under $35 and about watching a fifteen-year-old tentatively model her first fancy gowns in satin and tulle, desperately wanting something to work for her.

On Flatbush I never know who will walk through Hooti's door tomorrow, because nothing is static or predictable about the street and the people who seek it out—just like the clothes, purses, jewels, shoes and hats that fill my store.

The Thrill of the Hunt
Scavenging for a Deal

I don't remember how I first learned about the Italian designer Emilio Pucci, who is probably most famous for his use of hot and groovy colors—pinks, yellows, greens, purples—in the fifties and sixties. I do remember what I bought on my first visit to his Manhattan boutique: a $35 pair of panties—the cheapest item in the store with one of his psychedelic designs. It was another one of my can't-say-no days, sort of, so I also bought a pair of over-the-top circular dangling earrings that grazed my collarbone and seemed reasonably priced at $95. I did resist the Pucci blouses, though. I could say no to those, at $500 and more.

Pucci, new or vintage, continues to be one of my favorite labels—his clothes are both feminine and electric—and almost every early Pucci piece goes for top dollar in the vintage marketplace these days, even the lingerie. I'm not the only one wearing slips as dresses—and the same goes for nightgowns. Sixties Pucci PJs are more than beautiful enough to go out in public as evening wear.

I'm constantly hoping to find anything in vintage Pucci, but discoveries are rare—I've bought and sold maybe a dozen items. When I came across a table at an outdoor country auction maybe seven years ago, it had just stopped raining, and the auctioneer at this table was selling box lots of mostly wet merchandise. Suddenly, in his hands, he had three purses, only one of which was wrapped in plastic. All I could see was a swirl of turquoise and black, but that was enough. Immediately I knew it was Pucci, and I was confident it wasn't a knockoff because of the company it was keeping in the auction lot—obviously high-end vintage bags that were now quite damp. If this particular lot had also included Fendi and Louis Vuitton, I would have been skeptical about all the merchandise. But there were no such red flags.

"Do I have a dollar?" the auctioneer started. "Do I have a dollar?" My hand went up, and I was the only one bidding, so in less than a minute I had bought three purses for a dollar. As soon as I was handed the merchandise and could find cover from the rain, I opened the plastic bag, and there she was—a velvet Pucci convertible clutch with a gold-chain handle, in pristine condition.

A week later I sold her for $36. Sure, I could have asked more, and gotten it, but I love being able to deliver a bargain like that to my customers, knowingly—this was not like my Leiber "surprise." Just as important, I like to make the point that sometimes it is possible to find the genuine article for not much more than what a sidewalk vendor would charge for a knockoff. I love knockoffs just as much as any shopper, but it's not the kind of stuff I'll keep for a lifetime. Real Pucci? You bet.

Every September, usually on the first or second Thursday of the month, I introduce my fall "collection," the best vintage clothes and accessories I have collected over the past six months, with

an eye toward what's been shown on runways and what's being hyped in fashion magazines, particularly as the trends relate to color, fabric and jewelry.

Mostly, though, I stick to the same basics every year, seeking the best merchandise dating from the forties to the seventies that fits about a dozen categories: almost anything black, because it's classic; almost anything wool, but especially men's and women's suits and anything by Woolrich or Pendleton—another great woolen brand, from Oregon, dating back to the early 1900s; anything tweed in skirts, jackets and coats; any hand-knit sweater, scarf or hat, men's or women's; anything with sequins or beads; anything in cashmere or silk; anything in fur, fake or the real deal; almost any boots; anything in alligator, crocodile or snake; anything with netting or rhinestones; and any strands of pearls.

When in doubt, I buy what I love, and I hope my customers will love it, too.

A few weeks before the Big Day, we start telling everyone what the exact date is. When customers come into the shop, they hear about it, and when they call Hooti, a phone message gives details. A note is posted on the door, and a few days before we also call some of Hooti's regulars who might not have been in the shop in the past two weeks.

Last season, Barbara, who lives in Manhattan, called several times, just to make sure the opening date hadn't changed. She first heard about Hooti from a saleswoman at the Louis Vuitton boutique in SoHo, and she had been in the shop only once before, maybe eight months earlier. For her next visit, she knew exactly what she wanted: "coats with fur collars."

I'd told her we had several that would be going onto the racks for the fall collection, and that it would be a good idea to be at Hooti at eleven that day, to make sure she had a chance at the best stuff. That only made her want to know more. "What do you have? What colors?" I made the mistake of giving her a few details—of course I want customers to be as excited about this day as I am, but sometimes I talk too much—and then she wanted me to hold several pieces just for her. I explained that for this particular event it's first come, first served. I can't afford to be letting anyone get first dibs. But she was a woman possessed: "Can I come at ten?" she asked.

"No," I said. I liked her aggressiveness, but enough was enough. "The doors open at eleven. I'm looking forward to seeing you."

When the doors opened at eleven, no Barbara. Noon, no Barbara. One P.M., no Barbara, but the mailman handed me the fall catalog from Barneys. I didn't really have time for it, but I couldn't resist. As I flipped quickly through the book, I was stunned—and tickled pink—to find designer Marc Jacobs's version of a fifties creamy tweed, three-fat-button coat with a fur collar and a three-quarter sleeve, hemline hitting just above the knee—just like the ones I had. The Barneys price: $3,250. I turned a few more pages, and there was a pale yellow cashmere

sweater, also fifties, buttoning up the front with yellow satin detail. It was $995. I scanned my shop and caught my breath. I had about twenty coats, all similar to the Marc Jacobs interpretation, but these were originals—and a heck of a lot cheaper. And on two new mannequins, standing right in the center of Hooti, were two of the prettiest little sweaters I'd ever had in the shop: Both had satin trim on cashmere, one in pale pink, one in baby blue with pearl and rhinestone detail. Each was $95.

I already knew that this was my best fall collection yet, but now I had the ultimate affirmation from the nonvintage world that my instincts had been dead-on. I had loved these coats and sweaters when I first bought them, but, realistically, I'd never expected to see something so similar in one of the most coveted catalogs in Manhattan.

Barbara finally arrived at about two and headed straight for the coats with fur collars. Within five minutes she had tried on five coats and decided on two, though she seemed to be questioning my $300 price for each. That's when I grabbed the Barneys catalog and went straight to page 7. "You know, Barbara, Marc Jacobs is selling this coat for thirty-two hundred and fifty dollars."

"I know, I know," she said, laughing. "That's why I'm here. I've already tried that coat on. I also tried on their leopard one that's twelve thousand dollars. But I have a real leopard already." I smiled, and now it was my turn to laugh. "I've got a leopard shower curtain at home," I should have responded—but I wasn't that quick. I stuck firm with my prices, and I knew she understood.

Customers like Barbara are women I love to know, even if the relationships are casual and based on nothing more than my

shop's merchandise. She adores clothes, she is clearly someone who stays on top of the latest trends—on the day she was shopping for coats, she was dressed head to toe in new designer clothes—yet she rides the subway, she's a good negotiator but not a rude one, and she's willing to go all the way to Brooklyn because of a good deal on a fifty-year-old coat. And one last little detail I can't get out of my head: She wasn't above attaching a photo of her dog—a tiny white fluffball—to her key chain. Kitschy yes, but charming, too—and it's one more detail that helps define her distinctive stylishness, in my mind.

Barbara paid my price for her two fur-trimmed coats—one a cocoa brown, the other a camel hue—but then she headed back to the coatrack and tried on one of my favorites, in seafoam green with a caramel-color mink collar. She looked wonderful in it, and I said so, but it went back on the rack. She didn't say what she was thinking, and I didn't press, and off she went, back to Manhattan.

An hour later the phone rang. It was Barbara. She politely asked if there was any way I could hold the seafoam coat until noon tomorrow; she knew now that she wanted it, too. I was happy to put it aside. She had made an investment in my shop today. I was happy to reciprocate.

❧

When I'm searching for fall and winter looks, I shop the Northeast, because that's where I'll always find the best woolens and furs. But when it comes to preparing for my spring/summer collection, I head south, often making a round-trip to Miami in my Suburban, always coming back with a

truckload of goodies—and a little bit of a tan. When I get to Hooti, more boxes of merchandise that I've shipped will be waiting for me, too. And by the end of February, my customers will be showing the first signs of hunger for anything that doesn't have wool in it. Of course, the trip is also a good excuse to get out of the snow and ice and see my family.

My first stop in Miami, always, is Flamingo Plaza, a funky and weary outdoor strip mall that is now home to about a half dozen different thrift stores, each with its own personality and quality of merchandise. Flamingo Plaza is what the Tropicaire Flea Market was to me in the seventies, with three big differences: air-conditioning, a Cuban café and free parking.

When I go to Flamingo, I don't worry about how I look. Dirty hair? That's okay. Makeup? No way. I throw on a pair of Nikes, and my money is stashed in a fanny pack—the only time I'd be caught dead wearing one—so my hands are free to work the racks. I'm not there to impress anyone, I'm there to shop.

The stores open at either eight-thirty or nine, and my favorite is Red, White & Blue, where there's usually a line—most of us as anxious as a bunch of thoroughbreds at the starting gate at Hialeah Race Track—ready to grab our full-size grocery baskets, always keeping an eye on those baskets after we've started to fill them.

Once inside, the first thing most of us will determine is what kind of "sale" the thrift store is having that day. Each Flamingo store has a different sale every day—posted on large, easy-to-read signs. Certain color tags may all be 99 cents, or 50 or 75 percent off, but even the nonsale items are usually well priced. Then I push my basket as fast as I can toward the handbag sec-

tion, where I always find at least a dozen pieces from the forties to the early eighties. Next I move straight into dresses, and after that it's into skirts, and then onto men's. By the time I leave the store, my grocery basket is stacked so high I can't see over the top. On really good days, I pay for my purchases, load them into the car, then head right back to the store for a second round. I know that I can't handle two baskets at once.

The Red, White & Blue is where I'm most likely to get my hands on vintage Gucci, Louis Vuitton, Missoni and other couture, but on any day any one of the Flamingo stores may deliver a great find.

I shop at Flamingo several times a year, and I never buy just by season—if I see a good mink stole in April or an Esther Williams–era bathing suit in December, I'll just put it away for a few months. But when I do find "winter" pieces, I have to laugh, because I'm certain that much of what I'm buying once lived in Manhattan, Brooklyn or Long Island—many of the store labels tell me that—and moved south with a New Yorker who didn't realize how much of his or her wardrobe—furs, wool suits, lots of leather—would make no sense in the tropics. Now these things will make the trip back, for a second New York life.

But in February my highest priorities are not as easily defined as my fall shopping list might be. I'm looking for certain colors—cotton-candy pink, lime green or whatever is being trumpeted in magazines and store windows at that moment— but beyond that, spring/summer can be reduced to four loose categories: Summer Classic, Summer Kitsch, Summer Sexy and Cha Cha Cha. I *have* to have plenty of merchandise that serves

everyone from the "summer-house share" Manhattan twenty-somethings to the "Cape Cod every August" forty-somethings to the any-age "weekend in Atlantic City" crowd. But Hooti shoppers often have tastes that overlap these categories, making for a fashion free-for-all.

Summer Classic reminds me of my own childhood in Miami, where the "summer look" could be found pretty much year-round when the temperature was seventy or higher: seersucker suits, Bermuda shorts, anything madras—boy, I wish I still had the shirts Mom bought *new* for my brother, Mike, in high school—plus cotton shifts, capri pants and button-up-the-back crop tops. Every spring and summer at Hooti, the demand is constant, and I just wish I could find much, much more.

Summer Kitsch is a celebration of everything extreme and/or comical. Think kelly green double-knit golf slacks covered with yellow frogs, homemade dresses made out of beach towels and *anything* with appliqués. Remember Matt Dillon's wardrobe as a private eye/stalker in *There's Something About Mary*? The more outrageous the piece, the faster it seems to fly out of the shop. And a white belt can be the finishing touch.

Summer Sexy is how I like to dress on the hottest days of July and August. This can mean halter tops, slinky polyester dresses, lacy camisoles as blouses, strapless terry-cloth jumpers or short, short, short tennis skirts, from the seventies and eighties, in any

color. One thing is certain: These mini-minis will *not* be worn with modest tennis panties, because their appeal has nothing to do with a racket or a net. And sometimes, when I watch a teenager study herself in front of the Hooti mirror, all tanned legs and confidence and absolutely no cellulite, it's hard not to feel just a little bit old.

Cha Cha Cha is Ricky Ricardo waiting for Lucy at the Eden Roc Hotel bar on Miami Beach in the fifties, and it's ninety-five degrees outside. The style influence is often Cuban or Mexican, and I have a hard time finding enough men's guayaberas—those multipocketed, boxy, never-tucked, usually short-sleeved shirts that I first saw on the streets of Little Havana in Miami when I was a young girl. At Hooti I have sold at least a couple hundred in white and every shade of pastel and primary color, and I have no idea when this trend will end.

Finally, I am always on the hunt for summer pieces that, all by themselves, capture the flavor of a "summer" place: A neon-bright Lilly Pulitzer wrap skirt screams Key West or Nantucket, a crisp straw panama hat or fifties straw purse with 3-D woven-fruit detail suggests Nassau or Ibiza, and Hawaiian shirts and dresses say "Take me to the beach." At Hooti the tag might read: *"Gloria ordered a banana daiquiri and smiled at the pool boy . . ."*

By the end of my spring shopping at Flamingo, I'm beyond exhausted. I can't shop anywhere for at least another day or two. And I have bought so much stuff that when I'm unpacking back in New York, it's like Christmas, because I've forgotten what exactly I brought back with me. Occasionally, when I come

across a really outrageous piece, I'm filled with second thoughts, sure that I'll be donating it to another thrift store at the end of the season. Yet, invariably, those are the first things that sell. In vintage, summer is about "Let's go out and play."

～◌◌～

While I was in Miami on a short shopping trip in spring 1997, a longtime friend told me that the widow of Meyer Lansky had just died, and she wondered if I would be interested in bidding on the clothes once worn by Thelma "Teddy" Lansky, who had outlived her husband by fourteen years.

At the time I didn't know exactly who Meyer and Teddy Lansky were, but I knew that I *should* know, and I wasn't going to show my ignorance. "Sure," I said, confident that my parents would fill in the blanks about these people. I can't resist any chance to see the contents of an old woman's closet, especially a famous one, and when I saw the Lansky address—the Imperial House, Collins Avenue, on the Atlantic in Miami Beach— my heart started to race. For decades this was where wealthy New Yorkers and other "to hell with the snow" transplants had made their homes, alongside wealthy South Americans and Cubans, and many widows and widowers no longer able to do much more than creep slowly along the sand at the edge of the ocean.

"Who was Meyer Lansky?" I quizzed my parents, and for a few minutes they were back in the balcony seats of fifties and sixties Miami, recalling the years when the "Gold Coast" was sprouting outrageous new oceanfront high-rise hotels with

names like the Fontainebleau and the Eden Roc, when Art Deco buildings had yet to begin to crumble and you could still find perfect, unbroken sand dollars on the beach. Back then Meyer Lansky's name surfaced regularly in the news because of his alleged ties to Mafia legends in New York and Las Vegas, long before he would be the basis for a character in *The Godfather: Part II.*

The day I went to Teddy Lansky's condominium, I dressed as if money were no object, as if my father had built and still owned one of those big, fancy Collins Avenue hotels, even if it had fallen on hard times. The Lansky apartment was huge and pure sixties, rich with views of the ocean and as perfect as any Hollywood set for a movie starring Dean Martin and Sammy Davis Jr. The only thing missing was a fresh pitcher of martinis.

A nicely dressed older woman escorted me to each of Mrs. Lansky's two large walk-in closets and another smaller closet, and it was obvious that other potential buyers had already fingered the merchandise and left bids. I was given a few minutes at each closet to look things over—long enough to see lots of furs, Pucci, marabou and chiffon, all in garment bags—and velvet trays full of stunning costume jewelry, most of it marked with the best names: Weiss, Kramer, Marcel Boucher. If the estate included any fine jewelry, it wasn't being offered to me.

Once I had finished the viewing, I was asked, on the spot, what my offer was. I was ready with my reply, though not the one they wanted.

"I'm very interested," I said, "but I'll have to give you an answer tomorrow," knowing that this wardrobe wasn't going anywhere for less than $20,000. I knew I was way out of my league, that this time tomorrow all that I would own would be a mem-

ory of a place once occupied by the man the *New York Times* had called the "financial wizard of organized crime."

～⌒～

Most of my scavenging is a lot less dramatic, and a lot more productive, than a trip to the Lanskys' home, and wherever I go, my two-tone blue, rust-bitten GMC Suburban goes, too.

I paid $6,200 for the 'Burban several years ago, and I have put more than 120,000 miles on it since I first opened Hooti, packing the truck to the ceiling lining again and again as my shopping adventures take me all over New York, as far north as Maine and as far south as Key Largo. The 'Burban has seen me through hailstorms and black ice, subzero weather and the steamiest summer days, and I love my truck almost as much as I love the shop. Without it I could not be in business.

But early one Monday about four years ago, I left my apartment at 4:30 A.M., headed for a day of auctions in Pennsylvania. I walked to the parking spot just down the street from the shop on Berkeley Place, maybe twelve spaces from my front door. I stood there in the dark, with no coffee yet to jump-start my brain, my thinking slightly muddy.

"This is where I left the truck, right?" I ran through that mental double-check that happens automatically at moments like this. "This *is* an empty space," I told myself. "This *is* where the 'Burban *was*." Yes, I finally assured myself, she was gone, not just misplaced.

Suddenly I was very awake and thinking clearly. I grabbed my cell phone and I called the police, talking way too fast for four-thirty in the morning. The officer who took the report didn't

have time to commiserate—he just wanted the license-plate number—and he wasn't encouraging. I knew that my car was probably already gutted from bumper to bumper, the carcass sitting somewhere under a dark bridge in one of the darker corners of Brooklyn, and for a few minutes I hated New York City life.

I didn't call my insurance agent, because I didn't have theft insurance; in New York that would have cost more than the truck was worth. I did phone my friend Alexa—someone I knew would forgive me for calling at 5:30 A.M—and she met me on a street corner in her PJs to hand off the keys to her Toyota SUV. Work must go on, Suburban or no Suburban. But for the rest of that day, every hour on the hour, I called the Brooklyn towing yard, hoping and wishing my truck would be found.

Twenty-fours later I still wasn't ready to concede anything, and I was going to do *everything* I could to get the 'Burban back. Ridiculous as this sounds, I jumped on the subway for a trip to Canal Street in Manhattan. I needed to buy a good-luck charm—and I ended up with two, a carved Chinese stone on a red silk cord, which I wore around my neck, and another little Asian stone I put in my wallet.

Four days later, at 8:15 A.M. on Friday, the phone rang in my apartment. I was still in bed, half asleep and screening my calls, when the message machine kicked in: "Hi, Alison, it's Joe Rodriguez. Someone has found your truck—" I leaped out of bed while he was still talking, grabbed the phone and started screaming with joy. Joe is my insurance broker, and someone had just called to tell him my car had been found. Found? Yes, he said, and I better get myself to its dumping ground in East Brooklyn as fast as I could. It wasn't the police who had the car, so it

hadn't yet been towed to the pound. And he had no idea what its condition was. No time for a shower; I threw on my old jeans, some perfume, a little lipstick, and I was out the door. You never know who you're going to run into, even on the other side of Brooklyn.

Two city sanitation workers whose full-time job is removing graffiti apparently were the first people to notice the vintage lace slips spilling out of a straw basket in the back of my truck and blowing down the street, each with a Hooti Couture tag already attached. But what sealed the deal for the guy who finally made the call to my insurance company was my Montauk bumper sticker. His love for the beach town made him look inside my car, where he found my agent's name and number. Then this *saint* walked a block and a half to find a pay phone.

The thieves' primary target appeared to be the truck's "barn" doors, a rather charming name, I think, that describes one of two options that are offered for the back opening of Suburbans. Barn doors open out, not up and down. It seems the guys who wanted my doors didn't need vintage lingerie or my brand-new set of Pirelli tires, but they did take the side mirrors, hood ornament and two batteries. It could have been a whole lot worse.

I had the 'Burban towed to my mechanic, and then I went shopping for a new pair of doors.

Just like Hooti merchandise, my barn doors might be old, but they still had plenty of value—as I learned with calls to a few area junkyards. The going price was $500 a door, with rust. No way was I paying that much. Why would I hesitate to spend $1,000 on my car—resolving a problem quickly and easily—if I'm so willing to drop $2,000 for an Hermès jacket? Sometimes

I have a hard time explaining that, even to myself. But more than anything I love the challenge of finding a great deal, no matter what it costs me in time and energy. Some people are die-hard seekers of vintage Chanel; I'm always on the hunt for the ultimate bargains.

So, again borrowing Alexa's SUV, I went to the next Pennsylvania auction. My truck might have been out of commission, but my store was still open and needed new goods. At the auction I kicked into major vintage-networking mode, explaining my barn-door predicament to a few folks who know me. And that's how I heard about a giant junkyard northwest of Allentown, another two-hour drive away.

"Ask for Porkie," my informer said, handing me the name of the junkyard and the area code. He didn't have the phone number.

I didn't have time for a total boondoggle, so I tracked down Porkie's number and called. I had to know that this trip would produce results. Porkie was the one who answered the phone, but he wasn't much for conversation. "I got barn doors," was all he said.

"Are you really sure you have barn doors?" I asked for the second time, sounding pushy, I'm sure.

"Yeah, lady, we've got something for you."

"Porkie, I'm on my way," I said. "My name is Alison. What time do you close?" They shut the gate at four-thirty, and I assured him I'd make it in time. "Please don't leave without me," I begged.

"Yeah, lady," was all he said.

He'd better have something for me if I was going to drive two hours.

I finished my auction shopping and packed my friend's truck, leaving the roof rack clear to haul my doors. Porkie and I had a date.

At 4:00 P.M. I walked into the junkyard office in the same outfit I'd worn to the auction: leopard-print leggings, a fitted knit sweater and a fifties leopard scarf tied in a big bow around my neck. Old black, pointy-toe cowboy boots completed the outfit, perfect for protecting me from any junkyard snakes.

I smiled at the three-hundred-plus-pound fellow sitting on a stool behind the counter, and I could only think of one thing to say: "Are you Porkie?" trying not to giggle. He nodded. "Yeah."

"I'm Alison, the girl who called about the barn doors."

"Yeah. My brother's going to drive you around the junkyard."

With that, as if on cue, a guy about half Porkie's size, trim and weathered, walked into the office, and off we went in his pickup to scour a ten-acre graveyard of weed-infested cars and trucks. Joe *was* a talker, and he wanted to give me a grand tour of this car lot from hell, with dent-by-dent details of some of the most gruesome wreckage. "That one, the guy got hit by a train," Joe said, wanting to stop and show me the actual bloodstains. I tried to be pleasant but firm—I knew I had almost a four-hour drive ahead of me. I oohed, I groaned, I expressed sadness with every new story of metal mayhem, but all I really wanted to see were his Suburbans. And I didn't need to know anything about how these trucks and their barn doors had found their way to Porkie and Joe's place. For once, the less history that came with this vintage purchase, the better.

Joe eventually showed me five sets of barn doors, occasionally having to kick away heavy brush before I could get close enough to examine their condition. I looked at each pair—all of them were hurting, with dents, rust, missing hardware, broken glass—the way I'd scrutinize a python purse or a silk kimono. But I could not stomach the thought of canary yellow doors on my blue car—so I went right by those. When I finally chose a two-tone brown-and-tan pair with all their hardware and only a tiny bit of rust—okay, none of the colors were great—I asked for a price. Joe cocked his head, thought for a second and then spit out, "Seventy-five dollars."

I was confused.

"Seventy-five per door?" I asked, certain that's what he meant. "Oh, no," Joe said. "That's for the two."

I was thrilled. Then I remembered I needed side mirrors, too. "What would the side mirrors cost me?" I asked.

"Those are on the house," was Joe's response. Now I was feeling guilty that they weren't making any money, because some of the cars in this lot had been there so long I couldn't see the hoods.

"That's okay," I said. "I really want to pay for them."

"No," he insisted. "They're on the house."

I had found Pennsylvania's ultimate hidden treasure.

Joe went to work, armed with a pneumatic wrench. In less than six minutes, he'd unbolted the doors and popped them into the back of his truck. In another two minutes, he'd removed the pair of mirrors—which cost more than a hundred dollars each, new—and we were headed back to the office to settle up and move the doors to the roof of the SUV.

Porkie and his brother had delivered what Porkie had promised over the phone, and I wanted to give them a tip for their good service. They wouldn't hear of that. What role did fresh lipstick and leopard leggings play in such a great deal? Not much, probably. But maybe the two brothers shared a good laugh about my outfit. I'd like to think so.

Building a life around things that other people have passed by—or written off—is something that Henry (my homeless errand runner/jack of all trades) understands all too well. So I shouldn't have been surprised when he gave new meaning to the word "hunting."

I had taken him with me on a day trip to Pennsylvania because I needed help with some heavy pieces of furniture I was hauling back to the city. It was a highly productive day, and the 'Burban was packed to the ceiling as we headed toward Brooklyn. Still way out in the country, on Route 78, Henry spotted a dead deer by the side of the road. A huge deer with antlers.

"Alison, pull over. We have to stop," he insisted as we were flying along at seventy miles an hour. "We gotta get that deer."

"What?" I said, foot still on the gas and not believing my ears.

"I can sell that deer in Brooklyn and make a lot of money."

Henry was serious, and he explained confidently that the two of us could tie the thing to the roof of the Suburban—as if the weight of this carcass were my only concern. A *New York Post* headline, over a graphic photo, flashed before my eyes: FORMER MODEL SELLS ANIMAL PARTS. IS SHE DEAD MEAT?

"No, Henry," I said. "We are not bringing a dead deer back

to Park Slope." His stony sulk filled the truck for the rest of the way home.

Once, though, I did bring something back to Brooklyn that was almost as forlorn as that animal's body and had once been just as beautiful as that deer when it was alive. One of my favorite Pennsylvania auctions had just ended, and I was hauling all my new purchases to my truck when I noticed a piece of fabric laying in a mud puddle.

I looked closer and realized that the muddy mess appeared to be a full slip that had fallen off some seller's table. The sellers were long gone, so there was no one to even try to return this to. I threw the sodden glob into a plastic bag, dropped it on the floor of the truck and started for home.

Back at my apartment, I stuck the piece in a bucket of water with Biz, my favorite stain fighter for my most troubled pieces. I left it to soak it for about three days, throwing out the filthy water several times and watching with disbelief as my newest find emerged. What I had rescued was a gorgeous full-length silk gown, probably from the thirties, with lace trim and a fishtail hem, the kind that sort of wiggles along the ground behind you as you walk, the kind Norma Desmond could have worn in *Sunset Boulevard*. And once thoroughly washed, the gown showed itself to be in near-flawless condition.

Within a week of going into Hooti, the dress sold for $75, but that detail is insignificant. It's the conversations that were launched by women of various ages who, for just a moment or two, were reminded of another time in their lives or of a time before they were born. This dress, with its perfect balance of elegance and sexiness, had struck a chord.

I don't always have a chance to talk with customers about their purchases, beyond a simple pleasantry or two, and if customers don't want to talk, I never press them. Unfortunately, I don't remember anything about the person who bought this gown, but I wish there had been one more conversation before she—the gown—was gone for good. I do hope she was worn again.

~∽⌑∾~

I stood in the doorway of the little vintage clothing store on Twenty-fourth Street in San Francisco, and already I could feel the adrenaline pumping, as if I were about to meet a blind date whose résumé promised a cross between Pierce Brosnan's James Bond and Ethan Hawke straight from the set of *Before Sunrise*.

I had come to Guys & Dolls for two reasons: I'm always curious to see how other vintage sellers run their businesses—how they display, what kind of pricing and tagging they have and which product categories are a priority within their space. And, just as important, I need to see if there's anything I can't live without—something that makes me feel beautiful, sexy or even outrageous, while helping me sell my vintage message at Hooti and anywhere else I go. I don't wear or carry something vintage *every* day of my life, but the totally no-vintage days are rare.

I have left many shops empty-handed, because of ridiculous prices or tired merchandise, but almost instantly my inner-vintage voice told me that wouldn't be the case today. First, there was the matter of leopard. Guys & Dolls has leopard-print carpet on the floor and leopard-print velvet curtains on the dressing room. The owner and I must be kindred spirits, I

thought, bound by a passion for swirls and spots of black, tan and orange.

A quick glance at a few tags told me the shop's prices were comforting, too—every bit as affordable as Hooti's, if not more so. And even though the owner had sprinkled several new vintage-style items in among her old pieces, she had done it right. The store, small as it was, had as much electricity as any Emilio Pucci purse or silk undies. And while most of the labels reflected West Coast designers and stores, the merchandise was classic vintage, as likely to have been discovered in a Seattle attic as in the barn of a Virginia horse farm. I was in heaven.

Was that the owner behind the counter? Maybe, but we hadn't made eye contact, so an introduction could wait. I wanted to shop first and talk shop later.

I headed straight for the first thing that caught my eye, a rack with maybe thirty beaded sweaters, suits and jackets, all carefully marked as to condition and estimated size. I started pulling several suits that might fit me, and as I oohed and aahed, Graciela Ronconi, wearing a hand-knit orange-and-green fifties poncho-like jacket, watched this feeding frenzy and smiled. Finally I introduced myself as a fellow shop owner from Brooklyn who also loved leopard and was ecstatic to have found her shop. We chatted for a few minutes, but when a young woman came into the shop to buy a pair of fifties eyeglass frames she'd seen earlier, I resumed my hunt.

The first suit that worked was a camel-colored forties gabardine, a bit worn, but a near-perfect fit, though not for long if I picked up even three or four pounds. I particularly loved the amber-colored buttons and the lines of the pencil skirt, which

had an unusual small centered pleat. The satin label was a new one for me: "Tailored by Saks of California." Despite a small hole on the front of the jacket, near the hem, this would be a great weekend outfit for the shop. The price: $85.

Next came a very unusual chocolate-bronze forties suit with embossed flowers in the same color. The satiny fabric, something that could easily work for day or night, was in good condition. This outfit had two labels, one for the shop that sold it—"Nelly Gaffney, San Francisco and Burlingame"—and one for the designer—"Coppola Designs, Deitsch, Wersba & Coppola." Again, I had never heard of these folks or the store. But I loved the details: champagne silk lining and the jacket's six original brown faux-crystal buttons. Overall condition: very good. Price: $88.

The next suit—I was a little out of control at this point—had been "Styled by Gino, Ridge Park Fashions, Inc., New York City." Whenever I see a label like this, I can't help but wonder: Was there ever a real Gino or Dino, or did some company simply think that an Italian name would add cachet to its brand? The suit had wear and tear, but I could see past that because the "look" was irresistible, especially the three-quarter sleeves with winglike cuffs and the most distinctive little hip pockets that were just big enough for a very small hankie. Each pocket was trimmed with two V-shaped flaps that were topped by a short vertical row of gray buttons. The skirt was not quite a pencil shape; all the lining was a blush-colored silk. Price: $78.

As I laid the must-buys on the counter, Graciela began to write up my purchases, generously knocking ten dollars off each suit, though I had not asked if prices were negotiable. Then I

spotted what was probably my best vintage purchase of 2004, a coat-and-dress set in three shades of gray with a "Lilli Ann Knit" label. Lillian Schuman had started a design company with her husband, Adolph, in San Francisco back in the thirties, and for decades they produced many beautifully detailed pieces, particularly wool coats and suits, often trimmed with fur. Their work has aged well and become a still-affordable collectible. But when customers first asked if Hooti had any Lilli Ann, maybe a year ago, I didn't know who they were talking about. Now I'm always on the lookout, especially for her forties and fifties designs. But this outfit is newer, probably mid- to late sixties, and it is as elegant as anything I've ever touched in a double-knit.

What gives this design its drama is its simplicity and its fur: A six-inch band of pale gray fox cuffs three-quarter bell sleeves on the coat. But these aren't just any sleeves, because the underseam has been left unstitched—giving the sleeves a capelike flow when I walk. The solid gray collarless dress—with the slightest A-line—buttons all the way down the front and is finished with a contrasting band of darker gray fabric around the bottom— the same dark gray as the outer coat. The pockets are hidden in the seams, so there's nothing to distract from the clean lines, beyond four big ridged gray buttons on the dress.

The minute I put it on, I felt like a sixties-era couture model, ready to walk the walk. And I knew that the minute the temperatures plummeted for the first time in Brooklyn, I would be out and about, happy to share my new vintage find with the world.

Graciela's price: $140, discounted to $125.

My shopping—for me—was done for this winter. No matter how hard I hunted, I knew I could not top this.

⌐◦◦⌐

Six weeks after I found my Lilli Ann, it was twenty-five de-
grees out the night she made her neighborhood debut.

My girlfriend Jay and I had planned a gotta-catch-up dinner
at a favorite Italian restaurant in Prospect Heights, and I'd been
dying to give the coat and dress a "test drive"—to see what ac-
cessories would work best with it—and if any alterations were
necessary. I paired the outfit with black Ralph Lauren
equestrian-style flat-heeled, knee-height boots, and for extra
warmth and one more shot of pizzazz, I added leopard-print,
rabbit-fur cuffs at the top of the boots—a nice counterpoint to
all the gray. I finished the look with a tiny new faux-mink purse
with a Chanel-style chain and a large black-mink pin on the
dress, completing the black accent that had begun with the
boots.

Early for our dinner reservation, Jay and I stopped first at
Pieces, a hot boutique on Vanderbilt Avenue that's owned by
one of the most stylish couples in Park Slope, Letitia and Calvin
Smith. I know Letitia through mutual friends, but we've never
had time to talk business or clothes. Tonight, in an instant, that
changed.

"I need that coat you're wearing right now," she announced,
laughing as she, Jay and I all took a few moments to savor my
slice of the past. Then Letitia got serious: "How much is the
coat? When are you putting it in the shop?"

I smiled and shook my head. "This one's not for sale," I said.

What Is Style Anyway?
Spotting Trends, Disasters
and the Always Classic

The most elegant thing I own once belonged to a woman named Helen O'Shea Romer, who was born in 1910 and lived to be eighty-three. Helen was the mother of Dan Romer, an artist who lives in Brooklyn and has been a customer since the earliest days of my business.

The full-length fishtail gown, which dates from the thirties, is a rich persimmon, and the fabric is either silk crepe or something similar; there are no tags, and I never pretend to be a fabric expert—that's a tricky business with old clothes. Dan can't remember his mother wearing this dress, because he was the last of her five children and she had stopped wearing it by then. But she never let it go, and when his mother died, Dan took it because none of his sisters wanted it. Then one day he came into the store and gave me the dress, because he thought I would look good in it and because of our friendship, which was based on his passion for anything vintage. It is one of the most touching gifts I have ever received, from anyone.

The most elegant detail, besides the fabric, is a belt of the same material. It starts at the front, wraps around the waist and meets again at the front, cinched in place with a jet buckle encrusted with rhinestones. In every way this is a dress that is timeless, as stunningly stylish as it was the day Helen Romer brought it home—though I have very few occasions in my life that are as elegant as this dress demands. But I have worn it once—somewhat inappropriately—and I will never forget the response. The New York Daily News was sending a photographer and reporter to Hooti for an article on the favorite vintage shops of a Hooti customer they were profiling. I decided to really dress up for the occasion and wore the dress for the photo shoot. What ran in the paper was me, in the dress, shot from the back, so there was a lot of derriere, and Mrs. Romer's dress accented every curve.

A few days after the article appeared in the paper, the phone rang and a male voice asked, "Is Alison there?" Yes, I said, I'm here. A short while later, two forty-something men—city employees who might have been on a lunch break—came into Hooti and asked if the woman who was in the photo was in the shop that day. I laughed, a bit perplexed, and said I was that woman. They stared hard, and then one of them pulled out the newspaper clipping and held it up. "Yeah, that's you," they finally agreed. And then they asked me to autograph my picture, proving that this dress might be seventy years old, but it was still as sexy as ever.

I first met Ginia Bellafante in the early days of Hooti on Berkeley Place. At first I had no idea who she was, just another thirty-ish woman who would frequently pop into the store in jogging clothes on her way to—or coming back from—a run in Prospect Park. Occasionally she bought things, usually pieces

that made a sophisticated, early-sixties statement. She seemed curious about the shop—its history, my background—and we would chat for a few minutes if Hooti was quiet and she wasn't in a rush.

I only knew her first name—but I never seemed to pronounce it correctly. And there was one other curious detail from those early encounters: More than once, she questioned a low price I quoted her with "Are you sure?" or "That's too inexpensive." That seldom happens in retail, but I didn't give the comments much thought; I just assumed she was more accustomed to pricier Manhattan stores.

Eventually, as conversations became more comfortable, we often compared notes about fashion. Then one day I asked, "What do you do?" With vintage aficionados, you never know what the answer is going to be. "I write for the *Times,*" she said. I was surprised and intrigued, but I didn't want to get too nosy. "Oh, that's great," I said, never even asking what she wrote about. But now the questions about my pricing seemed to make more sense; I assumed she didn't want any "favors" just because she worked for the *Times.* Fat chance, though, since I had never made the connection.

One day in 2001, she came to the store in a hurry and armed with a notepad. She had no time for shopping. "The story is about Fifth Avenue, but I need to get you in it," she said. Fifth Avenue was the new Brooklyn hotspot for food, fashion and cocktails, so I understood why she was writing about that strip. But my shop was two *long* blocks away from it. I was a bit confused, but flattered.

Ginia's deadline was the next day. We talked, fast, and I just

hoped what I was saying sounded interesting and made sense. I didn't want to let Ginia down, and I knew that the publicity would be invaluable.

The following morning I raced to the corner market for the paper. Flipping through the pages nervously, I finally found Ginia's story on page B11. And there, in the second paragraph of a large article with multiple photos of vintage stores on Fifth Avenue, were words I will never forget: "Fashion as it is practiced elsewhere in New York City did not seem possible in Park Slope until Alison Houtte arrived on Berkeley Place in 1997 with a vintage-clothing shop called Hooti Couture."

The article had very little to do with me, and there were no photos, but that was okay. I had just been given a sweeping seal of approval by a *New York Times* writer. I read the paragraph at least ten times, a bit overwhelmed and giddy, too. I called Mom and Dad and read the paragraph to them—and they asked me to reread it at least three times. Then I called my friend Gigi, who had already seen the piece and was ready to be her usual wiseguy self: "Oh, I didn't know *you* brought fashion to Brooklyn."

This was not the first time Hooti had been mentioned in the *Times.* A devoted customer named Senta Sundberg—the owner of the most remarkable vintage wardrobe I'm aware of in Park Slope and one of those rare people who knows how to dress in vintage from head to toe—had been quoted naming the store as one of her vintage resources. And Hooti had gotten a passing mention when I was interviewed for a piece on recycled furs. Both items were great, but this was something else: public recognition of the niche I'd carved in Brooklyn, a priceless endorsement for Hooti Couture. I'd never even dreamed that

something this big would be possible and that my career would be so satisfying in so many ways that my life in front of a camera had not been.

At this moment though, reality set in: I had to get to work, to make sure Hooti was everything it could be when I opened the doors that morning. But first I had to get dressed. Today I needed just the right killer vintage outfit—something that wouldn't disappoint Hooti regulars and any newcomers who had seen the article and made the trek to Park Slope. I wanted to make sure that both Hooti and I lived up to the hype.

Whenever people ask me to define what style is, I struggle, because I don't have a good, easy answer. But they don't ask me that question very often. What they ask is "Where did you get *your* style?" I always answer, "My mom, I think." And then I quickly add, "My style changes almost daily."

For me style is about wearing what you love and what makes you comfortable, and feeling comfortable with using clothes, new and old, to express your personality. It can be a stunning seventies off-the-shoulder silver-sequined blouse, paired with large chandelier earrings and new Seven jeans. Or the look of my customer who's an assistant district attorney: For years now her work suits have come from the forties and fifties, not because they might be trendy but because they just seem to match her personality. And so do the vintage jewels she wears with them.

Style is often linked to the hottest designers of the moment—especially when a person has a "money is no object"

attitude—but, of course, lots of money does not guarantee good taste or a sense of style. And style can be elusive, even for those of us who spend a great deal of time thinking and talking about it. There are days when I think I've done a good job of creating my look, and then a few hours later I'll catch myself in a full-length mirror and flinch. It might not be "bad," but in my mind it doesn't quite work. And that may be because of something as simple as the fact that my shoes are killing my feet or the colors aren't what I saw in the morning light or my mood has changed from whatever it was when I first dressed.

I love studying snapshots of celebrities in *People* magazine and the best Bill Cunningham "On the Street" photographs in the Sunday *New York Times,* because they offer a quick and often entertaining glimpse of personal style, good and bad. When five people are photographed wearing the same suit, dress, coat or sandals, I'm glad I'm not one of them. And I'm ecstatic when a $20 vintage Mexican skirt looks as appealing as the newest Kate Spade interpretation of such a skirt, if not more so.

Just as I relish any story about someone who has created his or her own notable look without the help of a stylist, I'm always on the watch at Hooti for customers wearing a mix of clothes and accessories that I've never seen before. Often their style works because they are clever, creative and risk takers, women and men who aren't intimidated at the thought of expressing themselves through what they wear, even though mistakes may be made. I also like to think they are smart about money, whether they have a little or a lot, but I know that's not always the case. I am sure though that they share one goal: not to look like everyone else walking down the street or into a restaurant.

❧

The 2001 *Times* article wasn't the last word from Ginia about Hooti Couture. Her passion for vintage—one silvery blue brocade cocktail dress she bought at Hooti has been to six different weddings—became an August 2003 feature story about Park Slope vintage stores.

This time Ginia called the shop instead of stopping by. "I've got something really good," she said. She was writing about her favorite vintage destinations, and she wanted to schedule time for an interview. I was ecstatic. Then, immediately, I started weighing the *big* question:

"What am I going to wear?"

Any other details could come later.

I treated the interview like the ultimate casting call. I did "full hair and makeup"—model talk for being camera-ready. I wore one of my favorite dresses, a fifties turquoise cotton with white polka dots, and paired it with gorgeous turquoise and lime green kitten pumps with netting over the toes, handmade in France and found seri-ously marked down at a shop in Manhattan's meat-packing district.

My preparation for the interview seemed to pay off—Ginia loved the dress and wanted to know where I'd found the shoes—though I'm sure I appeared a bit manic at 11:00 A.M. after three coffees and no food. An hour and a half later, after talking about everything

from my childhood to life on the runways to Flatbush Avenue, over even more coffee, my dress was damp with sweat. I'd never had to talk that long knowing that *everything* I said could make it into print. As we were wrapping up the conversation, my mind began to whirl with self-doubt and second thoughts. What did I *really* know about vintage clothes and running a business? Had I said too much? Did I really have *anything* to say? Did I talk too fast? How would Hooti look in print? Did she notice I was sweating? For the next week, I would find plenty to rehash in my mind.

The following Friday, stripped across the bottom front of the Weekend section, there I was, in color, with a customer swathed in old mink. The article focused largely on Hooti and me—not on Ginia, as I had expected. Inside, there were more photos of the shop and customers. The phone rang maybe fifty times in the first hour that morning, mostly calls from friends who were as thrilled as I was. The rest of the day was a blur, especially after I broke open the first of six bottles of champagne at the store, sharing it with my sister Jennifer, who was in town because her daughter was just starting college, and Hooti customers who happened by between six and eight that night, to shop or just offer congratulations.

That weekend was chaotic—some came to shop, some came to stare—and it was all I could do to keep merchandise on the racks and chat with every customer who had seen the story and wanted to share in the good times. And even months later a new customer would come into the shop and say she was there because she had seen the article. Every time that happened I was thankful for one customer whose jogging path took her right by my door, whose

style was a match for how I defined style, whose idea of fashion includes old, not-always-perfect clothes and accessories.

❦

When I say that my style changes daily, that's because I love to play with my "look." Sometimes I walk into the shop wearing one outfit and leave wearing another, either because I'm bored or because I saw something in the shop that I love more than the sweater or jacket that came through the door with me a few hours before.

Also, I thrive on surprising friends and customers with my latest combinations of old and new, even if they don't always work equally well. Sometimes, however, my experiments are total style disasters, though I don't realize that until the end of the day, or days later, when I see photos and wonder, What possessed me? What mood was I in that made me walk out the door looking like a stuffed sausage, because I had added a tight belt to an already tight dress? Right then and there, if I were still in Catholic school, I would be made to write a hundred times, "Less is more. Less is more. Less is more."

I can never forget an outfit I concocted for an informal champagne party in front of the Berkeley Place Hooti, maybe a year after we opened. I wore a dress that truly sashays—a new Norma Kamali thirties-inspired black silk-fringed sheath that moves with every step. I found it at Century 21, marked down from $700 to $69.99. Maybe I felt compelled to accent the Kamali with a touch of vintage, maybe I was simply hungry for a major dose of attention. I can't remember. But something kept me from letting this dress be the showpiece, something made me

turn this little sidewalk get-together into a scene from *La Cage aux Folles*. I chose a black hat with a veil and a two-foot feather sticking out of the top, plus heels and heavy rhinestones for my jewelry. When customers told me they could see me from the next block, that should have been a clue. Then I saw pictures a few days later, and I looked ridiculous.

The Norma Kamali dress is still in my closet, and I recently loaned it to a friend who needed something elegant, but the feathered hat is history. And I now apply a fairly strict rule to hats: Horse races and weddings are acceptable destinations; anywhere else, I should be fined!

Sometimes, though, as with my Delano Hotel appearance in a slip dress, I'm just like so many of my customers, male and female: We're not really sure if something works until we have at least one vote of approval.

A couple of years ago, a Hooti customer who works at *People* magazine invited me to a season-premiere party for *Sex and the City*—a show that was almost more about clothes than about sex. This much I knew: The "competition" would be stiff—after all, a fashion legend, designer and vintage guru Pat Fields, was the stylist for the show, doing more for old clothes in one TV season than any other person in Hollywood or the fashion industry ever had. I had to look sensational. I began mentally cataloging my closet's party gear, sorting anxiously through my options and growing confused about the "perfect" statement, as if there *were* a "perfect" answer. What was I going to wear? *What was I going to wear?* The ultimate social dilemma, no matter how many clothes you own or have ever touched.

The black-fringed Kamali, sans hat, would have been perfect.

But sometimes a girl just has to go shopping. My good friend Gigi—who considers herself my personal stylist—dragged me straight to Bendel's, and that's where we found a Shoshanna Lonstein camouflage-print, one-shoulder, fitted chiffon dress with an angled hem finished with a scallop. "You've got to get that dress," Gigi ordered, and I agreed, paying full price, $168, I think. Okay, camouflage. Bare shoulder. Scalloped hem. There's enough going on here, right? Wrong. In hindsight, I know I got a little carried away with the rhinestones.

When my friend Brian and I arrived at the party, I was feeling two things: fabulous and scared. I was surrounded by all these gorgeous, dressed-to-the-nines celebrities, and my confidence was evaporating faster than cheap nail-polish remover. Then I spotted a woman I knew from the eighties, a model who is now a successful television actress. She was dressed in jeans with a sexy blouse; she looked great in that casual L.A. sort of way. But something in her face told me all was not well. I was right.

Her first comment to me, after we made eye contact, said it: "Nobody told me it was dressy." And then, without another word, before I could weigh in with something even mildly reassuring, she walked away.

Her anxiety was contagious. Suddenly I felt like a Christmas tree at an Easter pageant—out of my league and permanently robbed of all Manhattanite style sensibilities after so many years in Brooklyn. It was as if every one of my worst mistakes—about clothes, about men, about food—was flashing on a supersize, flat-screen TV for everyone at this party to see. Sounding just a bit melodramatic? Yes, but this *is* what I was thinking as I scanned the crowd.

Then, out of nowhere, a very tall black man walked up to me, and I knew who he was, though he didn't know me. All he said was: "Now, that's what I call a fabulous dress." In that moment I was no longer at a *Sex and the City* party—I was living a scene lifted straight from *Sex and the City*. I was one of Carrie's coolest friends, standing nervously at a party by herself, waiting for some kind of attention to be paid to her. "Thank you," was all I could say, beaming.

My friend Brian, who was a few feet away, came running up to me.

"Do you know who that was?" he asked, certain that I did and curious to hear what had been said between us.

"Yes," I said, trying hard to be cool but acting more like the giggly eighth-grader I once was. "I do know who that was."

André Leon Talley, *Vogue*'s larger-than-life editor at large, editor in chief Anna Wintour's man-about-the-world, had just given his blessing—at least to my dress, if not my total look. That was more than enough.

~⦿~

I always figure that Grace Kelly was one of those rare people who never had a moment of self-doubt about her style. The same goes for Audrey Hepburn. And it's obvious they shared many common, classic tastes when it came to fashion. The one I'm most familiar with is an Hermès alligator purse like the one I once considered purchasing at the Paris flea market.

The specific design dates back to 1930, but the purse was re-named for one of its most famous owners, Kelly, in 1959. The

style is still highly valued and often copied, so I wasn't surprised when I saw an item in the *New York Post* in the summer of 2003 about Audrey Hepburn's black Hermès Kelly purse selling for $16,000 at an auction. But I *was* surprised later that year when I spotted a black Hermès alligator Kelly in a Miami Beach vintage store and discovered that the owner had a $5,000 price tag on it. I wanted to kick myself, again, for not buying an old one the first time I had the opportunity in Paris. Back then I was drawn to the purse simply because so many smart Frenchwomen favored it. It took me a while to realize that this purse is one of those rare items that never loses its appeal and is truly timeless.

Fortunately, there are a few other things like that in vintage—Stetson cowboy hats, any suit or sport coat made with Scotland's Harris Tweed, a single sixteen- or eighteen-inch strand of pearls, Levi's 501 jeans—that are a lot more affordable and easier to come by. I love having these at Hooti, but they never last long.

Daisy Lewellyn and Love Collins park their car right in front of Hooti and step onto the street with a Beyoncé-like sass and style. In fact, they are roommates and best friends since kindergarten, women who started shopping Los Angeles flea markets when they were barely teenagers, looking for a way to make a statement when they weren't wearing Catholic-school uniforms. Both are passionate about clothes, and whenever they're shopping in Hooti, it's hard to ignore their banter and joy.

Love's Afro is huge, and today she has left her vintage at

home. Her legs are strutting four-inch wooden platform heels with baby blue ribbons wrapped around her ankles. A pair of khaki hot pants, rolled up for just an extra bit of shortness—she has legs of death—and a white fitted T-shirt complete the look.

Daisy is wearing a powder-blue Lacoste shirt and a Lilly Pulitzer A-line skirt, both seventies-era, and sandals, practical clothes for a day of store hopping.

Daisy and Love have been Hooti customers since the summer of 2002, right after they graduated from Howard University and moved to Brooklyn. They are the kind of customers any vintage-store owner would love, so devoted to old clothes that they can still recall their very first vintage purchase years ago, a joint buy because they both wanted the off-the-shoulder poly-ester dress with a circle print in orange, yellow, black and white.

Now they both have jobs where they are surrounded by clothes: Daisy is a fashion market assistant at *Glamour* magazine, and Love is a clothing designer whose label carries her name. So their passions just naturally seem to fill the room every time they step into Hooti, raising the energy level by at least 50 percent.

At this moment the shop is kind of quiet—the customers are intent on the racks, not conversation. Suddenly Love starts screaming out loud and runs toward the first item on the fur rack—a hand-knit, gold lamé sweater I've just bought from another customer. I love this sweater, but I know the shop needs it more than I do. I always try to have at least a few "Where did you find this!" conversation pieces, items that are memorable for their beauty or singularity, and this sweater is unlike any I've ever seen. Attached to each sleeve, running down the arm, are about a half dozen mink tails, each about four inches long. The

price is $95 because half of one tail is missing, not really obvious but still a flaw.

I mention the tail problem to Love, but she's not hearing me. Nothing is getting between her and this sweater.

She immediately slips it on over her T-shirt, and Daisy immediately proclaims the total look—sweater, hot pants, platforms—just right for an event they're attending that night, Kimora Lee Simmons's Baby Phat fashion show. The place will be thick with everything from the latest hip-hop to Louis Vuitton, but they are both certain no one will have a sweater quite like this.

As Love continues to admire her find, she briefly breaks into joy-induced tears—as emotional about her outrageous vintage find as some folks are about an evening of Julia Roberts movies. By now every other customer in the store has stopped shopping to see what else Daisy and Love will dig from the racks. That's okay. A little drama means Hooti shoppers all leave with a story to tell, even if they didn't find something for themselves.

Soon, Daisy strikes gold, as in gold brocade. The suit is slightly outrageous, something I would describe as "Ivana Trump goes to a wedding." The shiny fitted jacket has three cluster-pearl buttons and elaborate beading on the pockets. It looks like it has never been worn, and if it has, the outing was a tame one. The label reads "Rickie Freeman for TJ Nites," not a brand any of us knows. In fact, I later learn, this designer has been carried by Neiman Marcus and Saks Fifth Avenue, and her line originated in the early eighties. So this is "vintage" in just the broadest sense. It could have been worn by a fastidious mother-of-the-groom in 1985 or 1990 or 1995—the cut gives little hint of an exact age. But most of my customers don't put

too fine a point on what's "vintage"—they simply buy and wear what they like.

Daisy knows where she's going with this outfit, and it's probably not exactly what the designer had in mind.

"Is there any chance I can get this without the skirt?" she asks.

I seldom split matching pieces, but in this case the value is in the jacket, not the skirt. And it isn't Yves Saint Laurent—this isn't sacred ground we're crossing. In my vintage world, there are few rules, and I'm happy to break them whenever possible. And, most critically in my book: Daisy will give a fresh twist to this jacket, forgoing a blouse so she can show a little skin, pairing it with jeans and finishing the look with Christian Louboutin open-toed heels. Wedding apparel? Not on her.

As I wrap up their purchases, I insist that they come back to the store as soon as possible. I want a *full* report on the evening's adventures, a hat-to-boot snapshot of all the best looks. I'm confident that theirs will be among them.

I love seeking out merchandise for my male customers, because their vintage style generally leans more toward classic pieces, and most of what I buy will find its right match eventually. Men account for maybe 20 percent of my customers, and my stock is usually limited to two hanging racks of suits, shirts, blazers, trenches and leather jackets, plus a handful of hats, assorted cuff links and maybe a half dozen pair of shoes. I stock velvet and satin dinner jackets and old tuxedos whenever I can find them—but I suspect that many men never give away a tuxedo once they've made that commitment, even when there's

no chance in hell that they will regain their once-prized size-thirty-four waist.

One busy Saturday six men came into the shop together, led by one of my regular customers, a tall, handsome, twenty-something guy with a great name: Shawn Sharp. The first time I met him, I instantly knew his name because it was spelled out in the little diamonds on a dog tag hanging around his neck. Since then, every time he stops by Hooti, I find myself studying his style, especially the time he came into the store wearing a vintage seventies suit with a fitted white hooded sweatshirt underneath. His shoes are often impeccably white, fresh designer sneakers.

This day Shawn and his buddies, all dressed in the usual street attire of jeans and warm-up jackets, and all under thirty, needed make-a-statement blazers suitable for club hopping. Think Frank Sinatra meets Shaft, but *their* inspiration is musician André 3000, an artist who loves vintage.

I had maybe two dozen items on the rack and another half dozen that I brought up from the basement—mostly sixties and seventies, plus a few early eighties, in everything from tweed to polyester. I also pulled out my tape measure, because that's an essential tool when Shawn Sharp is in the shop. Shawn has long arms, so long that all his vintage jackets need alterations. He's become savvy about turning the cuffs inside out to make sure there is ample fabric to let the sleeves out, and that's where the tape measure comes in. Sometimes eyeballing the amount of extra fabric isn't enough; Shawn Sharp wants to measure exactly. I have long arms myself, and I hate a short sleeve that isn't supposed to be short, so I'm happy to help.

One by one the men found their match for evening wear, with Shawn acting as the style setter, signing off on the look for each of the guys as they narrowed their choices. In a half an hour, they were all done, with six blazers, plus two suits for Shawn. A good day for them, a good day for Hooti, because I was sure I would see most of these guys again, now that Shawn had shown them his vintage ways.

As he was leaving, Shawn had one last question: "When are you getting the three-piece suits. When should I come back?" The way he asked it was as if I could order them from a catalog. I laughed and told him I would do my best.

Within the next month, I had found three, all from the seventies, all perfect for this guy with his name in diamonds. I knew that Shawn would add his own magic and energy to these clothes, making them as hip as any suit he could buy in SoHo.

I am on constant watch for the next hot thing—knowing that Hooti customers like Shawn Sharp are my best barometer—but sometimes I stumble into a trend headfirst and by pure luck.

One notable look, which has lasted much longer than I would ever have thought, first came on my radar sometime in 2001. I had been driving in rural Pennsylvania, headed for a big flea market, when I stopped at a garage sale. I don't usually have the time to stop for a sale that seems to be oriented toward children's toys and clothing, but the Suburban was empty, and I was hungry. I noticed all these little boys' T-shirts, in bright colors with large images of Batman, Spiderman and other cartoon

characters. I bought eight for two dollars. I figured that the young children of some of my customers would like them.

Back at Hooti, the Batman tee was the first to sell, and it wasn't for a little boy, but for a woman who wanted the short, cropped T-shirt look—something I hadn't yet noticed. Within days the rest of the shirts sold, and now the trend has evolved to include all kinds of old T-shirts. Almost anything with a logo from the sixties, seventies or eighties is valued—especially if it's a known brand and the logo is an early version of that brand or the brand no longer exists. And some buyers then might snip and rip to customize the shirt.

Hooti has sold its own variations on the snip-and-rip style, thanks to my girlfriend Gigi. She starts with anything that has a logo or a cartoon character—new or old—and cuts up the sides of the shirt. Then she roughly restitches the seams with a large topstitch in a contrasting color. The seam is exposed, the fabric overlapping, almost as if you're looking at the shirt inside out. Then she cuts the hem off the bottom of the shirt so the edge rolls naturally. One version of the shirt is done as a halter top; another has just the hems of the sleeves trimmed off, so every edge is a rough cut. Hooti sells them for $18 to $25; Intermix was getting more than $100, and H&M introduced its version in late 2004 using faux-vintage T-shirts. How much longer will this trend last? I have no idea.

❧

Deep in Mom's closet, recently unearthed more than fifty years after its purchase, is a glamorous spring/summer dress, one

that is more obviously feminine in style than anything I can ever remember seeing on my mother.

Time, and a few moths, have taken their toll on small areas of the lining and the crinoline, but it is still stunning, pristine on the outside and beautiful enough even today to be eligible for any magazine photo spread on vintage dresses.

The label of the dress says simply "Helga," but this was one of those rare cases where my mother didn't buy the brand; she had no idea that Helga Oppenheimer was a highly regarded California-based designer. And she didn't buy the dress because she thought it suited her. No, it was the price: Originally more than $100 (in the mid- to late fifties), the dress had been reduced to $25.

I can't imagine why this dress wasn't snapped up at full price by someone whose life revolved around parties at Miami Beach's outrageously curved Fontainebleau Hotel, maybe someone who had even met Meyer and Teddy Lansky or been to their apartment, invited by a guy who drove only Lincoln Continentals. The ethereal fabric has the lightness of a fine cotton, though it could be a blend, and the colors, still rich today, are tropical without being harsh: chartreuse, aqua and lemon yellow, in a large and loose floral pattern. The dress's simple design—heart-shaped neckline, fitted bodice with two little bows at the waist and a very full skirt—is pretty without being froufrou.

But my mother never wore it, not even once.

As Mom recalls, the dress was "a little tight around the waist." Then she added, "It didn't suit me—it accentuated my hips." But she had tried it on before she bought it, right? Yes, my

mother said. Did she plan to lose weight? "I guess so." Of course she did. We have to be optimistic, especially when something is so tempting—such as a slightly small Prada leopard flat—that we simply *can't* walk away from it. Who among us doesn't have at least one purchase in our closet that *almost* fits?

But the dress is so different from anything else I've ever seen my mother wear that I can't help but think of it as her fantasy dress, something in the closet just in case she and my dad were invited to a party at the Indian Creek Country Club, which was about as likely as Frank Sinatra's stopping by our house for cocktails.

Maybe, though, she just finally realized it wasn't her style. And I think she was right.

I love my memories of thrift-store shopping with my mother—we can still kill hours in the hunt for a great find—and I think of those moments when I watch some of the mothers and daughters who are regular Hooti customers.

Wisely, most mothers observe rather than instruct, seldom overruling their daughter's choices, even when the girl's tastes are moving in a much different direction than her mom's.

That's the case with Debbie, a beautifully groomed and impeccably dressed single mom who works in advertising and has shopped at Hooti for a long time. Debbie first brought her daughter, Lucy, to Hooti when Lucy was seven, and back then, and for the first several years, the usual goal was nothing more than a Halloween costume. When she was about twelve, Lucy started buying vintage tees at Hooti while her mother was looking at my most elegant purses and coats. Then, seemingly overnight, Lucy became a major teenager with serious vintage

taste. What I consider her first real vintage purchase at Hooti was a gorgeous navy blue forties fabric-covered purse with a large bow built into the side of it. That same day she spotted an outrageous vintage necklace with a rhinestone cutout heart that had an arrow shooting through it. After a little bit of pleading, her mother gave in and bought it for her.

When it came time for Lucy's first formal dance, she was back at Hooti and left with an eighties-era spaghetti-strap, black lace dress. I knew she didn't have to buy vintage—her mother had taken her dress shopping at boutiques and department stores all over Manhattan—and I was thrilled to have a serious convert at such a young age.

Lucy has since worked at Hooti as a summer intern, and she was the first person to tell me about a fleeting look involving old girdles with hanging garters—teenagers were wearing them under jeans skirts in a way that just the garters were visible. As soon as I heard this, Lucy and I whipped up a display using an assortment of pretty old girdles—what's called new old stock; some of them still had tags, and none had been worn before—in assorted pastels and leopard prints. I had bought these in a moment of utter craziness and then wondered if I would ever recoup my investment. But I did, for various weird and wild reasons. Some of the girdles were so beautiful that a few people bought them to hang as art in their bathroom. One woman

bought a very tight one to wear while she was working out, in hopes of dropping more inches. And Lucy bought one, too. I'm sure I know what Debbie said when Lucy got home, because I've heard it before, when they're both in the shop but not quite on the same fashion page and Lucy is walking that fine line between fashion/style and age-appropriateness:

"I don't know about that . . . "

I would like to say that my mother had an equally reasonable response one day back around 1970 when my sister Jennifer, who would have been about fifteen at the time, decided to wear a minidress to church. Even though the dress had hidden matching hot pants, making it slightly more modest, a brief but intense battle was waged, tears were shed, and my sister ended up wearing her outfit to mass. However, once inside the church, Jen was so self-conscious that she stayed glued to the pew when the family was asked to bring the offering to the altar. That dress was never seen on Sunday mornings again.

Shopping Intimacies and Infidelities

With Clothes, with People

Several years ago my mother gave me a fitted houndstooth jacket with black cuffs that she bought at Peck & Peck and wore during her single life in Chicago. Double-breasted, with incredible jet buttons and a black silk-crepe lining, the jacket drew its sexiness from how it was cut. The built-in shoulder pads did their part to make the waist, which was already nipped, seem absolutely tiny. The jacket had drama, too: When I put it on, I felt like Lauren Bacall in a Humphrey Bogart movie.

When Mom passed it on to me, the skirt was no more and the jacket was a bit worse for wear after such a long time in the tropics. I wore the jacket with jeans many times, telling anyone who asked that my mother was the first owner. I think Mom assumed I would keep it because it had once belonged to her, though we never discussed that.

But the silk lining was starting to seriously deteriorate, the wool had a few holes, and the buttons were hanging by threads. The jacket was

weary though still wearable, and one day I gave up on it. I put it on the Hooti racks, and it soon sold to the friend of a friend. For $36.

How could I cash in—and for so little—on something that my mother had once treasured, even though she had passed it along with no strings attached? I can't explain that, really, beyond the fact that I was in one of my "the closets are out of control" clean-out frenzies, and it's almost too easy to move things from my co-op straight into Hooti. It took me a few months to regret that decision, and at some point I confessed to Mom about what I had done. She hid her disappointment in a reminiscence about that time in her life.

Then I did something I've never done before—or since. I called up the new owner to see if I could buy back the jacket. I explained my mistake and offered to cover all her expenses related to the reweaving, the new lining and the dry cleaning that I knew she had invested in it. I assumed she would be sympathetic to my newfound sentimental attachment. What I underestimated—badly—was her newfound love.

She actually laughed at my proposal, and there was a hard edge to it that made me both instantly despise her and appreciate the message she was sending. Feeling good about what we wear is important to most of us, and being noticed for looking good is important, too.

"I wouldn't sell this for anything," she said. "Every time I wear this jacket, people tell me how great I look."

For every customer who knows instantly whether something works for her, I have dozens more who stand in front of the full-length Hooti mirror consumed with ambivalence or frustration about whatever had promised so much while still on the hanger. The momentary fantasy has vanished, replaced by reality. It's too tight, or the color isn't quite right, or there's some-

thing elusive that keeps the potential buyer turning one way, then another, as if the merchandise will become more appealing if she stares into the mirror long enough and hard enough. I've been there myself.

At these moments with customers, male or female, I try never to jump in with a positive comment just to make a sale. If I'm asked for my opinion I will give it, carefully, but I usually add, "You have to love it. If you don't love it, don't buy it." Some-times I'll go to the racks, knowing I have something else that might be a better choice.

I know from experience that if you don't love it now, there's very little chance you'll feel different about it tomorrow or next week—unless, of course, it happens to be something that be-longed to your mother and you've only belatedly come to your senses about its value to you. Relationships with clothes have to start strong and grow; it seldom works the other way around.

The opposite is often true with people, of course, especially in an environment like Hooti. Over the years my relationships with many customers—women and men from their twenties to their seventies—have become so close that we talk about clothes—and life and jobs—not as shop owner and potential buyer but as friends. I love this part of my business, and I know that Hooti has done well because of the warm environment generated when friends come together.

That said, poignant encounters with strangers stay with me as strongly as any other experiences at Hooti, reminding me of how differently we all see ourselves when we look in the mirror and how strong our desire can be to make ourselves more attractive.

❧

*L*ast year, the Saturday after Halloween, a brunette in her early thirties, with shoulder-length hair and wearing no makeup, came into Hooti and stood quietly by the counter while I finished helping another customer. I didn't recognize her, but I could tell from her body language that she was unsure of herself, at least at this moment in Hooti.

When I was done, I moved from behind the counter and asked if I could help. Her one-sentence response explained everything, at least to me: "I'm going to my ex-boyfriend's wedding, and I need a few things."

Instantly I wanted to do anything I could to make her feel good about herself. I knew this scenario from personal experience, too.

"Tell me what you need," I said. "I'm sure I can help you."

She described her black dress—and she wanted earrings and a purse that would work with it. She had already picked out a boxy patent-leather purse, but I told her it might be too stiff for the flowing dress with spaghetti straps that she had just described. Instead I showed her a beautiful black fifties fabric-covered clutch-style purse with a fabric handle. On it I had pinned a new feathery black silk rose.

"The purse will move like the dress moves," I explained.

"I'll take it," she said immediately.

For earrings I steered her toward cluster clip-ons with dangling pearls and crystals that also would move when she walked. But she was hesitant.

"Don't you think these are a little much?" she said.

I started talking like I was either her therapist or her best friend.

"You're going to your ex-boyfriend's wedding," I said. "You want to look drop-dead gorgeous." I was not doing this to make a sale; I had taken her on as a makeover challenge.

She looked in the mirror again, studying the earrings more closely. "I like these."

I asked if she was wearing her hair up or down. She thought for a moment. "Up, I guess." I kept going, even though she hadn't asked, kicking into serious stylist mode. "All you need is a little red lipstick—I like L'Oréal—and a good mascara. Maybelline is the best. You can get it across the street at the drugstore, and it's four ninety-five."

At that moment a customer at the back of the store—the real fashion stylist I was trying to be—piped up, "Alison, you know your stuff. Maybelline does make the best mascara." I love these exchanges.

I had spent all of fifteen minutes with this customer, but I felt flush with excitement about helping her look her best on this awkward night, when she knew someone in the wedding crowd would think, "She didn't get the guy," even if *she* had been the one who threw *him* back.

She thanked me, and as she was leaving,

I couldn't resist one more tip even if some might consider it inappropriate: "While you're doing your hair and makeup, try a nice glass of champagne. You're going to look great."

◦⟋⟍◦

The dynamics with customers can get much more complicated when a couple is involved. If I were a marriage counselor, I might try to work the subject of vintage—or, at the very least, shopping—into a compatibility test. Here's my theory: When a couple shares a love for vintage, the relationship is full of promise for long-term success. But if one person is adventurous about old clothes and the other person barely tolerates that passion, stormy times are a distinct possibility.

One weekend afternoon a couple I didn't recognize began browsing. Judging by what they were wearing, he was fairly hip, she was middle-of-the-road. Almost immediately he was layering items over his arm, including a tweedy three-piece suit. He had tried on the jacket, and it fit beautifully, so he wanted to try on the pants and vest, too. The clothes he was choosing made me think he was looking to add fun to his wardrobe.

Meanwhile, his wife had spotted a simple sweater for herself, before turning her full attention to him and his growing pile of merchandise. It included a Kelly green Palm Beach–golfer-style sport coat; a rugged, Marlboro Man-esque shearling-lined vest; and a black-and-green Woolrich jacket that whispered, "I eat organic." He was unfamiliar with the Woolrich brand, which told me he was relatively new to vintage.

His tastes seemed broad, so I pointed out a turquoise cashmere sport coat that appeared to be his size. Immediately, as soon

as it was obvious the jacket fit, his wife weighed in, soberly and succinctly. "I don't think so. . . ."

He was not going quietly back to the dressing room, though. "What do you mean?" he asked as he continued to study himself in the mirror. "This would look great for my new job."

"Your new job is corporate," she responded, her voice now a mixture of disbelief and despair. That comment didn't sit well with him either.

"Why do you think they hired me? I'm the farthest thing from corporate." He seemed proud of that fact, but it did nothing to change his wife's opinion. "Well, what are you go-ing to be, a sports commen-tator?"

She really hated the tur-quoise cashmere, so I wasn't about to volunteer that I could easily see it paired with a crisp white shirt and jeans. I can't afford to be seen as the "other woman" in such discussions.

Finally, when the husband asked for prices, his wife came down hard, talking as much to me as to him: "We'll need to dis-cuss all this before we make any purchases today," she said. "We'll definitely take this," she added, holding up her sweater. The husband's demeanor became as cool as the items he would

put back on the rack, and the message was obvious: These old clothes weren't worth an argument, at least not at this moment.

As the couple headed out the door, another customer who had watched this conversation play itself out wanted the last word. "That woman was so controlling. She even wanted to control his style."

I nodded in agreement, but with some discomfort, too. I've been that guilty party before, acting "bossy," as my mother might say, confident that my sense of style is better than that of the man I'm with. I've been known to offer my opinion when it hasn't been asked for. It's not behavior that's pretty to observe, and I'm not sure I've learned from past mistakes. Once bossy, always bossy? Maybe so.

Fortunately, most of my customers with spouses or partners have figured out, wisely, that shopping can challenge even the best of relationships—no matter how romantic it looked in *Pretty Woman*—so they don't shop together for clothes. That's the case with my parents: My dad has gone into a clothing store with my mother only twice in fifty-five years—for a sport coat and a suit, for two different family weddings. The rest of the time, Mom shops for him, and his daughters do, too, all of us always on the hunt for khakis and nice polo shirts at thrift stores and garage sales. And, practical man that Dad is, that's how he likes it.

❧

When I do have a chance to watch a great shopping duo in action on the floors of Hooti, it's all I can do not to sit them down and get their recipe for love.

One of my favorite couples has been shopping with me for most of the ten years that I've been in business, and I still study their interactions as if I've never seen them before. They are in their forties, both favor vintage and both have a strong sense of style. It is a relationship, at least from what I see, that remains full of humor and romance.

Shortly before Christmas last year, they were in Hooti together, casually sorting through the racks. At one point the husband held up an item he thought his wife might like for herself. Her reaction was the same mine would have been to this particular choice, which leaned toward frumpy.

"Oh, my God, that's not me!" she laughed. "How long have you known me?" He didn't take the rejection personally—that was obvious—and went back to shopping for himself. Soon he had a forties suit, and she had a three-quarter-length coat and a newish cropped, tweedy sweater. Finally they both turned their attention to a seventies leather jacket with a zip-out lining. It fit the husband perfectly, and I thought for sure that he would buy it.

But she's always the negotiator on prices—I suspect she's the one who pays the bills and knows the exact balance in the checking account—and when it came time to leave, she was the one who said *they* were going to think about the jacket, which was $75, but take everything else. He seemed perfectly satisfied with this decision.

Later that day, just as I was turning off the lights, the wife raced back into the shop, a fraser fir wreath hanging from one arm like a handbag. She grabbed the jacket and brought it to the counter. "This is a surprise," she said. "You sold this this afternoon after we left and you haven't seen me. Okay?"

Of course, I was happy to go along with the plan, as I have in the past with other couples. Giving vintage clothes as gifts seems as natural to me as every other aspect of the business. And couples who share a passion for vintage are particularly romantic, in my mind, sharing qualities that are both creative and down-to-earth. I'm not saying the perfect man for me *has* to embrace vintage—after all, lots of guys don't like shoe shopping either—but it would be a charming bonus if he did.

❦

Not all of my customers would deal with criticism from a spouse the way Laura, a longtime Hooti shopper, did.

Laura is a busy mom with a small floral business, a strong personality, excellent taste and a full social agenda. She's only five foot one, but you can't miss her in a crowd because of her strong sense of style. Laura knows what she likes, and she seldom hesitates when shopping. She's also good about keeping me up to date on Park Slope–Seventh Avenue goings-on—a nice little bonus.

Last winter she fell in love with a simple suede three-quarter-sleeve creamy cocoa coat with a fawn-colored mink collar, probably from the late fifties, early sixties. The fit was a bit snug, but she was determined to make it work.

The next day she called, full of apologies. Her husband's assessment had been succinct: "You look like a bag lady." She laughed as she repeated his line. I've met her husband several times, and he seems like a decent guy. And I would expect the same from a boyfriend if he really didn't like something on me.

I might not agree with him, but I'd hope he would feel he could speak up.

I told Laura a return would not be a problem, and when she came back to the store, I was prepared to give her a full refund. I normally don't do refunds but this was a long-standing customer who had never asked to return anything. I didn't want to penalize her.

Laura had no interest in cash, though. She brought back the coat and immediately started sorting through Hooti's jewelry trays, finally falling for a glamorous fifties necklace that would never, ever be mistaken for frumpy.

~☙~

*J*oyce, another longtime customer, has never returned any gift from Hooti that was bought by her husband.

Bob knows that his wife loves good-quality forties and fifties costume jewelry—especially bracelets and rings—so for the past three years he has come to the store to shop just days before Christmas. I was so pleased when he made the "crossover" to the new Flatbush Hooti, because they live in the heart of Park Slope and this location wasn't nearly as convenient for him as the old one had been.

I always show him an assortment of pieces, but he's the one who makes the final choices, and price never seems to be a factor.

The first year he made a purchase, I asked him if he'd like me to wrap the gifts individually in vintage handkerchiefs. This was a bit of a desperation move, because Hooti had run out of tissue,

thanks to a busy holiday season. I wanted to make these gifts as special as possible, and then my eye caught the basket of hankies. He loved the idea and immediately set to choosing the squares of cotton, many with embroidery, that he thought his wife might like. Once I had his selections, I set each piece of jewelry in one handkerchief, then brought all the ends together and fastened them with a piece of ribbon. The result was so distinctive that I used this trick for other special purchases that season.

The following Christmas, Bob was back, and when it came time to wrap the purchases, he specifically asked if we could do the gifts in hankies again. Of course I said yes, and that's how Joyce's gifts were wrapped last year, too.

That first year, Joyce dropped by a few weeks into January, and I asked about the gifts, "Alison, I love everything he picked out," she said. "They're perfect." I know from personal experience that that's a rare event, even in the best of matches. I was thrilled, for her and for Bob.

*R*unning a retail business isn't always warm and fuzzy, full of just good times and happy customers and memorable merchandise. Hardly. I have chased shoplifters down the street—very dumb, but once I did get back a couple of hand-embroidered pillowcases. I have drawn a line in the sand when someone like "Where's my purse?" Gator Woman has made me angry. I have closed early and opened late—sometimes simply because I was tired or the weather was crappy—possibly disappointing someone who had made a trip to Flatbush just for my store. And because I

sell old stuff, I'm sure customers have purchased merchandise that was more flawed than either of us realized. I hope they came back, but you never know.

Almost every day, through experiences at Hooti and experiences at businesses that I patronize, I'm reminded that what goes around comes around, and sometimes when you least expect it. So I try to make sure that whoever is working in Hooti never takes any customer for granted, knowing that the bonds that have been built with shoppers are our most valuable asset.

I was reminded of that, memorably, after I bought a box of assorted wallets at a Pennsylvania house cleanout where the owner had been a pack rat. As I remember, there were at least two dozen wallets, forty-eight handbags and dozens of pairs of gloves. The price was right, so I took it all.

I sold five wallets the first morning they were in the shop, and I was thrilled; this had been a good buy. Hooti was bustling when a young woman started whispering at me, because she didn't want the other customers to know what she and her sister—two of my favorite regulars—had found inside one of the wallets.

"Alison, you need to look in this wallet," she said. "It has a secret compartment."

They handed me the wallet, but I still couldn't understand why they were whispering. "Look in the wallet. Look what we found," one of them insisted.

Hidden away in a wallet priced at $7 was $200 in twenties, plus a silver dollar, none of which I would have seen if they'd just bought the wallet. I looked at the sisters and smiled in appreciation. Then I handed them $100 of their find—and the wallet, too. I know I don't always do the right thing in business—sometimes I'm shortsighted and sometimes I'm too oriented toward the bottom line—but this was an easy decision.

They were thrilled with the reward—and within minutes they had spent $80 of it in the store.

❧

I was not in the store the day Mary Coleman had to cut a customer out of a dress, as intimate and awkward a situation as we've ever had at Hooti.

The woman—who is still a Hooti regular—was shopping for something appropriate for her niece's wedding. She had taken several items into the dressing room, mostly looser-fitting seventies-era pieces with Empire waists that flattered her figure.

As the woman worked through each of her selections, she would come out of the dressing room to discuss the pros and cons of a piece with Mary in front of the mirror. Mary thought a split-skirt dress looked good on the customer, and so did the customer. But when she returned to the dressing room, all of a sudden Mary heard a cry for help. The woman was

"stuck," literally, and couldn't get out of the dress that just seconds ago had seemed so promising. As she tried to remove the dress, the customer discovered straight pins running down one seam—as if someone had started alterations and never completed them. But pins weren't the only problem. Once the woman found herself stuck, she began to wriggle around in such a way that the dress became twisted into a knot, and not one that was easily untied. To this day Mary cannot figure out how things got as bad as they did as fast as they did, but it's possible the woman also had both legs in one side of the split skirt.

When Mary saw the situation, she immediately called me on my cell phone. We agreed the best solution was to cut the woman out of the dress, if the woman was okay with that, of course. But we had no idea what alternatives we might have to this plan if she didn't like that one. Fortunately, she agreed, so Mary got her scissors and went to work, stopping briefly if another customer needed help. It took about twenty minutes, because the woman was both embarrassed and very nervous about being cut—and Mary was doing everything she could not to aggravate the situation.

Finally they were finished, and the woman blurted out, "I'm not going to have to pay for this, am I?" Of course she wasn't. But that was the end of her clothes shopping that day at Hooti.

<center>❧</center>

Hooti has lots more competition—from new vintage stores to online vendors—than it did when I started selling. So it's more important than ever that the Hooti experience be as distinctive

and appealing as the clothes and accessories we sell—preferably without incidents involving hidden straight pins.

Not a week goes by that someone in the shop doesn't comment, "You should be on eBay," and I love how this single site has opened the vintage market to every corner of the world, so that anyone can buy a pale pink sixties beaded minidress or a David-Andersen enamel butterfly.

Hooti customers report from time to time about their online vintage adventures, especially when they've scored a real bargain or found something that's hard to come by. A few have brought me their eBay mistakes—usually fit is the big issue—hoping I'll be interested in buying the merchandise. I don't encourage that, because I know I can't pay them what they paid and still make any kind of a profit. But there are exceptions—it all depends on how much I love the item and how willing the current owner is to negotiate.

When customers do press the point on why I don't sell on-line, I explain how I think it would hurt them and Hooti, the physical store. The way I see it, I would need to sell my best pieces on eBay—the ones likely to draw the biggest bidding wars: the finest alligator purses and fur wraps, the trendiest labels. And what would that leave for all the people who make the

effort to come to Flatbush Avenue, who never know what "finds" they will find?

Another option would be to make Hooti just an Internet store, but I can't see that ever happening. How would I have the chance to watch twenty-something Japanese women—tourists visiting friends in Brooklyn—mix clothes in fresh and ingenious ways? How would I have heard an exchange between a woman who was showing off her beautiful vintage alligator purse and another customer who voiced her disapproval by announcing she was a vegetarian? To which the purse owner announced, "I didn't *eat* the damn thing!"

But the biggest factor, by far, is my personality. I love talking to people about everything from colors and fabrics to what's in the windows at Bloomie's and Saks. And I can bring life to my merchandise, wearing a leopard-print half-slip to the shop so potential buyers can see for themselves why these will work as great summer skirts or strapless tops. I love the look I get when I put on an oversize fifties sweater and, instead of buttoning it, I wrap it in a way so that one front panel overlaps the other, using a brooch to "close" it at my rib cage. With that one little twist, I've given myself a more fitted silhouette—and just the way Prada was doing for a while.

And when it comes to the merchandise, could I ever make the perfect match with a buyer if I had only words and a couple of photos to describe a coat by Pauline Trigère, the design legend who brought her French sensibilities to American fashion for decades? Sure, I could provide dimensions and even the weight of this amazing piece, but nothing short of putting this

coat on your body, with its alternating vertical panels of light and dark gray wool, would tell you if you could wear this coat—or if *it* would wear *you*.

For a week I watched women wrap themselves in this sixties-era design, because it was a rare find and in perfect condition, and once you touched the dense, rich wool, you were hooked. Finally the coat found the right owner—a tall black woman with broad shoulders who would make it swing when she walked. And I got to see her in it, beautiful and elegant and thrilled with her newest discovery. Only later did I learn that Trigère, whose clothes were worn by everyone from Lauren Bacall to Josephine Baker, was the first major American designer to put her clothes on African-American models, back in 1961.

In my book a perfect match had been made.

It's one thing to sell a houndstooth jacket that belonged to your mother, but it's beyond dumb to sell it to someone whose social circle overlaps yours. I never stopped to think that I might be reminded of its existence on a *regular* basis, and that I would have to endure a constant stream of compliments directed toward the new owner because she was wearing something I wished I still owned.

Then, a few years back, I ran into the jacket's owner at a barbecue and she introduced me to her new husband. "Alison owns the shop where I bought the forties jacket," she said, as if this were the most important possession in her life. "Oh," her

husband said without prompting, "that's her favorite jacket. She lives in it."

With this, I realized I had to move on, to be genuinely gracious, as well as grateful. After all, I know where the jacket is. And that it is loved. I can't ask for more than that.

What We Keep and What We Don't

Tales from My Closet

The minute I saw the double-breasted, leopard-print, faux-fur coat, I knew it would go in the Hooti window for my fall 2004 "collection." It had to, because everywhere I turned—magazines, catalogs, store windows—I was seeing spots, in a good way. Big-cat prints of almost every swirl and stripe were hot.

There was only one problem: I really wanted to keep this coat. It was in gorgeous condition and well made. The label—"Safari, Styled by Fairmoor, Fabric by La France"—is one I see on some of the nicest coats from the fifties and sixties. This one fit me perfectly, hitting just at the knee, and I knew winter would be a lot more fun every time I wore it.

I seldom price anything higher than $400—unless it's an exceptional real fur coat. I don't want customers to see Hooti as unaffordable or intimidating, and I think my strategy has worked. But this time I was breaking my own rules intentionally, which is seldom a good idea. I priced the coat at $485 and put it in one of the windows. It would make Hooti a tempting stop for several weeks, and then I could take this

home with a relatively clear conscience, after customers had decided it was more than they wanted to spend.

As expected, the coat was the perfect conversation piece for fall. Almost everyone who saw the coat mentioned Kate Moss, who was the first supermodel to put vintage in the limelight back in the nineties, and who has been photographed many times in a coat just like this. It didn't hurt either that Moss often talks in interviews about how she grew up shopping for old clothes in England at "jumble sales." But even though the coat looked like Kate Moss's coat and it came out of the window several times for try-ons, the price did prove to be more than most customers wanted to pay.

One afternoon in early October, a twenty-something woman whom I'd never seen before stopped at the shop. She was wearing workout clothes and seemed headed for a shower.

Immediately the woman asked the price of the coat. When I told her, she didn't hesitate, beginning to peel off the top layer of sweaty clothes so she could try it on. Since Hooti sells lots of things that have probably seen their share of sweat down through time and I don't know of any good way to discourage a customer from trying on clothes, I pulled the coat out of the window and off the mannequin.

The customer put on the coat, and I almost turned away. I couldn't bear to see how good it might look on someone else. But it did look great, and in just minutes the platinum card had been swiped and pleasantries exchanged as I wrapped up the leopard in lots of tissue. And then my coat was gone.

When the temperatures began to drop in New York later that fall, my winter coat of choice was whatever I grabbed off the Hooti rack of coats at the end of the day—coats as practical or stylish as the weather and any evening plans might demand. This wasn't nearly as much fun as

*the leopard would have been, but I'd had my chance. And I figure I'll
have another, sooner or later.*

I have loved leopard ever since I first sat on one of my Grand-
mother Houtte's homemade corduroy pillows done in an or-
ange, black and cream animal print. In her living room,
dominated by matching La-Z-Boy recliners, the pillows seemed
absolutely exotic.

In all the years since, my leopard-print fetish has led me to
buy, in no particular order: lingerie, vases, rugs, dishes, shower
curtains, chair coverings, scarves, pajamas, umbrellas and lots of
gifts—even if the recipient doesn't share my passion. And, of
course, I've bought lots of vintage leopard for the store, because
animal prints never seem to lose their appeal, and when I have
leopard anything in the windows, Hooti is practically irresistible
to most passersby.

So why did I sell the faux fur? Because over the years I have
managed to develop at least a slight bit of self-control when it
comes to all the clothes and accessories that I touch. When I
keep something, it's often because I've never seen anything like
it before and may not ever again. I don't collect any one label—
actually, several items in my "permanent" wardrobe don't have
labels, and at least two pieces in my closet are homemade—and
I don't collect any one look. In fact, I would never describe my-
self as a collector, because I don't have enough closet space or
focus for that hobby.

All of which means that the dresses, suits, jewelry and purses
I keep for the long haul are an eclectic hodgepodge that can't be
neatly categorized or explained, beyond the sentimental value of

a few of my possessions. I haven't sold *everything* that once belonged to my parents or grandparents.

But I have worn to death a few vintage pieces that I once treasured, because all the things in my closet are for wearing, and even the best-made pieces don't last forever.

Something deep inside—something I still can't explain—clicked for me the first time I saw the only red, white and blue dress I've ever bought for myself. I usually don't like that color combination in *any* outfit, but I was hooked by the cleverness of the designer, the wit that she had worked into maybe two yards of lightweight white cotton.

Vera Maxwell is known by many of my over-fifty Hooti customers for the happy table linens and scarves she signed with just "Vera." She used bold colors and bold graphics in everything from flowers to geometrics, and her pieces were well made. You could wash something over and over again, and the colors still looked crisp and fresh. My mother has several Vera cotton napkins from the sixties in her linen closet, and I still see her work all the time at garage and stoop sales. But Vera did much more: For decades, starting back around 1930, she was recognized for her strong use of fabrics in wonderfully shaped dresses, coats, suits and separates. However, I seldom saw these pieces—beyond the occasional seventies polyester blouse—until a regular customer walked into my shop one day years ago with something to sell me.

"I know you love Vera, and I have a dress," she said. "I think you would appreciate it. But it's not cheap."

The minute someone starts talking high prices, I begin to lose

interest. My shop-owner hat is on, not my pleasure-shopper hat, and I can say no to a lot if I don't see a good profit down the road. It was obvious this would not be a $5 deal or even a $10 deal, and that's my preferred shopping "zone." The dress was folded up in a plastic bag—not exactly careful handling for something truly valued. My expectations for a great find were sinking fast. Then the customer held up her dress, a simple, straight-lined, sleeveless sheath with a mess of wrinkles. And she said her price was $35.

"I'll take it," I said, on the spot. No usual Alison Houtte wheeling and dealing. No "It's nice, but I need to try it on first." No "I need to think about it."

What the customer had brought me was a piece of artwork, a slightly boxy, unlined white dress with two patch pockets on the front, at the hip. What Vera Maxwell did with this modest backdrop is what makes me smile every time I put on this piece. The pockets are "painted" with irregular, horizontal navy and white stripes, and above the pockets, hanging right at the waist, is a painted-on "belt" with a painted square buckle and even painted belt loops. The "belt" circles the dress, and above the belt, on the front, are five black buttons, with thread, all painted on, and the whole bodice is red-and-white check, again in a screen print. Finally, there is the "Vera" signature in a red box with her signature ladybug visible on the left hip.

I didn't think to ask at the time, so I have no history for this dress, and the customer must have moved or lost interest in vintage, because I haven't seen her in years. But I'd never seen her wear this dress, and she didn't seem at all attached to it, the way some of my more reluctant sellers are.

The dress has the original size twelve tag, which in today's clothes would be a six or eight, and it fit almost perfectly. But I wanted a slightly less boxy feel. I didn't want this dress to sit in the closet because it *almost* worked. I've done that with clothes before, and I don't know anybody who hasn't.

So I took the dress to a tailor, which is, of course, something that no serious vintage collector would ever do. But that's why Hooti is not a museum and I don't insist on treating clothes like museum pieces. I think you should wear clothes that fit well, that you're comfortable wearing and that are as flattering as they can be. So I had the side seams taken in about an inch by a man who has done work for me before. I knew he would be careful, and he was, and I don't feel I compromised the design or the painted details.

One of my good, conservative friends, who doesn't own one speck of vintage, says my Vera is her favorite dress in my wardrobe. When I wear it to the store, customers go crazy. And it has such an "all-American" feel that I feel like I'm at a Fourth of July picnic whenever I have it on. On the other hand, my mother doesn't get it; the dress does nothing for her, and she's always been a Vera fan. But that's okay—she's not wearing it, I am.

I often wonder what inspired Ms. Maxwell when she created it. And I wonder what she would say about one particular match I made with the dress. I was invited to a big summer party at the Brooklyn Museum, so I teamed up the Vera with new Moschino red, white and blue boots with white stars all over the toes. Over-the-top? Yes. But that night people repeatedly stopped me, asking where I'd bought my outfit.

My Vera gets a hand washing when she's dirty, but she has none of the wrinkle-fighting power of the new fabrics, so my freshness

"shelf life" expires quickly when I'm wearing her. But once people start studying the real details, no one seems to notice.

~⌒⌒⌒

I know how to sew—thanks to Mrs. Snook at Redland Junior High—but I know my strengths, and I would never be able to pay the bills as a seamstress. I don't have the patience for such detail-oriented work, but whoever created my black-and-white polyester "arrow" dress, which one of my favorite Pennsylvania dealers sold me for $2, certainly did.

The dress is obviously homemade—I can usually tell by the way hems, necklines and armholes have been finished—and whoever created it was not easily intimidated by needle and thread. The maker also was intent on making a statement, no matter how much work that might require, and that statement was "Look at me." The dress says sexy, as sexy was defined in the late fifties.

One design detail gives this dress its sizzle: Three large black arrows—set against a white waffle-textured backdrop—shoot up from the hem of a slightly flared skirt, narrowing as they cross the fitted waist, before stopping right at breast level, one arrow ending at each nipple, the third one set in between. Two inch-wide straps hold the dress on the shoulders, and the hem hits me at the top of the knee—so nothing else about the design is the least bit provocative.

I can't help but picture the owner of this dress wearing it to a summer party, maybe just at dusk at the beach, probably with white sling-back heels, her hair well sprayed to keep it in place. The dress tells me she wasn't voluptuous, maybe a 34B, but she was going to flaunt everything she had. I can even imagine her

standing on a boardwalk, waiting for a sea breeze to make her dress swish and swirl just the way Marilyn Monroe's did.

Before I ever put it on, I knew that this dress would be fun to wear and to talk about. Still, its "worth" didn't really fix in my mind until someone else began to covet it.

The day I returned to Brooklyn with the dress—which I already knew I would keep, at least for a little while—I hung it temporarily in the bathroom while I unloaded the Suburban. I don't believe in teasing customers, so I never display anything that isn't for sale, but I forgot momentarily about my purchase because the shop was so busy.

A fashion stylist on the staff of *Vanity Fair* magazine was visiting Hooti for the first time that day, because she had a freelance project, a shampoo commercial for which the director wanted a totally

vintage wardrobe. I never rent merchandise for photo or film shoots, but I do encourage stylists to consider buying, because they may pay the same amount elsewhere just in leasing fees, especially if they use a Manhattan source. This stylist, a very pretty blonde, came armed with an assistant, and they were busy building a huge pile of goodies that would work for the assignment, so I let them be. And when the blonde asked to use the restroom, I didn't think for a second about the arrow dress—until she came out holding the dress as if she already owned it.

"What are you asking for this dress?" she said, smiling brightly, as if she had just unearthed the natural, permanent and affordable alternative to Botox. Damn. Here was someone who I really wanted to like my shop, and now I had to disappoint her. I immediately apologized and explained that I had just bought the dress for myself, but that I hadn't yet been home after a buying trip. "This dress is going to the Saratoga horse races in ten days," I said. "I'm so sorry."

She laughed. She understood. But she was hooked. "Can I try it on? I have to see how it looks on me." Sure, I said. I knew that this dress was tough; nothing was going to hurt it, certainly not one more zip-up.

Not surprisingly, the stylist's instincts were dead-on; one glance in the mirror confirmed her expectations. But she didn't linger or try to change my mind—and I appreciated that.

"This is my kind of dress, this is me," she said, as she handed me both the dress and her business card. "As soon as you get tired of this dress, please put me at the top of the list. Whatever you're asking, it doesn't matter."

I agreed, though I knew that wasn't a likely outcome. I apologized one more time for not being able to sell it to her, and as soon as she was gone, the arrow dress went into a bag; I didn't need to dash any more hopes that day.

The arrows and I made it to Saratoga Springs, but as is sometimes the case, my race-day fantasy had become so overblown—huge winnings tickets and, who knows, maybe a first encounter with the man of my dreams?—that something was bound to go wrong. It would have helped a lot if I'd eaten a decent breakfast, but I didn't, and then there was the heat factor. Before long,

Saratoga Springs's wooden grandstands were shaking with excitement while I was a pathetic mess, stretched out on a bench and overcome by heatstroke, more wilted than my dress could ever be. At that moment, as one of my friends fanned me and my arrows, and my neck and head were wrapped in moist napkins from the hot-dog stand, I didn't care what I was wearing or who won the next race.

I've worn the arrows dress many times since, almost always drawing great feedback from both men and women, and now I have an old fifties-era black-and-white vinyl purse to match. It has an arrow, too.

<center>～§∞～</center>

*A*lmost always, for everyday life, I dress according to my mood—and the weather, and my list of obligations—and several dresses in my closet meet a variety of needs. When I'm feeling more *Stepford Wives* than *I Love Lucy*, I'm likely to pull out a sleeveless turquoise dress with a slight A-line that hits right at the knee. What sets this dress apart, besides the color, is the heavily beaded, asymmetrical neckline—also in turquoise. If that weren't enough, the designer has a bow lying on the shoulder. Generally I'm not a bow person, but I left it as is.

Like so many labels that have made their way through Hooti, the one on this dress tells me nothing. I've never heard of Ricky Ann New York, and who knows whether the manufacturer used this name for two years or twenty—and if there was ever a real Ricky Ann? The fabric is some mystery blend, but it's a good mystery blend, because this dress was truly filthy when I bought it from one of my favorite sources, a woman named Lily, who

also sold me the arrow dress. I knew that dry cleaning would kill the beading, so I took the dress home and filled a bucket with water and Biz. I stuffed every part of the dress except the neckline in the bucket and started soaking it. Soon the water was black, so I drained the bucket and repeated the process. Then I rinsed it out again and again before laying it flat on a towel on the kitchen table—just the way Mom taught me and my sisters to dry sweaters. By the next day, the dress was perfect, and I've worn it many times since, always washing it the same way.

If I'm in a Doris Day, "Que Será, Será" state-of-mind—I think that's when I've had more than three cups of coffee before noon—my go-to outfit is a find from a thrift store, an early-fifties, heavy cotton dress fitted at the waist and covered with small white polka dots on a turquoise background. It's another one of my homemade finds, and I like that. Even in the vintage world, I know that no one else has this dress. Because it is singular, when I wear it, I feel one-of-a-kind, too. My business is clothes, so I feel that I should love what I'm wearing, at least most of the time. Otherwise how would I be able to inspire customers to select their own one-of-a-kind purchases that give them that just-fell-in-love bounce in their step?

One other dress has found its way into my home closets, and I call it my Audrey Hepburn/*Breakfast at Tiffany's* dress. Except for me the appropriate meal, in Manhattan, is dinner at Balthazar.

I love the simple sophistication of this sleeveless, eggshell white brocade with a daisy pattern in the fabric, a cutout back to keep the look from feeling too prim, a fitted waist, piping around the neck and armholes, and baby bows on the back, at the top and bottom of the zipper. I got it for $1.

When I wear it with a simple mink wrap, I do feel like I'm channeling a 1950s film star. That's what I love about vintage; any one outfit has the potential to be a time-travel machine. I don't want to live in the past, but I don't mind taking on the present swathed in another decade's finery when the mood strikes.

⁓◠

As much as I love dresses, I'm not always in a dress state of mind—or up to shaving my legs, if that's what is required that day. That's when I might pull out my favorite 1970s polyester pantsuit, which is a busy mess of black and white triangles, finished off with fake pockets and big lapels. The suit is made by Russ Togs—which was a huge, affordable brand in the sixties and seventies. It cost me $4 at a thrift shop, it's machine washable and I've worn it all over Manhattan and Brooklyn, with simple black boots, which instantly give the outfit a modern twist. It's hard not to be in a good mood when I'm wearing this outfit. I just wish I had a matching car, say an early-seventies two-tone Cadillac Eldorado, to complete the look. My Suburban doesn't quite do it.

⁓◠

Hooti has many customers who shop just for good costume jewelry, and I love hunting for great pieces for them, though I wear very little myself and keep only a few pieces that have either sentimental value or are so one-of-a-kind that I just had to have them—and occasionally spent way to much money to get them.

Most watches I wear are cheap knockoffs from street vendors in Manhattan, but when I really "dress up," out comes a flashy, Art Deco–era, custom-made fourteen-karat-gold watch that I found in a downtown Miami estate-jewelry store maybe twenty years ago. What sets this watch apart is its "door," which is encrusted in rubies and diamonds and covers the face of the piece. When I push a little latch, the door springs open and I can see what time it is. Kind of ridiculous, I know, but I love it just the same. I plan to keep this watch for the rest of my life, and I'm quite sure I will never see another one like it, which is 90 percent of its charm.

I am just as attached to a bracelet that has no brand, no great worth, no personal history; I just love it. It's a two-inch-wide band of solid rhinestones set in a silver-tone metal. It's big and bold, and I found it at a flea market for $20. Because it has no serious monetary value, I have no trouble loaning it to friends, and for me and them this bracelet is the ultimate celebratory accent. Every time I spot it in my jewelry box I am reminded of good times.

My grandmother Houtte's charm bracelet is a more old-fashioned possession, but one that never seems to lose its charm, even among the *coolest* women I know. (My sisters say I got the bracelet by sweet-talking Mom, and that's probably true. Fortunately, none of them is too possessive about such things, so a family fight is unlikely.)

My grandmother loved this bracelet, and I remember her always wearing it for Thanksgiving and Christmas, as well as every time she dressed up for bridge parties. A day of cards at a country club to which one of her friends belonged seemed to

be the highlight of her week, time spent where no one would know her as anything but Clemmie "Hootie," of course.

Everything about my grandmother, from her hair to her outfits to her home, was always kept meticulously perfect and in place. As children, my sister Caroline and I became obsessed by all her pretty things, to the point that we would watch for the moment when she was in the farthest corner of her backyard, then rush into her bedroom and open the top dresser drawer, just to admire all her costume jewelry, each piece displayed in its original box and still sitting on its original fluffy white square of cotton. I especially loved petting the little blond fur clip-on earrings that matched her blond fur stole. But we both knew what was off-limits in Grandma's house, and at these moments we were way out of bounds.

Keeping watch through the bedroom window, we would then determine if there was time to slide open Grandma's closet doors, just so we could grab a fresh glimpse of something that always made us giggle: a row of wigs, each sitting on its own Styrofoam head. For a second or two, we were transported to Clemmie's Museum of Hair, before racing back to our seats in front of the television set once Grandma headed back toward the house.

Grandma didn't say much about her wigs, but she could talk all day about her charm bracelet, a slice of her life memorialized in fourteen-karat gold. The bracelet has fourteen charms, six of which are the profiles of me and my sisters and brother, each with our name engraved on one side of the head, all of us looking so neat and orderly—very unlike we were/are in real life.

The most poignant charm is a flat heart engraved with the

name Edmund, for my dad's brother and my grandmother's only other child, who died in World War II. Another flat heart has my father's initials engraved on it, and my favorite charm isn't a charm—it's my grandmother's wedding band, with my grandparents' initials and their wedding date engraved inside, "9-16-17."

Other charms include a wishbone with a little pearl on top, and one with a diamond-and-pearl flower engraved "To Mother," a gift from my parents one Mother's Day. That may have been the occasion behind a "tree of life" charm too, but the bracelet doesn't confirm that.

I usually wear the charms only on special occasions, but whenever I have the bracelet on, people want to study the details, the intricacies that tell them a little bit more about me and my past. I'm happy to share the facts, but I never take it off. And I will never add any charms to it; this should remain a reflection of my grandmother's life, not mine.

I think it would be difficult to document my own life in charms—unless I decided to have a bunch of men's heads dangling from my wrist as a reminder of past relationships. No, I don't think so. But one gift from a former boyfriend was so special that I still have it. The elegant stacked-pearl earrings, set in gold, were made by an artist who also created the Hooti logo and painted the sign that hangs over the store. He remains a part of my life, thankfully.

I seldom wear rings, but the one that has a permanent home with me is a forties-era design with a red stone and diamond chips that I found at a house cleanout at a dairy farm. I had just filled five large garbage bags full of forties and fifties suits, jackets, blouses and dresses with the help of Melanie, a onetime *Cosmo*

cover girl and very good friend who now buys and sells country antiques with her husband. She and I had retrieved boxes and crates filled with clothes from the the the attic of a bedraggled home belonging to a family that Melanie knew from her church. This was a true estate sale: A woman who had spent her life on this large, remote piece of land in the heart of Pennsylvania Dutch country had outlived her husband, and when she died, the children realized that neither of them wanted to run a farm. The property had been in the family for three generations, but now all that was left was a very old house with dead groundhogs in the front yard, victims of two aged but tenacious farm dogs.

The son and daughter seemed slightly uncomfortable selling off the family furniture, even though the most valued pieces had been kept. They were less attached to the clothes, but connections to the past were inescapable. "I remember my mom wearing this," the daughter said more than once as we sorted through items that were forty and fifty years old. "But I'm never going to wear this," she would quickly add. "Find it a good home."

Melanie had warned me that the emotional strain from the mother's death might be evident. "We'll get in and we'll get out," she said. This was not the time or place to be studying labels—or getting into a major negotiation. I was buying everything, so all I needed to do was determine a price. After a quick examination of the goods, I ran a dollar figure by Melanie. She thought it sounded reasonable, so I offered that figure to the family, they accepted, and we were done. Then I jammed the bags full, knowing some of the stuff might never make it into Hooti, that some pieces would be suitable as thrift-store donations while others should go straight to a Dumpster. But I could

make these decisions without the emotional guilt that one of the family members might have, if they were responsible for disposing of all possessions.

As we were leaving, the daughter asked if we would like to look at some costume jewelry. "Sure," I said. But again it was clear there wasn't time to turn over every piece in hopes of spotting a designer's mark or a reference to the metal content. I just picked out the stuff that caught my eye, building a little pile of goodies, in hopes that some real surprises would surface once I got back to the store. It was the rich pinkness of rose gold that caught my eye—it reminds me of my mother's Longines watch, which she picked out as her engagement gift from my father, instead of a ring. Actually, he already had a ring, because someone had broken up with him just before he moved to Florida. My mother wanted nothing to do with *that* piece of jewelry, so my Dad traded for the watch, later buying her a simple, wide gold wedding band, too.

This ring has an Art Deco setting, in white and rose gold, with two diamond chips setting off the very large red stone. I had no idea if it was a garnet or a ruby or something less—as it turned out, it was just glass—but I didn't care. I had already rationalized why this wasn't going into the store; it would be a wonderful match for my crazy ruby-accented watch.

❧

Some women love diamonds; as you might have surmised, I love alligator—particularly when we're talking handbags. The skins are beautiful to touch, and I love the fact that no two are the same, so no two purses can be exactly the same.

In the eighties, when I was making $10,000 for a photo shoot and first got crazy about gator, the seven bags I bought at the Twenty-sixth Street flea market, were as diverse as the rest of my wardrobe.

Whenever I had a modeling-assignment go-see, out came one of my purses to complete whatever eclectic look I'd pulled together that day, something that I hoped would make me stand out from all the other women competing for that job.

But once I started selling old stuff, every alligator I owned went into the shop. At that point very little in my wardrobe was sacred; I was in the mood to make money, and the more stock in my store, the better. Maybe, too, I was tired of having so many possessions, though I didn't realize it at the time.

I didn't own even one alligator for years, until I spotted my black Vassar at another house cleanout—another find by Melanie. I never buy a purse by the label, and I had never heard of Vassar, though I now know it's a good name in the world of old gator. What I always start with, in bags, is the shape and the look. And I touch it; if the skin doesn't feel rich and real, I keep moving.

At the house cleanout, I bought two alligators—one black, one chocolate brown—for $10 each. The original owner must have been tall, because these were big bags and they would have overwhelmed someone with a slight figure. The purse I kept is seventeen inches wide and eight inches tall, with plenty of room for a modeling composite when I still go to the occasional appointment for a client seeking a "sophisticated woman."

As is often the case with all kinds of vintage, the black purse needed work—one end of its handle was cracked and about to

break. So I hauled to it Superior Leather, a shop in Manhattan that is known for its quality work, and prices to match. Superior wanted $150 to fix my purse, and I'm sure they would have done a beautiful job, but this was more than I was willing to commit, even though I knew the purse was worth it.

Instead I took it to my shoe-repair shop, had them trim the handle by an inch or so to get rid of the damaged area, and then the end was restitched to the hardware. That was all it needed, and for another $10 I had a purse I love and use often. As for the chocolate bag, it went into the shop and sold in one day, for a very nice profit.

Three other purses have a permanent place in my wardrobe. A big, brown alligator clutch—complete with a small head and feet—was a gift from my friend Chris Houghton, who owns a Park Slope store named Trailer Park and who was a Weeds customer long before he started selling vintage furniture and Amish-made tables. It's perfect for those days and events when classic good taste simply won't do. I love those days.

But for nights when the bag must be proper and polished, Whiting & Davis purses are near the top of the list, for me and for Hooti customers. I've sold at last fifty of the metal-mesh bags in the past ten years, and recently they've been as hot as ever. Grandma Houtte owned a Whiting & Davis simple gold-mesh bag, which is now about fifty years old, and I usually carry it to weddings and black-tie parties. It's as essential to my wardrobe as it was to my grandmother's.

By far the most expensive purse in my vintage wardrobe was an impulse buy that I've never regretted. The bag, which shrieks early eighties, is covered in python with buttery leather detail in

assorted shades of chocolate, crème brûlée and putty. It's huge and fits comfortably on my shoulder. I paid $250 for it at Sasparilla—a South Beach consignment shop I try to visit whenever I'm in Miami—only to later discover another price, $8, marked inside in Magic Marker. For once the shoe was on the other foot; one person's garage-sale find was now my treasure, with a healthy markup in between. But I love the purse, so there are no regrets. I can't get *everything* for a buck or two, and it's important to support businesses like Hooti.

❧

When it's really cold, out comes my fifties mink jacket, which goes wonderfully with jeans and boots. This jacket was once an important part of someone else's life, and I met that woman, briefly. Her initials are EGH, and they're stitched inside the jacket, along with a label that tells me it came from a store in Rhode Island called McCarthy's. I had never heard of it, and once, out of curiosity, I went hunting on the Internet and discovered that it was first opened as a general store in the late 1800s.

The mink is a butterscotch color, the sleeves are three-quarter length, it hits just below my belly button, and the full collar stands up to protect my neck on a really cold day. In its second life, I wear it just as I would a Levi's denim jacket.

The woman who owned it called Hooti from Long Island one day, shortly after the store was profiled in the *New York Times*. She explained that her husband had had several pieces custom-made for her in the fifties and she was wondering if I might be interested in them. Could she bring them by?

The seller was probably in her late seventies, and she had been

a good caretaker of her possessions, because, incredibly, the four pieces she showed me were still stored in the original boxes and tissue. That's always a good sign, especially when I'm dealing with someone I don't know. I had no doubt the furs would be ready for their second shot at glamour.

I bought all four pieces, and I wish I'd kept all four.

A fox hat with a matching neck wrap sold at Hooti the same day I bought them—so I didn't have much time for a change of heart.

But since my birthday was just around the corner, I had my justification for a "treat" and held on to the mink jacket and the largest fur muff I've ever seen.

The muff, which could double as a plush sofa pillow, is labelless, and I'm not certain about its origins, though I suspect it is mink dyed to look like leopard. Inside, it has a hidden compartment with a zipper for carrying your cash and keys, and it's lined in the most amazing silk, in an assortment of polka dots in browns, tans, butters, bronzes and cream.

Our transaction was so quick that I didn't have a chance to ask questions, and I'm not sure I would have, even if there *had* been time. Sometimes it's hard to gauge why something is being sold, and I don't want to add to what might be a painful moment. Besides, would I enjoy the pieces as much if there was a sad story behind them—of a bad marriage or financial difficulties? So all I really know is that once Mrs. EGH received beautiful clothes from her husband, she cared deeply for them, and now I'm lucky enough to have them.

One other fur piece in my closet has no past that I'm aware of, but whoever wore this must have been the picture of ele-

gance when she had it on. The labels read "Isabel of Saks Fifth Avenue" and "Made in Scotland expressly for Saks Fifth Avenue by Caerlee," and the fifties-era black cashmere sweater has tan-and-cream fox trim that runs up one side of the front edge, where buttons might be, if this sweater had buttons, around the neck and down the other side. I wear it everywhere, and when I do, I feel glamorous.

Two Hooti customers who work at the Brooklyn Museum, which is just down the street from the store, invited me to a show celebrating the late designer Patrick Kelly. I needed a new/old outfit, preferably something by the designer. I have never owned any Kelly, but I first knew about him when I was working in Paris because he'd come to Paris about the same time I had, and he became a famous designer there, creating colorful and often over-the-top clothes. He died at thirty-five from complications of AIDS.

When I have something specific in mind, and nothing at my store fills the bill, one of my favorite vintage stops is Allure, a tiny store on Fifth Avenue in Park Slope. I send customers there when they need something I don't have. But, as I learned long ago with vintage, if you set too narrow a goal, you're likely to come up empty-handed. Allure didn't have any Patrick Kelly either, so I had to improvise—I needed something that would be *appreciated* by fans of Patrick Kelly. When I saw a very short, black leather jumper with a slight A-line, two chest pockets, a bit of rickrack detailing and a single gold button at the top of the back zipper, I knew I had what I needed. The designer was

Gemma Khang, whose work I had only ever seen new, at Century 21, the big Manhattan discount department store. The one thing I remembered from that encounter: It was expensive.

This dress gave very few clues as to just how old it was, and I really didn't care if it was five years old—or fifteen. I just knew I liked it.

For the museum celebration, I added a plain fitted white short-sleeve T-shirt—this jumper *requires* a shirt or blouse—and finished off the outfit with midcalf black leather boots and a brown gator clutch. And even though the outfit wasn't by Patrick Kelly, the *Vogue* magazine photographer at the event took my picture. I'm always flattered when that happens—and I felt that this confirmed the appropriateness of my choice, though maybe all it meant was that this outfit stood out in a crowd. Is that what I wanted to achieve? Yes, to be honest, but I knew that would be hard to do among so many fashionable people.

Since then, whenever I wear the dress in the shop, men and women are curious: "Who made that dress?" they ask. Or, "Where did you get that dress?"

Only a few people recognize the name, but many people know Allure, so I have an opportunity to send the message that I shop at other neighborhood vintage stores, too, and that you never know where you'll find the next great surprise for your wardrobe.

The Art of Renewal
What's Junk, What's Good, What Works

When I opened Hooti on Flatbush in 2002, there were four empty spaces on my block, on my side of the street. Now there are none, and one of the newer tenants is redberi, the sleek boutique owned by my "supermodel sale" companion shopper, Suewayne Brown.

Suewayne, who is also a longtime Hooti customer, named her shop for a small town in Jamaica, her family's home country. But there's nothing small-town about her merchandise, casual clothes with designer labels, pricey costume jewelry and the finest lingerie. I find it difficult not to splurge on a regular basis.

A few months before Suewayne opened her doors in 2003, she asked about buying some old fur wraps—if the price was right. She planned to update them to sell in her own shop. Suewayne was very up-front about this, and I was happy to strike a deal. Though I had no concrete details about her plans for the furs, I was confident her merchandise would be more complementary than competitive. In general, I

figured we would be targeting different types of customers, and the improved ambience her store would bring to this little stretch of Flatbush was worth a lot to me. I was very curious to see how the wraps would be transformed.

Almost all my furs were selling quickly, for between $100 and $225 each. And, just as I hoped, when redberi finally opened, the "refined" stoles were notably different—fresher, more "girlie" and more expensive—giving customers a broader choice within the shopping world of the 300 block of Flatbush. I know I like choices when I'm shopping, so I was thrilled. Her minks were fun, too, lined with pink-and-yellow polka-dot silk and with new ribbons working as ties. The price: $275.

Since her opening, Suewayne has kept her shop's focus largely on new clothes, jewelry and accessories, but she continues to buy vintage for herself, and she lightly sprinkles old pieces throughout the store—mostly jewelry and the occasional purse. We talk frequently about business—and clothes—and sometimes I recognize an item in redberi, because I sold it to her years ago and now she's taken it out of our personal collection and put it in the store. When that happens, I feel like I've rediscovered an old friend, at least for a moment. And I adore it when a piece of vintage holds its own so well in the company of the newest and coolest.

I love watching for the first signs of North Flatbush renewal, seeing old buildings being painted or reroofed or rewired, wondering what the owner or tenant has it mind and whether this will be just a superficial face-lift or a wholesale gutting, and hoping that the final product will add to the eclectic flavor of Flatbush, not detract from it. I worry when I think the character of a building is being lost, and I'm thrilled when a new busi-

ness owner seems to know what our community needs to keep on thriving—from gourmet pizza to a pet-grooming salon.

These days when I walk out the front door of Hooti, it's difficult not to notice the newest, biggest neighbor on our street. And it's the boldest reminder yet of just how much change is happening to this small corner of Brooklyn.

The building is an eight-story, forty-seven-unit luxury condo complex whose entrance will be on Park Place—a short, modest street that shares only a name with one of the most expensive properties on the Monopoly game board. But the ground-floor commercial space will open onto Flatbush, hopefully fueling yet more business for all the existing establishments that surround it. When the units are finished sometime in 2005, prices are expected to start at $400 a square foot, which means that a two-bedroom apartment will cost somewhere around $400,000. That's cheap by Manhattan and Park Slope standards but a notable upgrade for our world, kind of like putting a bold signed rhinestone pin on a slightly worn but still-handsome wool winter coat.

I welcome the addition, because not everything old—in buildings or clothes or jewelry—has value, and the nondescript building that once housed the Brooklyn Tabernacle Church was not nearly as notable as the church's choir. Our neighborhood did not lose an architectural jewel to hasty developers, and only time will tell whether this new building has better prospects for aging well, whether its designers gave a nod to the structural flavor of the neighborhood or just ignored it. But I know that any new space has to draw fresh faces to Flatbush Avenue, and I look forward to meeting at least some of the dozens of families and couples and single men and women who are thrilled to be buy-

ing into this dynamic intersection of Park Slope and Prospect Heights.

As Hooti has taken root on Flatbush, I have tried to weave both the old and new residents of the street into my life, even when I don't know exactly how to do that.

A hairdresser and regular customer named Dorian—a twenty-something guy who is another one of my walking billboards—loves his seventies gold-tone chains with medallions, as well as seventies wool blazers with suede elbow patches. He also bought a blond mink wrap for his mother for her fiftieth birthday.

Dorian works just two short blocks away, at G's Urban Hair Styles, which is one door off of Flatbush and one of several salons in the immediate area. I seldom see Caucasian women in these salons, so it took me at least a year to get up the nerve to ask Dorian a question that nagged at me as sounding inappropriate: "Do you cut white women's hair?" Dorian laughed, thank goodness. "Of course I do." And then, knowing that a single brand can say it all, he added, "All our products are Aveda."

So Dorian has cut and colored my hair many times—he saw me through a blond phase—and I'm thrilled to pass along his name and number when someone is looking for a new stylist.

I love being a businesswoman in a "small town," which is what my neighborhood feels like much of the time, for better and worse. As vice president of the North Flatbush Business Improvement District, I spend more time than I'd like to dealing with political dustups. But when I need some downtime, and

maybe a quick meat-loaf dinner, all I have to
do is go around the corner and see Maha, a
woman I've known since my earliest Berke-
ley Place days who now owns a tiny deli
two blocks from Hooti. When I need a
quick dose of Paris, I head for Petite
Fleur, next door to Maha. And I'm always
on the lookout for the next hot venue for a
Hooti party.

From a purely vintage point of view,
all the little pockets of neighborhoods
on and around Flatbush Avenue, espe-
cially those in the blocks circling
Hooti, remind me of the old fur stoles
Suewayne and I have sold. No two are the same, new linings are
being sewn into some as we speak, and ribbon ties may be com-
ing soon. With both the neighborhoods and the stoles, there's a
strong sense of history in the original, but a face-lift isn't always
a bad thing. I am frequently reminded, too, that lots of folks
who came to this neighborhood long before I did have played a
big part in Hooti's success.

One of my other neighbors in the 300 block is a hair salon
owned by one of Hooti's regular customers, who swings by the
shop most days to show off her latest vintage finds before open-
ing for the day. I first got to know Diana's hairstylists because
once they saw what Diana was wearing, they started shopping at
Hooti, too. And once they were hooked, I realized that they
were talking about Hooti while they cut and colored hair, and

their customers who were getting the cuts and coloring were curious. So they would stop by to see what their stylists were talking about, and many have become regular customers of Hooti as well.

My relationship with another neighbor has not been as easy, largely because I'm a competitor and in any "small town," competition is not always welcomed.

A few months after I opened on Flatbush, Marlena, who has been selling vintage in Brooklyn for at least two decades, stopped by to discuss fur coats, even though I had no inkling that was her mission when she came into the shop. For maybe five or ten minutes, she worked the racks, scrutinizing every mink and rabbit in the store. Finally, she explained, in a very friendly manner, why she had stopped by: "Alison, now that you are on Flatbush, I think the smartest thing we can do is keep our furs the same price. I'm asking two hundred dollars, and I think you should, too."

I've known Marlena for years, although not well, and I was caught by surprise. She had never suggested anything like this before, but I was closer to her business than I used to be—less than three blocks away. I nodded; I didn't want to get into a discussion while customers were in the store. But I didn't like the message.

"I can't do that," I finally said quietly, trying to be polite but not wishing to continue this chat. "Marlena, we should each run our businesses the way we want to run them. For me, the quicker I move these furs, the sooner I can get back to shopping for more in Pennsylvania." She looked at me and smiled. She was not go-

ing to push this. "Welcome to the avenue," she said. "It's great to have you. And by the way, your shop looks beautiful."

I still invite Marlena to parties, I still send customers to her shop almost daily if they're looking for other vintage stores in the area, but we never talk mannequins and menswear over mochas.

<center>～◇◇～</center>

In the middle of the winter of 2003, a longtime contact from my modeling days, an editor named Lois Joy Johnson, called about a story her magazine was planning for the following spring. The magazine is *More,* a monthly with a circulation of about a million that targets women over forty. The story would focus on three former models and their professional lives after the beauty business dried up.

Photographs were taken, the interview was done, and I wanted to make the most of this latest wave of publicity. The article would appear in the March issue—the perfect time for a goodbye-winter party.

This one would be big, because there was a new restaurant that had opened at the corner of my block, a space that was empty and ugly when I first moved to Flatbush. Long ago the corner had been the home, for decades, to the City Lights electrical-supplies store. Once it closed, all that remained were the name and lots of large, dirty windows. The new owners, who already had three other bars in Brooklyn, had just finished a restoration and remodeling and were about to open City Lights Restaurant and Bar. A Hooti party would be a good thing

for them, too, so they gave me a great price. I would do an open bar for two hours, with three hundred chicken wings—I've never met a chicken wing I didn't like. After that, my customers were all on their own.

I had a stack of party invitations in the store—for better or worse, I've never done a postal mailing for anything Hooti-related in my life—and everyone who stopped by heard about the event. All the while I was watching the calendar and checking the magazine stands, waiting for the March issue to come out. I was also going a little crazy about this party: I decided we needed entertainment, and who better than Twirla, a Hooti customer and baton twirler who performs in Manhattan and favors vintage for both her costumes and her day clothes. Twirla agreed to a store credit in exchange for doing two five-minute sets, and one of her outfits would be head-to-toe Hooti: a black-and-white sequined majorette costume, plus white leather majorette boots.

The restaurant owners were a bit nervous about this latest development—it was obvious this would be the first twirling performance in any of their bars. They'd seen a lot in the business, but they hadn't seen Twirla. I assured them their fourteen-foot ceilings were more than high enough to handle her baton and that no one would be hit because of a bad toss.

A week before the party, the newest *More* magazine went onto the racks at a store across the street from Hooti. The minute I spotted it, I stood in the aisle frantically flipping through the pages, looking for *my* story. I couldn't find it, so I started flipping all over again. It *had* to be in here somewhere.

It wasn't. As I soon found out, the issue's content had been changed at the last minute. I was told the story would run in

May, but I knew what that really meant: It might, and it might not. I broke the news to my parents and my closest friends and Hooti customers—and I felt kind of foolish for telling so many people about something like this when I know that nothing is guaranteed until it's in print. I was disappointed, but the party must go on, even if the reason for the celebration had evaporated. After all, did I really need an excuse to throw a party? Wasn't this more about spending time with people whose company I enjoy and whom I like to thank on a regular basis for their patronage? Absolutely.

I hate the prospect of a small turnout, so five days before the party we went to the phones, calling our best customers to remind them about the event. That was a waste of time. When I arrived at the party—ten minutes after the announced 8:00 P.M. open bar—twenty-five guests had already beat me to cocktails. Soon City Lights was a mob scene—more than two hundred people had shown up to drink, strut their best Hooti outfits and see Twirla. I had never actually seen her perform, so I was as curious as the rest of the guests. Once she'd changed into her first vintage outfit, I had to clear a large space in the middle of the room. When I announced her debut at City Lights, everyone broke into screams and clapping, and she hadn't even made her first toss. But her recorded music and classic majorette persona had set the tone. Twirla had a few drops in the first show, but the crowd didn't seem to care, and when she returned for her second show, everyone started chanting "TWIR-LA, TWIR-LA!" Again the fringe flew and the sequins shone. And for weeks to come, customers were talking about what a good time they'd had, and the buzz all along Flatbush was about Twirla.

"Where did you find that girl?" I was asked again and again.

The timing had been just right, for my customers, for the neighborhood, for me. After a long, nasty winter, people were in the mood to get out of their apartments, and I was happy to provide a show, to be the ringmaster for a night of pure fun.

Two months later we had something else to talk about, too: The *More* magazine article finally came out, as promised, in May. The phone started ringing with calls from all over the country—California, Georgia, North Carolina—and almost everyone wanted a pleated denim mini skirt like the one that had made it into one of the magazine's photos of the shop. My friend Gigi makes these from old jeans, so we took waist sizes over the phone, along with buyers' heights and their preferences for where the skirt should hit on their waist or hips, along with a sense of just how short would be acceptable.

For a brief time, Hooti had become a mail-order business with a whole new group of customers. We didn't have one return among the skirt orders, so I think the buyers were all satisfied. But I wish I could have seen them do a couple of twirls in their new purchases.

When friends hear that even something as odd as an old majorette outfit has a new life at Hooti, they assume that customers buy such pieces for a costume party or Halloween. And I do always have a steady stream of shoppers like Twirla, who are entertainers or have an invitation to a themed party.

But my most creative customers are constantly reminding me that this recycling business has few boundaries. Almost anything

old with sequins and beads has a good shelf life in the vintage market, and smart women who like a bit of flash have figured out that a glittery majorette body suit looks hot with a pair of jeans or as a wild accent under a simple suit jacket. Other customers love the look and feel of the old-fashioned short, boxy, low-heeled white leather majorette boots, wearing them with both jeans and skirts.

For me, every sale of a majorette item means a brief flashback to my elementary-school days, when both my sister Caroline and I were Hurricane Honeys, wearing black felt cowboy hats and little black taffeta circle skirts as members of a twirling squad that would appear each year in our rural town's rodeo parade. And one year we even went into Miami, for the Junior Orange Bowl Parade—maybe that was the year we wore costumes covered with layers of white fringe.

Caroline remembers better than I do how one day each twirling season was devoted just to making red-and-white yarn pom-poms, to be tied on our short leather boots that are just like the ones I still sell in Hooti, whenever I can find them. The costumes might have varied from season to season, but the boots were a constant, and we loved them. They were unlike anything we'd ever owned before, and I know they stayed in our closet for years after we'd outgrown them.

☙

One day just a few weeks after the article about Hooti appeared in *More* magazine, the phone rang at the shop. The woman on the line had just arrived in New York from Indiana, and she wondered if I would be interested in looking at the

contents of her aunt's apartment, which was just a few blocks from Hooti. She had seen the *More* article and had already driven by the shop, just to confirm my story, I guess.

Her aunt had recently died, in her nineties, and the niece had to move quickly to clean out her home. So on a Friday night, after I closed the shop, I spent an hour sorting through the clothes of a lifetime.

The address was on Prospect Park West, a doorman building, and the apartment had two bedrooms plus what used to be called maid's quarters—spacious by the standards of many New Yorkers. The crystal wall sconces, Persian carpets, formal dining room with its red-flocked wallpaper and the peacock blue walls of the living room told me an elegant life once had been lived here. But now it was every bit the home of an old woman who had lost interest in her surroundings over time or just couldn't afford to spruce things up. The fifties furnishings were tired, and the paint on the walls was faded and chipped.

I was met there by the niece, a warm, gracious, simple woman in her sixties, and her daughter, a Martha Stewart–in–training who lived north of Manhattan and had come down for the weekend to help dispose of her great-aunt's possessions.

I wasn't really in the mood to socialize, but I knew I was a bit of a curiosity—the "ex-model" thing does that to some people, and they just stare at you, though I'm not sure what they're looking for. And the older woman was curious about my current business, fascinated that I could make a living off people's old clothes.

"Who would want this?" she asked nicely. And she asked it

again, and again, and again as we pulled her aunt's possessions from dusty shelves and slightly musty dresser drawers.

Her daughter, though, had no questions. She had no interest in her great-aunt's clothing—or in my interest in them. She could not relate to the idea of vintage on any level, and that was fine with me. In this cleanout I wouldn't be getting just the leftovers, at least not with the clothes. I figured the jewelry was another matter, but our first priority was the packed closets.

I soon felt as if I knew the deceased woman because of what she had kept from the decades when she was still socializing, though the clothes told only so much. Did she throw elegant parties, or did she prefer dinners and the theater in Manhattan? Did she play bridge or have a country house? I didn't know, and I didn't feel comfortable asking where she might have worn what I was about to buy: at least a dozen hats, all in beautiful condition and still in hatboxes; maybe two dozen handbags, day and evening, nestled carefully in storage bags; and three closets full of clothing in sizes six and eight, much of it wonderful suits and dresses from the fifties into the early seventies. For the most part, she had bought stylish things that had aged well, even if there were no notable labels.

As I "read" the clothes, I could tell when she had turned to the "retirement home" phase of her life, even though she remained in her own apartment. The pieces, mostly weary polyester housedresses and stretch pants, had no character—nothing that could help them have another life.

I was moving quickly when I spotted a simple lime green polyester Lacoste-type short-sleeved knit dress—pure Summer

Classic, if I had to categorize. It had an alligator logo on it, but it was obviously a knockoff, because the gator was a bad reproduction. Of course, the real French-made Lacoste of polo-shirt fame would have been best, but this was a good item. I tried to engage the niece and her daughter with my view of vintage. "This is a wonderful dress," I said, holding it up for them to see. "I think I'll wear it to the shop tomorrow." It was in perfect condition, and I had great pink shoes with green accents—$42 from Baker's—that would work nicely with it. Why not wear it?

Hearing this, the younger woman looked at me as if I'd just landed from Mars. And she didn't say a word, though I swear her lips were pursed. Her mother just smiled and kept working, trying to be pleasant without getting too engaged with this weird woman who had no qualms about wearing other people's clothes without even washing them. So much for making any vintage converts tonight.

The estate's jewelry was piled up on the dresser, and I knew that the women had already claimed some pieces for themselves—and I was thankful they would have some reminders of their aunt/great-aunt's life. But there was plenty left for me—maybe fifty pieces—earrings, necklaces, bracelets and lots of rhinestones. Almost everything was designer costume jewelry, and the markings—they included Weiss, Kramer, Trifari and Coro—are popular at Hooti and with jewelry collectors, brands that cover almost a century of design. I bought it all, along with every piece of the woman's "preretirement" clothing, stuffing everything into large black plastic garbage bags.

After I wrote out a check to the niece, I hauled the merchandise onto the fancy elevator, looking grimy and tired and feeling a little embarrassed when I made eye contact with the uniformed elevator operator. I was sure I looked every bit a junk scavenger, but I knew I was hauling quality vintage that had already seen one heyday and was headed for another. Let appearances be damned.

Most of the merchandise was on the racks and in the display cases when Hooti opened the next morning, and I sold almost everything within two months. "This just came out of an apartment on Prospect Park West," I said again and again, because I always like to tell the origins of something, if I know it. And most Hooti customers know that Prospect Park West is a good address, and with that comes the assumption that the people who live there probably own nice things—especially if they held on to them for forty or fifty years.

I wore the green dress that Saturday, too, with the pink shoes. It was a big hit with customers, and I wore it many more times that summer, feeling both sporty and a little bit sexy every time I put it on. Nothing about it made me feel old or tired.

⚘

One thing Hooti customers never saw was an old Singer sewing machine that found a corner in my bedroom for about six months. My co-op is full of vintage goodies—everything from eight place settings of hand-painted rooster-themed dinnerware to two stuffed pheasants and assorted gilt mirrors—but I draw the line at most things electrical. I've invested in rewiring for old alabaster lamps and iron chandeliers (with new

miniature leopard-print lamp shades), but I have no interest in surrounding myself with forties-era appliances that could burn me out of my home. So the purchase of the Singer was somewhat out of character. My desire to sew something had grown stronger that winter, but my original plan for that day had been to buy a cheap new sewing machine at Wal-Mart after I finished shopping at the auction.

Then I spotted the Singer, which was built into its own dark-wood table and probably dated back to the sixties, at the outdoor auction that happens every week no matter what the weather. Once again—just like with the Pucci purse—the opening bid was a dollar. And since the industrial-grade machine and table were covered with ice and snow, the closing bid was a dollar, too.

My good friend Tony, who had come along for the day, looked at me, mouth open and shaking his head in disbelief. "You are amazing."

Then he carried the machine, walking awkwardly across large patches of ice, to one of the nearby auction buildings, where we hunted for an electrical outlet. We chipped off the ice and swept away the snowflakes, I dried her with the sleeve of my coat and then we plugged her in. Not "we," really. I let Tony do the plugging—I was afraid of getting shocked. As soon as I put my

foot on her pedal, her motor was humming and the needle went up and down just the way it's supposed to. Tony looked at me again. "Alison, only you have luck like this." I was giddy and ready to stitch up a storm, even though I had only a vague idea of what I would sew.

But Tony was the one who insisted that this machine needed *some* attention, so after the auction we headed straight to Wal-Mart—for a can of Three-in-1 oil. Before I slipped the first piece of fabric under the presser foot, Tony had oiled every moving part.

I sewed my way through the rest of the winter, playing with assorted ideas and selling maybe a half dozen totes made from barkcloth remnants. But spring came, and I was ready to be outdoors when I wasn't in the shop—my passion for this machine had been as short-lived as some of my relationships with men, intense but relatively superficial. However, *this* relationship would be a whole lot easier to end: I put a notice on the bulletin board in my co-op.

OLD INDUSTRIAL-STRENGTH SINGER SEWING MACHINE
WITH TABLE. $40. RUNS WELL.

I had not been back in my apartment more than twenty minutes when the phone rang. The woman lived on the fourth floor and was a new mother on a tight budget. She wanted to know if the machine came with a manual. *A manual?*

I hadn't expected that question, and I didn't want to discourage her. I explained that it was vintage, that I was not the original owner—I did *not* mention the ice—and that I had sewn on it recently. Before she would commit, the woman wanted to call

the Singer company to see if they might have a manual, so I gave her the model number—assuming she would get nowhere. Within another ten minutes, my neighbor was back on the phone. Singer would sell her the manual for $15, so she wanted my machine.

The next day it had a new home, and I knew that if I ever bought another old sewing machine, it would be a Singer.

❧

Gambling on the unknown is risky business, of course, whether it's old equipment, an old house, old clothes, an old neighborhood or a man like my tree mover Henry Williams, whose ups and downs are as unpredictable as the winning numbers for a Lotto ticket.

Several years ago, a stranger called me at Hooti and asked for Henry. "Henry?" No one had ever called him at the store before. "Can I ask who's calling?" She explained that she was a relative of Henry's and that the family had learned that he occasionally worked for Hooti. She wanted him to know that there had been a death in the family. "We haven't seen him in a long time," she said. "Would you please ask him to call us?"

Henry stopped by later that day. I gave him the message and then let him use the phone to return the call. When he was done, Henry said he wouldn't be able to work the next day—his nephew had been murdered and he needed to go to the funeral. He was sad, a mood I hadn't seen all that much with him. And he was curious. It had been a *long* time since anyone in his family had seen him.

I assured him that Hooti would be okay without him for a

day. When I pressed him for details, it quickly became apparent he had no idea how to make this trip happen. But I did.

"How about if we call a car service, and you can pay me back by doing some extra work at Hooti," I said. He liked that idea. "But you can't go the way you are," I added. "You need to look your best." He agreed. "My family isn't used to having someone who is homeless," he added.

That afternoon I went about dressing Henry from the racks of Hooti. We started with a dark seventies suit, a tie and a leather belt. A good friend donated a men's long-sleeved white shirt (left in the closet by her soon-to-be-ex-husband), and Henry was currently wearing acceptable shoes. Once the outfit came together and he had tried it on, I knew I couldn't let Henry keep it overnight—I had no confidence he would still have it in the morning.

Finally I asked Henry to make sure he cleaned up the next morning before coming over to Hooti—and that meant a shave and a good hot shower. Fortunately, I knew that a neighborhood minister who has had his own share of ups and downs with Henry would let him use the bathroom in his house.

Henry arrived right on schedule and dressed at the shop, looking dapper as he stood for a few minutes studying himself in the mirror. Just before the car service arrived, he asked for a favor. "Is there any chance you can take a picture of me?" He was so proud of how he looked, and so was I, but I couldn't help wondering when he would have last had a photo taken of himself. So a picture was shot.

Henry made it to the funeral—"Everybody was surprised that I was alive"—and he liked the driver so much that he called

the shop before returning to Park Slope to see if the same car and driver—Car 62—could be sent for the return trip. Yes, that could be done, though I was surprised he had noticed a detail like that.

Back on his familiar turf, Henry said he wanted to stay in the suit for a while longer so he could visit some friends. Sure, I said. I knew where this was going—the suit would soon become a part of his street life—but that was okay. For that day, for a few remaining hours, when he walked down the street, people wouldn't see Henry, the homeless guy on Flatbush. They'd see a proud person, with a face that seemed vaguely familiar, and there would be nothing threatening or sad about him.

After ten years of selling vintage, I sometimes put on a favorite outfit and fresh makeup and step back into my last life for a few hours. I'll get a call from my agent about a particularly lucrative ad campaign, and if I can spare the time from Hooti, I'll make an appearance at a go-see. Forty-something models who pursue the work full-time can make a nice living, thanks to all the products targeting wrinkles, menopause, impotence and every other aspect of our aging bodies. I would be foolish to turn my back on this business entirely.

But at the end of the day, I'm happy knowing that I'm going back to Brooklyn, to Hooti, to my home. Maybe there will be a box of clothes waiting for me at the store from my mom or my sister Caroline, who both shop for Hooti, too. Or a phone message from Dad, asking how the go-see went, because he still gets a kick out of seeing his youngest daughter's face in print. But he

also loves hearing about all the friends I've made, and all the adventures I've had because I'm in the business of *old*—and it is such a young and high-energy place to be, no matter what the age of my customers.

That's the biggest surprise about owning a store like Hooti Couture. Almost every day I help dress people of all backgrounds and ages—men and women, rich and poor, black, white, Hispanic, Asian—in a way that brings out who they really are or who they want to be. At the same time, we are both giving a new life to something that had become a castoff, something that still has value and potential for a new story to be told, even if its past is a mystery.

When those stories become my stories, too, I feel like the luckiest girl on Flatbush Avenue.

Vintage Shopper's Guide

WHAT TO KNOW ABOUT ESTATE AND RUMMAGE SALES, THRIFT STORES AND SECONDHAND BOUTIQUES

E state and garage sales, flea markets and auctions can be a great source of vintage. But no matter where you go, you have to be willing to dig through someone's possessions—the good, the bad and the ugly. If you don't want to get your hands dirty, this may not be the way you want to shop for vintage clothes and accessories.

Here's what I've learned in almost thirty years of shopping and scavenging:

* **Start early.** Smart buyers, and especially collectors and re-sellers, get to a sale before it actually starts. That way if there's a line, they're at the head of the line. However, *do not* knock on people's front doors or ring their doorbells at 7:00 A.M.—or at any time before the sale starts. That's the single quickest way to alienate yourself from the seller—and it's very rude, too. Check the classified ads in your local

newspaper every Thursday or Friday to find the latest batch of sales.

* **Go on Sunday**. Many estate sales run Friday through Sunday, and some are managed by companies that do nothing but organize and coordinate such sales. Their goal is to move as much merchandise as possible, so prices are often reduced on the last day of the sale. Of course, by then the merchandise has been heavily picked over, but good pieces may have been passed by because the prices were too high. If your town or city has professional estate-sale managers, learn how they operate. And if you do save your shopping for Sunday, get there early, because you won't be the only one looking for markdowns.

* **Go to church!** Great deals can be found at annual flea markets and rummage sales put on by churches and other nonprofit groups. They usually draw on donations from members, so you have access to multiple households with one stop. Again, check the classified ads, free local advertising "flyers" and neighborhood bulletin boards for notice of such sales.

* **What's in a name?** If the word "estate" is used, you will generally pay more than at a garage sale, because those professionals I mentioned above are more savvy about what's hot at the moment. Professional sellers are likely to look more closely at labels and markings, too. Watch out for the bogus "estate" sale, though, where a seller has combined merchandise from several sources and stuck it all in an empty house, attempting to make it look as if the goods ac-

tually once all belonged to the same person. It's possible to find a good deal at this kind of sale, but usually someone has bought the merchandise elsewhere and is a reseller. If a garage sale seems to happen every week or every month at the same location, be wary—these sellers are probably re-selling merchandise they bought elsewhere, and there probably won't be many true bargains.

* **Expand your boundaries.** If you live in a city, plan a day trip to nearby rural towns on a Saturday or Sunday. Flea markets, garage sales and thrift stores are all potential gold mines, and you'll be facing a lot less competition. And when traveling in foreign countries, do some preliminary research on the best flea markets, including their days and times of operation. However, if you know only ten words of French or Italian, negotiations may be difficult.

* **Assess the condition of the house or vendor's stall.** At any private sale, in someone's yard or home or at a flea-market stall, the state of the property can tell you a lot about the general condition of the merchandise. If the property is uncared for, it's likely the merchandise will reflect that. If there's a smell in the house—especially a smoker's house—the clothes are likely to smell, too. If the flea-market stall is chaotic and clothes are lying on the ground, the prices might be appealing, but you may really have to dig for even one good item. At any location, if the clothes smell, I usually walk away, because some smells—especially smoke and mothball odors—can be extremely difficult to remove. But if a location is just dirty and a first glance at the furnishings

tells me the owner had good taste, I'll head straight for the closets, because there may be big bargains to be had among the dust bunnies and debris.

❋ **Be decisive.** If I like something, I know I need to grab it now, because it may not be there tomorrow—or even five minutes later. One Sunday years ago, when I was a regular shopper at the Twenty-sixth Street flea market in Manhattan, I found two suitcases, probably from the sixties, covered in a faux-leopard fur. The seller wanted $40 for the pair, and I had to have them, so I didn't hesitate. As I continued to shop, suitcases in both hands, a woman started following me from table to table, offering several times to buy the suitcases from me. She raised her price several times, but to me these were priceless. I still have the bags, and I've never seen any quite like them.

❋ **Does it fit?** Most garage and rummage sales don't provide space for trying on clothes, but you can always ask if that's an option. But usually you will have to gamble, assuming that something can be altered if the fit isn't perfect. If you want to try on something over your clothes, ask first if that is allowed. Most sellers will say yes, unless the item is very fragile.

❋ **Can I put it on hold?** This is tricky, and the answer varies from seller to seller, in stores and at weekend sales. I seldom hold merchandise, especially at busy times of the year, but I will do it for an hour or two if someone needs to run to a cash machine. When in doubt, ask.

❋ **Be prepared.** Carry a lightweight bag so it will be easy to haul all your purchases, and it's really helpful if your cash in-

cludes some small bills. Don't assume that anyone at a flea market or garage sale will take a check, though some sellers will; it varies from sale to sale. And don't assume that every vintage and thrift store takes charge cards; for several years I accepted only cash and checks.

IS THE PRICE NEGOTIABLE?

Don't assume that every garage sale or vintage shop's prices are flexible; however, many are. The best way to determine a seller's policies is to ask, politely, about a specific product once you've spotted something you are interested in. "Are you firm on the price?" or "Can you do any better on the price?" are friendly but direct ways to approach the subject.

I promise that you will get nowhere if you say something like, "How much for this old thing?" Never be negative about a store or its merchandise; if you don't like the place, just leave. And I can guarantee you that "I saw it for less down the street" just doesn't work in vintage, because you're seldom comparing apples to apples—sixties bell-bottoms with embroidered pockets are not the same thing as DVD players at Best Buy or Circuit City.

If you've got a great item in your hand and the seller quotes a reasonable price, don't try to negotiate, because it's possible the seller might take a closer look and see that he or she has made a mistake and back off the quoted price. The time to negotiate is when you like an item but genuinely think the price is high. In general, nothing ventured, nothing gained.

At Hooti one other factor figures into the final price of mer-

chandise: quantity. If it's obvious the customer wants several items, I will quote a better price for the total package.

Consignment shops—businesses that sell clothes on behalf of private sellers and keep a percentage of each sale—usually aren't open to negotiation, but there are exceptions, so when in doubt, ask. And do look for a sale rack or ask if the store ever has sales. Recently I spotted an unusual fur in a consignment shop, but the price was more than I felt like paying that day. When I inquired if there was any flexibility, the shop owner said it would probably be reduced in about three weeks if it hadn't sold by then. That seemed like a reasonable approach to me—though I knew that someone could come along and snap it up at any moment. But I wasn't *that* crazy about it.

I've shopped at Goodwill stores where the price is negotiable and other thrift stores where it isn't, so it pays to ask. Many charity-sponsored stores do have regular sales and often offer a senior-citizen discount.

One more tip on pricing: If a shop is a mess, you might find some real bargains if you're willing to dig. But if nothing has prices, get an early read from the owner about some piece of merchandise. You don't want to dig for half an hour, only to find out that the prices are ridiculous.

Finally, if a tag says "firm," that tells me that many pieces in the shop are negotiable, but not this one, obviously.

REPTILE-SKINNED PURSES: WHAT TO KNOW

The favorite alligator purse I keep at home is made by Vassar—one of about a dozen labels I see regularly in alligator purses

from past decades. But I really don't care that it has a label; I like it because of the shape and size (big, to balance my five-foot, eleven-inch body). But when I spot a bag that's stamped or tagged "genuine alligator," I know the bag will sell quickly, because the shopper knows it's the real thing—and it's not always easy to tell the difference between a real skin and leather printed with an alligator pattern.

Of course, there are hundreds, if not thousands, of purse manufacturers who have made beautiful but unlabeled alligator and crocodile purses, and even purses with labels may not tell you whether the skin is crocodile or alligator. And just because a purse has a label doesn't mean it's top quality, of course.

Before buying, I always look closely at the handles (often there will be breaks, but handles can be fixed if everything else is to your liking), and I check out the general wear at the corners. Also, an interior lined with leather is usually an additional indicator of quality. And I always make sure the clasp works; you don't want a purse that doesn't stay closed, no matter how beautiful it might be.

Finally, if a purse has a label from a well-known store, say Saks or Bendel's, it will probably also have a stamp saying "genuine alligator." If it doesn't, look closely at the "skin." If the pattern and coloring are too perfect, it's possible it's a beautiful but faux gator. But, again, many label-less bags are the real thing, so your best bet is to learn by touching and feeling a lot of bags, and buying from someone you trust, if you aren't sure what to buy.

Here's a sampling of brands you might spot:

Bellestone
Deitsch

Escort

Hermès

Koret

Lederer

Lesco

Lucille de Paris

Mark Cross

Nettie Rosenstein

Rendl

Rosenfeld

Sterling

Varon

Vassar

Major high-end stores, existing and defunct, such as I. Magnin, Saks Fifth Avenue, Bonwit Teller, Neiman Marcus and Marshall Field, have also produced great bags, and many beautiful gator, crocodile and python bags come from Europe, too.

THE QUICK FIX FOR A PURSE HANDLE

Daisy Lewellyn, who works at *Glamour* magazine and has been wearing vintage since her Catholic-schoolgirl days in Los Angeles, came in one day carrying a small vintage gator bag she'd recently bought (not at Hooti). The handle had just broken, so I offered to hold the purse while she shopped so her hands would be free.

It was a quiet moment in the store, so her dilemma became

my challenge. I don't know what inspired me to think of a skinny, vintage butterscotch-color snake belt, but I did, so I asked Daisy if I could remove the broken strap, and that was fine with her. I cut away the handle, which had cracked in several places—a common problem with older gator and crocodile purses. I then looped the belt through the two metal handle fasteners and rebuckled it, just as I would if I were putting it around my waist. The new "handle" looked fantastic, especially because the colors of the two skins were similar enough to be complementary, but not so close in color that it would look weird.

Another inexpensive variation of this fix involves cutting off the buckle and tip of an old gator or crocodile belt, weaving the new "strap" through a purse's existing hardware, then cutting the handle to the preferred length, with about an inch of overlap at the ends. Once the length is determined, glue the ends of the strap together and take the purse with its new handle to a shoe-repair shop, where the two ends can be stitched together.

I have seen several other creative handle solutions. One involves wrapping a scarf around an existing handle that has become noticeably worn or otherwise damaged. The scarf is knotted to the hardware at one end of the handle, then wrapped tightly around the handle in overlapping layers and finally is tied in another knot at the other end of the handle.

For a Chanel flavor, remove the old handle and then double up a heavy-duty gold-tone or silver-tone necklace—choose the color that complements the existing hardware—through the remaining fasteners. The chain should be quite thick and at least sixteen to eighteen inches long, with a strong clasp.

WILL THOSE FRAMES WORK?

I love vintage eyeglasses, but it's a tricky business if the frames are plastic. In general, I don't recommend putting expensive prescription lenses in old eyewear unless the frames are metal—and there are great frames out there, some of them very expensive because they're either gold or gold-filled. If you are buying eyeglasses just to work as accent pieces—or you want sunglasses—plastic may be fine, but look closely at the frames before buying, and avoid anything with even slight cracks.

WHAT'S FIXABLE, WHAT ISN'T

* Make sure a **zipper** works, unless you're very handy with a sewing machine or the item is so fantastic, and reasonably priced, that paying a tailor to replace the zipper makes sense. I rarely buy anything that needs a new zipper.

* If the **underarms** of a piece are heavily stained or discolored, I usually keep moving. However, if the fabric or design is irresistible, you might consider removing the sleeves and cutting a slightly larger armhole. Hooti customers do this all the time, often finishing the new armhole with simple hand stitching. I've also seen thirties and forties vintage pieces where the underarms had already been replaced, probably decades ago. This usually looks a bit funky, but with vintage everyone has her own personal limits of what's acceptable and what isn't. I do buy pieces that are heavily stained if I think the item can be used as a

"cutter" because the fabric is incredible or the piece has valuable buttons or a fur collar that can be removed and reused.

* Many vintage pieces are lined, and if stains and other damage are limited to the **lining** and the piece's overall condition is good, I'll snap it up, knowing that many vintage buyers realize linings are often the most fragile component—but seldom affect the outward appearance of a piece.

* Missing **buttons** are common on vintage pieces, but if you're looking at a great suit or coat, consider shopping for a new set of buttons; look for specialty fabric stores that may sell new and/or old buttons. They aren't always cheap, but they can be a stunning addition to a piece. I also know people who buy new clothes and then replace dull plastic buttons with a distinctive vintage set.

* If a jacket is a bit **snug** but you love it, consider moving the buttons. Even a quarter inch can mean the difference between comfort and confinement. The same usually goes for a hook-and-eye or button on a skirt.

* If a vintage suit has a nice cut but you need something slightly **dressier,** consider replacing the buttons with jeweled buttons.

* If I'm selling something from the early eighties, I almost always remove the **shoulder pads**—they make a piece look dated, not stylish. However, I would never touch the shoulder pads in anything from the forties. I would be ruining the piece if I did that.

✳ Look closely at **old wool** before buying, because if it has begun to rot in several spots, there's not much you can do—and reweaving can be very expensive. With any vintage clothing, hold the piece up to the light, and you should get a quick assessment of its condition. If holes in the fabric are tiny, and the price is right, a few simple stitches may fix the problem, especially if the weave is loose or nubby and a repair won't be noticeable. However, doing a home repair on a finely woven cashmere sweater is not as simple as it may seem—unless it's a simple seam.

✳ If a vintage item you covet has nothing worse than an unstitched **seam or hem**, grab it. This is an easy fix, either with hand stitching or at a tailor. Do look closely at sleeve and skirt hems, to make sure the edge of the hem hasn't worn through. If it has, see if the item's sleeves or skirt can be shortened and still work for you.

✳ Hooti customers frequently have the **sleeves** of jackets and coats lengthened. Just make sure your piece has enough fabric to do the job right, and also make sure there isn't a faded line where the fabric originally folded under, because that line will show when the sleeve is lengthened.

✳ When considering a vintage **fur,** watch for dryness, rips, bald spots, odor and shedding. If the coat or wrap is shedding in your hands, you know this fur is not for you, no matter how appealing the price. Also, if the lining is a mess, this tells you the fur may not have gotten the best care, at least in recent years. In general, old furs are tricky business; if you plan to spend a lot, make sure you buy from a seller you trust.

* Old **fake furs** are much more durable than the real thing. Seams can be easily resewn, and some are even machine-washable. However, some fake furs, mostly from the seventies, have a sealer on the "skin" side that can deteriorate and turn into a powdery substance. If that's a problem, and the coat is fabulous, purchase a large can of *unscented* aerosol hair spray, flip the coat inside out and thoroughly spray the skin side. Let the coat dry for a day or two, in a well-ventilated room, and it should be good to go.

* I'll snap up almost any weathered **leather** jacket I see, if the buttons are okay and it still has its belt, assuming it originally had a belt. However, I won't buy leather jackets or coats with serious ink or oil stains or if they are as stiff as a board. And I avoid dirty suede, though weathered suede can be attractive. To me, "weathered" means assorted signs of use that add to the overall character of the piece. It's totally a judgment call; if you like an old leather piece and it feels comfortable, buy it. Do be aware of the weight; I've tried on a few jackets that were simply too heavy to be comfortable.

PACK A MAGNIFYING GLASS

My eyes are still pretty darn good, but I never go on buying trips without a small magnifying glass. That's the only way to read the markings on most jewelry.

OLD-SHOE SHOPPING

Good vintage shoes are hard to come by—and some old shoes aren't worth buying. If you follow a few rules, though, you probably won't get burned.

1. Never buy a pair without trying them on.
2. Feel free to try on shoes in your bare feet. You are not shopping in Neiman Marcus.
3. Check out the condition of the soles. If they need replacing, that's expensive. The only time I consider resoling is if the shoes or boots are alligator or lizard. But if the skins have cracks, keep looking.
4. If patent leather shoes have any cracks, put them back on the rack.
5. If you're shopping for old cowboy boots, avoid those that are stiff. They've probably been through a lot of rainstorms and may never loosen up. And rub your hand across the leather; if it "sheds" in your hand, keep moving.
6. If the shoes only need fresh liners or heels, and the price is right, grab them. Heels are relatively cheap, and shoe-repair shops offer an amazing assortment of liners these days.

BUFF IT, SPRAY IT, TUMBLE IT

If you spot something wonderful but your budget doesn't allow significant dry-cleaning expenses, consider these options:

At-Home Dry-Cleaning "Cloths": Toss one into a dryer with up to six of your new finds; these "revitalizers" are a quick way to freshen up a garment, especially if it isn't seriously soiled.

A $2 Buffer: This is great for cleaning anything leather, vinyl or patent leather. The sponge comes lightly soaked with oil, and I use it on jackets, purses, belts and shoes. If something in leather has mildew, I clean it with a little Murphy's Oil Soap diluted with some warm water. Apply with a clean cloth.

Liquid Sprays and Cold-Water Fabric Detergents: I love Febreze, and Target now sells a knockoff version of this liquid spray clothes freshener, too. If something appears clean but has even a hint of mustiness, Febreze is a quick, easy fix. If something is soiled, consider hand washing, always in cold water, with a detergent like Woolite. But avoid putting any vintage clothes in a regular washer, unless you're working with polyester. Even then, use the delicate cycle.

Biz: This powder can be found at larger grocery stores and Wal-Mart, and it's what I add to Woolite or a heartier detergent when I'm wrestling with serious stains or dirt, especially if I'm dealing with a color fabric.

Armor All and Vaseline: My friend Nancy gets credit for this tip. The car-cleaner Armor All is very effective at renewing most leathers, patent leather and vinyl. But start slowly because leathers can be difficult. Always test any cleaner on a small spot, preferably inside the piece of clothing, just in case you don't like the results. If you are trying to soften stiff leather, try a coat of Vaseline. *But* you need to apply it to the underside or rough side of any piece of leather, *not* the smooth surface of the item.

IF YOU DON'T KNOW ANYTHING ABOUT VINTAGE . . .

My vintage education has come from hands-on experience, as well as the guidance of friends and customers, and I suspect that many of my customers have learned the same way—and keep learning.

But shopping for vintage is as much about style confidence as it is about knowing the finer points of dating clothes according to metal zippers or being able to say whether something was late sixties or early seventies. Who cares, really, if you like what you're seeing in the mirror or holding in your hand? I sure don't.

Most Hooti customers don't buy vintage as an "investment," and most of my merchandise is not museum quality. But I do have many *casual* collectors—people who buy only purses or signed rhinestone jewelry or a specific "look" such as *Charlie's Angels* mod—and almost everyone who falls into that category buys with the idea of wearing her finds, not putting them into storage for safekeeping. And most people are happy to share what they know, if asked.

If you have a friend who loves vintage, ask to tag along on a shopping trip. If you don't, just start by browsing on your own. Walking into a vintage store for the first time can be a bit intimidating, especially if the prices are steep and a lot of the merchandise is behind glass. However, you don't have to buy—you just need to spend time in the racks, touching fabrics, reading labels, fingering bracelets and earrings, and trying on anything that's appealing. If the products you like have helpful tags, read them. If they don't, ask the store owner or salesperson what he

or she knows about the look or the label. Figure out what styles flatter you, think about how a jacket or a scarf might be incorporated into your current wardrobe. And make a mental note of prices.

For price comparisons—as well as an introduction to a vast array of merchandise—explore eBay. It is an excellent resource for tracking the latest prices and generally learning about everything from Lucite to pearls. But you need time, patience and a sharp eye. Many sellers are knowledgeable about their goods and provide detailed descriptions of what they're selling, including condition, which is essential to determining a price range for a category of vintage merchandise. If details are skimpy, skip that seller or ask questions *before* bidding. Remember, all white leather go-go boots, thirty years old, are not equal.

Obviously the big drawback with Web shopping is the fact that you can't try on merchandise or even hold it in your hands *before* you buy. And many sellers don't allow returns. So if you want to start a collection for a specific item—say, Diane von Furstenberg wrap dresses—take the time to watch several eBay transactions before jumping into the fray. See where the pricing ends when the bidding stops—if the product even has a single buyer. And scrutinize how merchandise is described, paying close attention to measurements and other such details.

Also important, if you're shopping on eBay, are the feedback ratings of the sellers as well as the amount of merchandise they've already sold. If a seller doesn't have a great rating, be very skeptical about any information you take from his or her posting. If the seller claims to be a vintage specialist and has logged at least several hundred past eBay sales, I'm more likely to

trust information in one of that seller's listings. Bottom line: You can learn a lot on eBay, even if you never make a purchase there. But don't believe everything you read.

Books also do a good to excellent job of covering specific categories of vintage and can be especially useful for people who want to start a collection. However, I don't generally recommend clothing price guides, because they're quickly outdated and I have yet to see one that is close to comprehensive. The one exception is any guide that focuses on a single label, like Chanel or Dior, or category, like jewelry or purses. Depending on your interests, consider these books:

* *DK Collector's Guide: Costume Jewelry* (DK Publishing, 2003): This book is incredible, almost as much fun as trying on jewelry at Tiffany and not nearly as expensive. Author Judith Miller provides brief histories of major designers, plus more than fifteen hundred color photos of marked and unmarked pieces, price ranges for specific items and a collection of designer marks and signatures.

* *Vintage Style: Buying and Wearing Classic Vintage Clothes* (HarperCollins Publishers, 2000; by Tiffany Dubin and Ann E. Berman): I love how this book easily mixes and matches among decades, offers snippets of history on everything from the A-line dress to the cashmere sweater and uses real people as models for all of its photographs.

* *Wearing Vintage* (Black Dog & Leventhal Publishers, 2002; by Catherine Bardey): This book has several wonderful vintage photos that capture great style details from past decades, including the cuffed chinos John Wayne wore in a 1959

movie, a Nehru jacket shown to best advantage over a turtleneck by actor Robert Wagner in the sixties, and Mary Tyler Moore in cigarette pants and flats.

* *The St. James Fashion Encyclopedia: A Survey of Style from 1945 to the Present* (Visible Ink Press, 1997; edited by Richard Martin): When I wanted to check my facts on designers like Patrick Kelly and André Courrèges, this is one place I looked. But it probably contains more information than most vintage buyers will ever need.

* *American Ingenuity: Sportswear 1930s–1970s* (The Metropolitan Museum of Art, 1998; by Richard Martin): This ninety-six-page book accompanied a show at the Met, and its focus is limited, but the photos of Claire McCardell's work from the thirties to the fifties, particularly a black-and-red silk evening gown, make it worth the price.

* *Boutique: A '60s Cultural Phenomenon* (Mitchell Beazley, Octopus Publishing Group, 2003; by Marnie Fogg): This book is filled with incredible vintage photos, and anyone passionate about the 1960s will want to take a walk through London as fashion flourished in specialty stores on Carnaby Street and the King's Road.

* *The Aloha Shirt: Spirit of the Islands* (Beyond Words Publishing, 2000; by Dale Hope and Gregory Tozian) and *Western Shirts: A Classic American Fashion* (Gibbs Smith Publishers, 2004; by Steven E. Weil and Daniel DeWeese): These two books capture the essence of two of Hooti's most enduring vintage categories. I don't think hula girls and pearl snap buttons will ever lose their appeal.

Want More?

Turn the page to enter
Avon's Little Black Book —

the dish, the scoop and the
cherry on top from

ALISON HOUTTE &
MELISSA HOUTTE

Get Smart About Vintage
With the Internet

Hungry to learn more about all things Mod? Ready to step into someone else's boots? Or simply desperate to find your closest vintage stores? The Internet is a great place to start.

The web sites listed below have been chosen for the quality and depth of their information and/or the quality of photographs and illustrations of vintage clothes and accessories. Some sites are more sophisticated than others, but our highest priority was providing diverse vintage resources, whether you are just about to make your first vintage purchase or have a closet full of classics. Some sites named here also sell merchandise, but we are not in a position to endorse their "store" (or guarantee a satisfactory transaction). We have included them because of their vintage content on designers, the styles of a certain decade, a particular topic of interest to vintage shoppers and/or general advice on the care and repair of your favorite vintage finds.

While we have scoured the Internet for this list, we're certain we have missed valuable resources. If you know of one, please tell us about it at *hooticouture.com*.

General Vintage Information

vintagefashionguild.org

The Vintage Fashion Guild has created a highly useful, information-packed site, whether you are just entering the vintage world or already know the difference between Lilli Ann and Lilly Pulitzer. We particularly love the Labels Resource, where you can type in a name and see assorted labels from past decades for many mainstream and couture designers. It's a great tool for dating a piece of clothing.

fashion-era.com

This massive site is the work of one British woman, Pauline Weston Thomas, whose passion for everything from Edwardian swim wear to '60s miniskirts is reflected in more than 500 pages of web content. She also has written an "ebook" on vintage clothing, which you can buy at her site for $15.

ebay.com

For information on everything from appliqués to zippers, click on the Community section of eBay. Once you are here, you can ask a question or visit the discussion board. The amount of knowledge shared among sellers can be overwhelming—but it can be a whole lot of fun, too.

fashiondig

This well-designed site has delightful content (and also sells clothes). But the No. 1 reason to visit, especially if you want to shop vintage while on vacation or a business trip, is its Store Locator. Put in the appropriate zip code, then get ready to explore. You can also do a search for vintage sellers in a limited number of international cities, but when we did a spot check for London and Paris, we got modest results. Also, please remember: As with most business listings in print or on the Internet, call a shop before you visit. Stores come and go, and it's hard to keep listings up-to-date.

costumes.org

Don't let the name fool you; this is about much, much more than theater or movie garb. The home of the Costumer's Manifesto is a wild and crazy place to visit, and you could spend weeks sorting through the diverse collection of material and Internet links gathered by Tara Maginnis at the University of Alaska Fairbanks. Our favorite: her "Shoes" page.

vintagevixen.com

At this site, you'll find great "female fashion facts" for every decade from the 1900s through the 1970s. The site also has lots of tips for vintage clothing care as well as an excellent list of vintage reference books. At the home page, just click on "Free Information Section."

thefedoralounge.com

Here's a vintage chat community where the topics can range from Borsalino hats to bomber jackets. An affiliated destination, retroradar.com, calls itself an "information clearinghouse for anyone enamored of mid-20th century pop culture." This site includes more than 200 links to online vintage clothing and accessories sellers.

collectics.com

This eclectic site is largely focused on antique and collectible home furnishings and accessories, but click on "Reference & Education Program" to find information on Coro and Miriam Haskell jewelry, as well as guidance on identifying Bakelite, Lucite and celluloid.

Specialty Sites

dimlights.com

Cowboy boots aficionado Jennifer June has created a delightful web site devoted to new and vintage cowboy boots. Her shopping directory for where to find vintage boots is just one of many wonderful elements at this user-friendly destination. She also has a lively blog.

heyviv.com

This site specializes in poodle skirts and other Fifties goodies, and we particularly love the repair tips. Click on "Vintage 101."

fabrics.net

This homespun site has a bunch of information on vintage fabrics and related vintage topics—everything from buttons to rickrack to embroidered hankies.

avintagewedding.com

Anyone who wants to put a vintage twist on their marriage ceremony should start with this site, which offers "Tips & Traditions" as well as a state-by-state directory of seamstresses.

bagladyemporium.com

This quirky site is devoted to handbags, and if you click on "Bag Lady University," information on dozens of vintage purse makers can be found. Sometimes the reference material is nothing more than an old print ad, other times you get multiple photos and the history of a label.

Museum Sources

metmuseum.org

The Costume Institute at The Metropolitan Museum of Art offers rich online samplings from many of its past exhibits, including Jacqueline Kennedy: The White House Years and Rock Style. You can find the Costume Institute by clicking on "Permanent Collection."

collectionsonline.lacma.org

The Los Angeles County Museum of Art has an extensive online presence, and that includes both illustrations and photographs of work by major clothing designers. Go to Departments and use the pull down menu to get to "Costume & Textiles." Once here you can see hundreds of sketches and some photos of the work of Rudi Gernreich, or look at notable couture pieces, organized by decade.

museumofcostume.co.uk

The Museum of Costume, Bath (England) has a delightful tradition called "Dress of the Year." The museum has been making such a selection every year since 1963, and you can see them all, with a brief write-up about the piece and the designer. Click on "The Collection," then click on "Dress of the Year."

philamuseum.org

This is the home of the Philadelphia Museum of Art, and once you click to the Costume and Textile Collection, click your way through delightful exhibitions, discovering everything from a maroon silk velvet evening jacket by Elsa Schiaparelli (Best Dressed exhibit, 1997–1998) to the wedding dress of Grace Kelly (Spring 2006).

vam.ac.uk/collections/fashion

The web site for the Victoria and Albert Museum in London has extensive online information in the Fashion, Jewelry & Accessories archives. In particular, check out "1960s Fashion and Textiles," where you'll find photo-rich "micro sites" devoted to everyone from Mary Quant to Courreges to Ossie Clark.

http://www.library.ucla.edu/libraries/special/scweb/ cashin/bonniecashin.htm

This is where to find the Bonnie Cashin archives, acquired by the University of California-Los Angeles in 2003. Great photos, great sketches, and the fascinating story of a remarkable designer who created wardrobes for '40s movies and later moved on to Coach handbags.